ALL
About Techniques in
WATERCOLOR

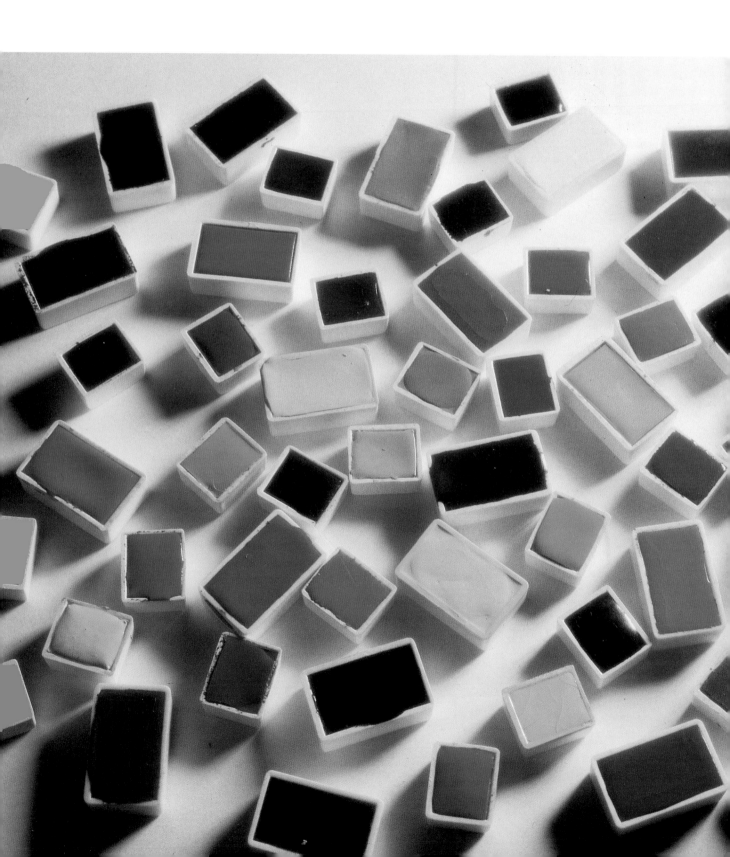

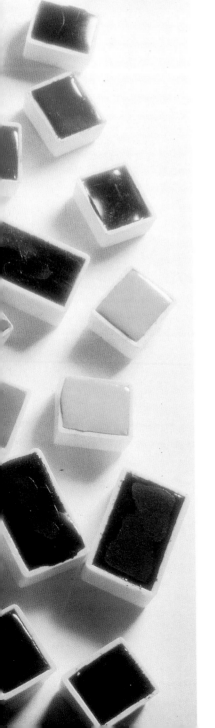

ALL
About Techniques in
WATERCOLOR

BARRON'S

Contents

Although it is possible to find examples dating back to ancient times, watercolor painting, as such, started in the fifteenth century. Despite its relatively recent development, however, it is second only to oils in popularity. This technique is based on the interplay of water, pigments, and the brilliancy of white paper to create effects of light, transparency (watercolor's main quality), and subtlety of tone.

Today, watercolor is one of the basic painting techniques, as well as one of the best known and appreciated. It is fascinating to work with a medium that allows the artist to paint such fresh, spontaneous, and flowing works. Although it is a naturally fragile medium and requires little equipment, it can produce works of great beauty and elegance.

As with any other technique (probably more so, given the difficulty of correction), mastering watercolor requires the artist to paint constantly, to practice time and again, to experiment a thousand times over. In time, practice makes perfect and arouses the imagination. Much will depend on the individual's efforts, willpower, and constancy: If the artist can combine a firm attitude with sound knowledge of the technique itself, the result will be the perfect artist.

All About Techniques in Watercolor is an attempt to deal exhaustively with the knowledge necessary for mastering watercolor painting. It seeks to provide a solid basis that is well documented and up to date. In addition to the paints, paper, and the other necessary materials, the artist will find tricks of the trade, advice, basic exercises, and demonstrations set out clearly in the form of detailed step-by-step procedures.

The practical format of this book makes each subject and detail easy to understand so that anyone who paints can put the information into practice effortlessly. It is, therefore, a true handbook in which the reader will find everything about the watercolor medium—that is, answers to questions, tricks needed to achieve a certain effect, and exact information on every aspect of the technique.

This book has been designed for the fine arts teacher, who will find abundant information for his or her classes; the art student, for whom it will be an unrivalled reference work; and the professional, who will benefit not only from its thoroughness but also from the way it classifies the graphic materials, and the wealth of new information it contains. All About Techniques in Watercolor will be an essential companion for beginners and more advanced amateurs, who are unlikely to find such a far-reaching technical and practical guide as this one elsewhere.

To anyone who paints in watercolor, we offer this work as a guide to entering the world of this exciting technique.

Paint

Watercolor, or aquarelle, is a water-based paint that has as its principal characteristic the transparency of its color. (The opaque water-based paints, including gouache and casein, will not be covered in this book.)

This quick-drying medium makes use of glazes that are applied from light to dark. Light tones are introduced before the dark ones because, being transparent, a light color will not conceal a dark one. Whites are obtained by reserving certain areas of the paper itself.

Watercolor is both the simplest and the most difficult of techniques. Simple, because all the paints can be carried in small boxes and the painting surface is paper. Difficult because the paint's transparency means that your work must be carefully planned as it is a rather unpredictable medium that is virtually impossible to correct.

The effect of watercolor glazes resembles a dye more than a continuous layer of paint. The colors can be combined on the palette or the paper, as well as by superimposing one glaze over another.

These colors can be applied thick and hardly diluted—as they come out of the tube. In this case, the paint will not adhere well to the paper, and the color will resemble an opaque brushstroke. Watercolor applied this way may crack if the paper is not kept perfectly flat.

COMPONENTS

Watercolor paints are obtained by mixing pigments, binders, and moisture-retaining agents called humectants.

Quality in watercolor paint is determined by the quality of the pigments and other components it contains. Two basic features reveal the quality of a paint: stability and permanence.

Stability is a feature that depends on the binders. After its use, a stable paint will not crack or peel off.

Permanence, or resistance to light, refers to the color and is directly associated with the pigments used. The color should not change over time and alter the overall tonal balance of the picture.

CHARACTERISTICS

The main characteristic of watercolor paint is the transparency of its colors. This is because gum arabic is the binder and water is the only solvent used to dilute the paint.

Transparency affects the entire procedure of watercolor painting. To begin, white is a color that is rarely applied; instead, the artist uses the white of the paper—a method called reserving or masking. As watercolor paint does not entirely conceal any underlying colors, it is impossible to cover up a dark color with a light one. For these reasons, when painting in watercolor, it is essential to plan the work before starting and to paint the light tones first.

PIGMENTS

Watercolor paints are priced according to the quality and density of the pigments in the paint. Paint of good quality can be diluted with a lot of water without losing its color because it consists of 50 percent pigment.

The raw materials from which pigments are produced are ground until an extremely fine powder is obtained. The smaller the grains of the pigment, the easier it is to spread the paint evenly.

Each pigment reacts differently when it is mixed with water and is in contact with the paper.

Pigment is the component that gives paint its color.

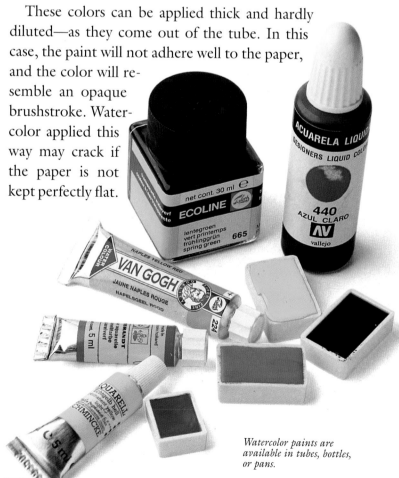

Watercolor paints are available in tubes, bottles, or pans.

Burnt sienna tends to form granules and the particles collect in the grain of the paper producing a mottled effect.

Ultramarine blue contains particles that attract each other instead of dispersing, an effect which also produces a mottled look.

Yellow and red contain only one pigment that is resistant to fading: cadmium. As it is rather expensive, you will only find cadmium yellow and red in the best-quality watercolors.

A few pigments dye the paper and leave a mark if removed. Others can be lifted off the paper without leaving a trace.

Some pigments are naturally transparent and are ideal for glazes; others are opaque, even though they have a high glycerin content—such as cerulean blue, chromium oxide green, and Naples yellow.

Although watercolors are applied in fine layers, it is not true that they fade more than others due to the effect of sunlight. Only semitransparent pigments or those of a doubtful origin are likely to fade, as they would if used in any other type of paint.

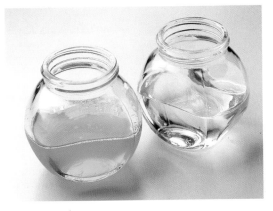

Gum arabic is used to bind the pigments; glycerin acts as a humectant.

Magenta and organic reds have a limited permanence, whereas yellows that contain cadmium, umbers, and ultramarine are resistant to sunlight.

BINDERS

Pigments are gradually mixed with binders to produce a paint of pasty consistency.

In watercolor paints, the main binder used is purified, natural gum arabic of various types. This substance, when dissolved in water, makes the paint flow spontaneously and evenly.

Glycerin is also added to the paint as a humectant to lengthen drying time.

For the same reason, some manufacturers even use honey in their formulas, as painters did in the past.

PAINTS ON THE MARKET

Watercolor paints are available from art supply stores in three forms: solid, creamy, and liquid.

Liquid watercolors are sold in bottles; the solid form, in pans of various sizes; and the creamy type, in tubes.

TUBES

The watercolor paint paste that results from mixing the pigments and binders can be packed into tubes or pans. Both forms have the same quality, though the procedure is slightly different when it comes to using them. Of the two, tube paint contains a greater amount of humectants such as honey and glycerin; thus, it is creamy, fresh, and moist. These characteristics make it more suitable for large formats. Because they dry more slowly, tube paints allow large areas to be covered quickly. They are also practical for slow, more detailed work.

Pans and tubes also differ when it comes to mixing the color on the palette. Tubes allow you to mix one color directly with another to create a new color without smudging the first two colors. In other words, two store-bought paints can be combined easily to produce a third color. Tubes can be bought singly or in boxed sets. The number of colors to buy depends solely on the artist. Stores offer small boxes with

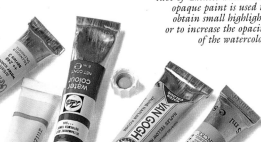

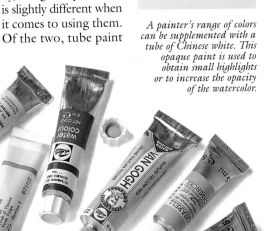

A painter's range of colors can be supplemented with a tube of Chinese white. This opaque paint is used to obtain small highlights or to increase the opacity of the watercolor.

Tube paint that dries on the palette should not be thrown away; it can be remoistened with water and used like pan paint.

The tube threads should be wiped clean before replacing the cap because gum arabic is a glue. If the cap sticks, the tube could be damaged when it is reopened.

only six tubes and large boxes that hold a manufacturer's entire range (see page 28).

Advantages: Colors inside a tube never spoil. A color can be applied directly onto the palette. Tubes are also more practical for blending diluted washes in the cups as it is not necessary to add the color with a brush.

Disadvantages: You must decide first how much of which colors you are going to use. If you do not, you will have to interrupt your work to add more paint as you need it. In practice, you must either waste some paint or spend time adding more as you work.

Watercolor paints in pans.

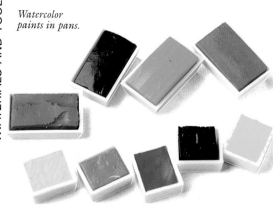

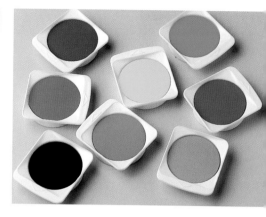

PANS

Watercolors in pans are of the same quality as tube paints, though they contain more gum arabic and less glycerin. As a result, they dry more quickly. The paints are subjected to an evaporation process during manufacture. This eliminates most of the water and produces a doughlike paint, which is then cut up, packed into plastic pans, and labeled.

Pans enable you to see all the colors you have at a glance. Moreover, pans are also practical because they are portable, and the lid of the box can be used as a palette.

Pans are sold whole, or by halves for the smaller

After using the pans, it is advisable to dry them with absorbent paper to clean them and prevent the colors from accidentally mixing.

boxes. The boxes themselves range from shirt-pocket size to others as large as an attaché case. The latter may contain the manufacturer's entire color range, a palette, and an assortment of brushes (see page 28).

Advantages: One glance is enough to see all the colors on the palette. No time is wasted as you don't have to stop to add more paint. Neither do you have to plan your colors ahead.
Disadvantages: When a pan is opened, the label showing the name of the color is lost. The paint has to be taken to the palette one brushstroke at a time. Pans are less practical for making cupfuls of diluted washes.

When using pans for the first time, they may not provide enough color; the same sometimes happens when they have not been used for a long time. The problem can be easily solved: Wet the pans with a few drops of water and let it penetrate into the paint; rehydration will make the paint softer and easier to dissolve.

LIQUID WATERCOLORS

Manufacturers pack liquid watercolor paint in small plastic or glass bottles. Liquid paints have vivid colors and are more suited to graphic art and illustration. The plastic bottle has a tapered inner spout that allows you to pour out exactly the amount of paint you need. The liquid products are useful for painting in plain colors as they are already diluted and will always produce the same tone. Artists who use liquid watercolors tend to have a large assortment because the paints are a little awkward to mix.

Advantage: The paint does not need diluting as this has already been done.
Disadvantages: You cannot vary the intensity of the colors as the paint is always the same tone. Mixing is difficult because the colors would have to be poured into the cup in exactly the right proportions.

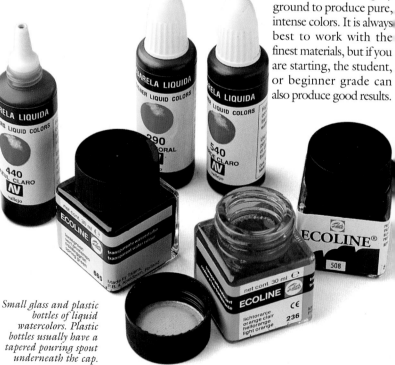

Small glass and plastic bottles of liquid watercolors. Plastic bottles usually have a tapered pouring spout underneath the cap.

DRY PANS

Dry-pan paint is the watercolor typically provided to young school children. These paints come in round cakes that contain hardly any glycerin. Consequently, these paints are difficult to remove and often need hard rubbing with the brush. Their quality is not suitable for artistic work.

As they have a scant amount of pigments and use low quality binders, the colors do not spread evenly and the result is unstable when dry.

Dry watercolor pans fo school use. As thes colors lack quality, the do not spread evenly an yield unstable results. The are not intended fo artistic works

QUALITY

Watercolor paints come in two different grades one quality for artist and another for students.

The difference between the grades lies in the amount of pigment the paint contains and the process by which it has been ground.

The best paints contain 50 percent pigment that has been thoroughly ground to produce pure, intense colors. It is always best to work with the finest materials, but if you are starting, the student, or beginner grade can also produce good results.

COLOR CHART

A color chart is a range of colors manufactured and marketed under a given brand name. It is a fairly accurate representation of the hues the user can buy ready made. This chart is practical for finding and selecting the colors that best suit your style or requirements. Of course, no watercolorist uses such a vast palette as the job of constantly searching for different colors would be a hindrance, not an advantage. An artist usually works with a palette containing between 15 and 20 colors. If more colors are kept in the palette than are generally used, they just take up space and can interfere when you look for tones that you use more often. When choosing a palette, most artists usually work with three tones of red, yellow, blue, green, and earth. These are more than sufficient to obtain any other color by mixing them (see pages 50–57).

Manufacturers offer such widely ranging color charts to enable artists to choose the tones each feels most comfortable with. Note, however, that color designations are not completely standardized: The same hue may be given different names by different manufacturers.

Depending on the brand and the quality of the paints, the chart will be more or less extensive. The one shown here has 39 colors, plus Chinese white. It is useful to keep a chart handy in the studio as an aid in finding a specific tone or to see if one obtained through mixing colors is available in ready-made form on a manufacturer's chart. Some artists who demand the widest range possible from each tone work with different brands at the same time to make the fullest use of their palette.

All charts include information on the permanence of the colors. As mentioned earlier, permanence is the capacity of a pigment in the color to resist change. This permanence is usually indicated by small symbols such as stars, asterisks, crosses, or circles. The

TUBES OR PANS?

A person who decides to paint in watercolors will naturally dismiss the liquid form as it is more suited to graphic art; the round, dry pans are not for artistic work. So the choice narrows to watercolors in tubes or in professional-quality pans.

It is impossible to say which type of watercolor paint is better as individual artists have their own preferences. If the work has a large format, watercolors in tubes are preferable because they stay fresh longer. On the other hand, you need to squeeze them out of the tube; thus, any unused paints will dry on the palette. (To reduce this waste, art suppliers have available palettes with covers.)

Watercolor paints in pans have the advantage that the entire range of colors can be seen at a glance and they are easier to carry.

Probably, for beginners who have never painted in watercolor, the most advisable step is to start with pans, which will enable them to arrange the colors on the palette and paint directly from the pans.

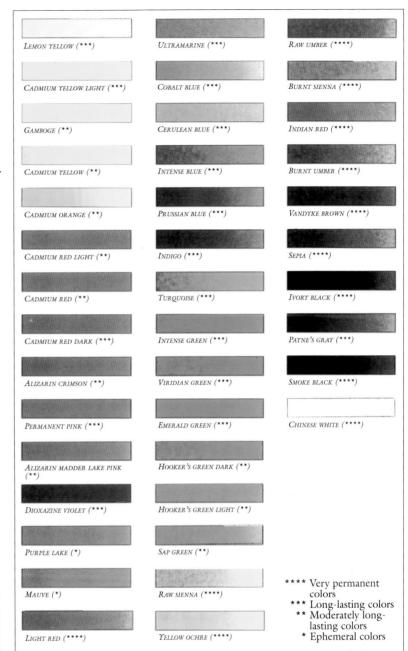

LEMON YELLOW (***)
CADMIUM YELLOW LIGHT (***)
GAMBOGE (**)
CADMIUM YELLOW (**)
CADMIUM ORANGE (**)
CADMIUM RED LIGHT (**)
CADMIUM RED (**)
CADMIUM RED DARK (***)
ALIZARIN CRIMSON (**)
PERMANENT PINK (***)
ALIZARIN MADDER LAKE PINK (**)
DIOXAZINE VIOLET (***)
PURPLE LAKE (*)
MAUVE (*)
LIGHT RED (****)

ULTRAMARINE (***)
COBALT BLUE (***)
CERULEAN BLUE (***)
INTENSE BLUE (***)
PRUSSIAN BLUE (***)
INDIGO (***)
TURQUOISE (***)
INTENSE GREEN (***)
VIRIDIAN GREEN (***)
EMERALD GREEN (***)
HOOKER'S GREEN DARK (**)
HOOKER'S GREEN LIGHT (**)
SAP GREEN (**)
RAW SIENNA (****)
YELLOW OCHRE (****)

RAW UMBER (****)
BURNT SIENNA (****)
INDIAN RED (****)
BURNT UMBER (****)
VANDYKE BROWN (****)
SEPIA (****)
IVORY BLACK (****)
PAYNE'S GRAY (***)
SMOKE BLACK (****)
CHINESE WHITE (****)

**** Very permanent colors
*** Long-lasting colors
** Moderately long-lasting colors
* Ephemeral colors

larger the number of symbols, the more resistant the color is to damage from age and weather conditions. Remember that any kind of paint with long exposure to sunlight or excessive indoor lighting is prone to fading or changing color.

Some colors such as crimsons, madder lakes, olive greens, and the yellows that do not contain cadmium are more sensitive to the effects of sunlight.

Regarding the intensity of the colors, keep in mind as you start to paint that when the colors dry they will lose between 10 and 20 percent of their intensity. You will need to compensate for this loss if you are painting from life or want to be true to the original coloring. Part of this loss of tone can be offset by applying a fine layer of gum arabic over the paint or adding it to the varnish.

As regards color charts in general, remember that you are looking at printed colors that may appear slightly different from the original watercolor.

A color chart of average-quality watercolor paints. The asterisks indicate the manufacturer's evaluation of the permanence of each color. Names of colors vary among manufacturers.

Paper

Paper is the main and nearly the only painting surface used for watercolors, which, being water based, require a surface that retains moisture. The water and the pigments determine the characteristics that suitable watercolor paper should have.

The paper must have capacity to take up water and expand, so it is important the fibers create a porous surface that can absorb the moisture well, can expand in all directions, and can return to its original shape when dry.

In relation to color permanence, the capacity of the paper to absorb and retain the color is just as important as the adherent properties of the paint. Additionally, the paper must enable the the paint to flow easily with a surface that provides small troughs and pores in which the paint can accumulate.

The difference between watercolor paper and drawing paper is the sizing applied to the surface. During the manufacturing process, watercolor paper is pressed and immersed in a sizing bath of gelatin. Because both sides of the paper are treated, the paint remains on the surface and does not penetrate to the center. If penetration occurred, the colors would appear flat and lack their characteristic brilliance.

In the past, sizing was applied to only one side, so it was important to distinguish one from the other. Nowadays, this is not the case and the watermark is there only to identify the manufacturer.

Pressing of the pulp can be done when it is either hot or cold. Cold pressing is best for watercolor paper, as this maintains the structure of the fibers and their original porosity. The heat of the hot-pressing process alters the fibers and gives the paper a fine-grain structure with a smooth and less absorbent surface, making it more suitable for drawing and detailed work.

Many types of paper can be found in the market. Each manufacturer has its own range. Some artists find no difference between papers of the same grain, whereas others are very sensitive to these differences. The only way to discover your preferences is by using and practicing with different types of paper to find the one that best suits your style of work.

COMPOSITION

Watercolor paper is made of wood pulp, glue, and cotton, sometimes called rag.

Fifty percent is the minimum amount of cotton a good paper should contain. Cotton is a vegetable fiber with sufficient absorbency and elasticity to provide the resistance and versatility that quality paper requires. The best paper is made entirely from cotton.

The sizing that binds the cotton and wood pulp determines the paper's capacity to absorb water and resist washes and the use of large amounts of water. In the best paper,

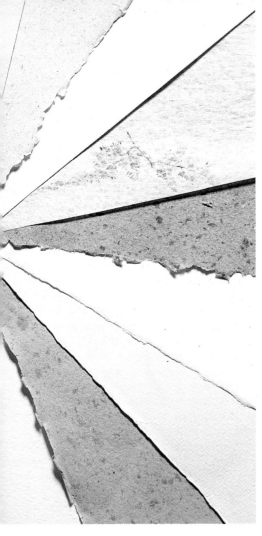

gelatin is used twice during its manufacture, first as a binder in the pulp stage and later to coat the surface.

Papers of lesser quality are sized using synthetic glues. Badly glued paper disintegrates easily when the paint is reworked on the surface.

Because paper fibers are a natural product, they can oxidize, which becomes apparent when the paper turns dark or yellowish. To prevent oxidation, an alkaline substance is added to the paper pulp to maintain a neutral pH value. Anti-fungal products are also added to prevent fungi from developing and causing a yellowish stain that grows over time.

Some brands, such as Arches, have the same roughness on both sides. Others do not, but this can be useful as the same piece of paper will have two different types of texture—the manufacturer's watermark is read backwards to find the rough side. In the past, the watermark indicated the side of the paper that had been treated. Today, watercolor paper is usually available with size on both sides.

WEIGHT

The weight of paper is calculated in pounds per ream or grams per square meter. The heaviest papers are usually the thickest. Weights of watercolor paper range from 90 to 300 pounds (185–640 g). (Weights per ream are given for the popular 22-by-30-inch [56 × 76 cm] sheet).

Weight differences affect paper performance. Paper weighing more than 140 pounds (300 g) does not need stretching before painting, unless the paper is soaked. Papers with less than the aforementioned

weight need stretching to stop them from warping and are useful only for small formats because they warp easily.

Resistance to warping differs even among papers of the same quality; generally, however, the heavier the paper, the better it handles water as wrinkling and curling are factors related to paper thickness and weight. A large amount of sizing on the surface of the paper usually increases its weight. Consequently, when a paper of the same brand and the same grain as another weighs more, the additional weight is due to the amount of size applied to the surface.

QUALITIES

Paper comes in three qualities that are differentiated by the paper's composition and the type of size used.

In watercolor painting, the quality of paper is judged by its resistance to washes and corrections: Does it permit lifting out some paint to create highlights, for example? Does it retain the pigments on its surface to maintain the intensity of the colors?

STUDENT GRADE
Paper of ordinary quality, or student grade, is

To read certain watermarks you need to hold the paper up against the light. Some manufacturers emboss their mark on the paper.

CHARACTERISTICS

The principal characteristic of watercolor paper and what differentiates it from the others is its surface.

The surface of watercolor paper is treated with a special sizing solution that causes the pigment to remain on the paper's surface without penetrating to the center. The sizing allows the colors to retain the brilliance and intensity that characterize watercolor paints. In addition, watercolor paper is manufactured in various degrees of roughness that are graded as fine, medium, or coarse.

useful for developing artists in the beginning stages of learning.

Usually, paper of this grade consists of cellulose from wood pulp, contains no cotton, and is sized with synthetic glue. It is the most economical and is not necessarily bad. It can be used for making sketches and drafts.

MEDIUM GRADE
Fine art students and dedicated amateurs are the principal users of medium grade papers.

Paper of this grade has a high cotton content, over 50 percent, and is sized twice, in the pulp stage and after pressing. It is more expensive than those of inferior quality but reacts much better to washes and corrections and is more stable. A serious painter will find the difference is significant.

TOP GRADE
Top-grade paper is intended for artists, professionals, and earnest amateurs.

This paper is made totally from cotton, with a size of gelatin added before and after pressing it. Being extremely stable and extraordinarily resistant to repeated washes and corrections, this paper responds well to all kinds of treatment and yields results that cannot be equalled by papers of lesser quality. It is expensive but its quality more than makes up for its price.

OTHER PAPERS
Although this book primarily refers to watercolor paper, some artists use papers that have not been manufactured specifically for this technique. Whichever you choose, remember that watercolor work done on unsized paper will have a dull, flat appearance.

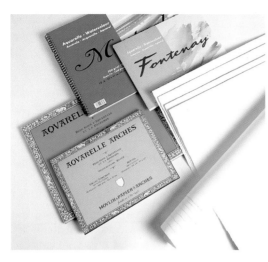

COMMERCIAL PRESENTATIONS

Watercolor paper is sold in several different forms, including sheets, pads, blocks, and more.

SHEETS

Sheets are available either packaged or loose and in many different sizes. Fine handmade papers are not made to precise measurements. Names are used to indicate approximate dimensions. An Imperial sheet, for example, is about 22 by 30 inches (56 × 76 cm).

ROLLS

Rolls usually measure 10 yards (10 m) in length by 1 yard (1 m) in width. They can be bought whole or in part. The great advantage, and disadvantage, of a roll is that it needs cutting after deciding on the format you want to work in.

Watercolor paper can be bought in pads, blocks, sheets, and rolls.

PADS

Pads come in all sizes and types. Pads generally measure between 7 by 10 inches (18 × 26 cm) and 20 by 28 inches (50 × 70 cm). Small sizes are also available for making sketches and miniatures. Pads come in either book or spiral form. The book form allows you to work on a double page.

BLOCKS

There are also blocks of glued sheets that are more suitable for professionals. They may be held together with adhesive on one side or on all four sides. The latter are practical because the glue around the sides stretches the paper, enabling you to

Pads and glued blocks of sheets; to separate one, just slide a knife between the sheets.

work on the block itself and save the time otherwise spent stretching it yourself. To separate the sheets, simply slide a knife between them, taking care not to cut the paper.

POSTCARDS

Watercolor paper in postcard format has appeared recently on the market. One side of the sheet is printed for addressing the card and the other is blank so artists can paint whatever they like.

Postcards made from watercolor paper.

TYPES OF PAPER

Several types of watercolor paper are offered. Some are differentiated by texture: satiny, fine, medium, and rough. Others are distinguished by their manufacturing process, such as handmade paper; their composition, such as Japanese paper; or their color. (Some papers may be difficult to find in North American art supply stores.)

SATINY PAPER

Although not really for watercolors, satiny paper has become popular among artists recently. It is better suited to illustration and graphic arts than to artistic work. It is hot pressed and its surface is completely smooth. As it has neither grain nor pores, satiny paper cannot

FORMATS

The format of the work usually dictates the type of paper to be purchased.

Large formats usually call for a heavy paper. A roll of paper is practical in that it will let you work in any format because it is sufficiently large and can be cut to the desired size. On the other hand, its large size and tendency to coil makes it difficult to handle and requires stretching.

For small formats, a pad will work well; a block is the best choice, however, in the appropriate size and with a fine grain. Blocks save the time and bother of stretching the paper yourself.

For paintings of intermediate size you can use paper in any form and of any grain.

retain the water on the surface and dries quickly. The effect it has on the brushstroke can be seen readily. The brush can easily leave bristle marks and the paint may separate; thus one brushstroke may create streaks over another because the paper surface does not allow the strokes to blend or because the paint has dried too quickly. Satiny paper is suitable for precision work.

Advantage: The results can be seen immediately.

Disadvantages: Satiny paper produces breaks and makes gradations difficult.

GELER, SATINY (1)

Geler is a good satiny paper, but it does not withstand retouching and the paint pigment does not spread easily over the surface.

ARCHES, SATINY (2)

Arches satiny paper has characteristics similar to Geler's. It is, however, slightly more resistant for retouching.

FINE-GRAIN PAPER

Although watercolor paper ought to be cold pressed, some manufacturers hot-press it and also leave a certain roughness without which the color would not adhere to the surface of the paper. Working with this paper requires skill in controlling color boundaries, in blending, in gradating, and in manipulating wet contours because the fine-grain of the paper surface causes the paint to run. Fine-grain paper can be used for small formats and watercolor drawings.

Advantages: Fine-grain paper enhances the luminosity and transparency of the colors. It allows clean, precise brushwork.

Disadvantages: Working with fine-grain paper is not easy. This paper does not absorb very well and if too much water is used

Texture of fine-grain paper, shown in actual size

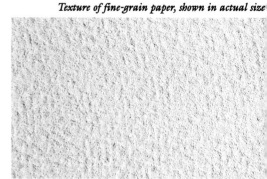

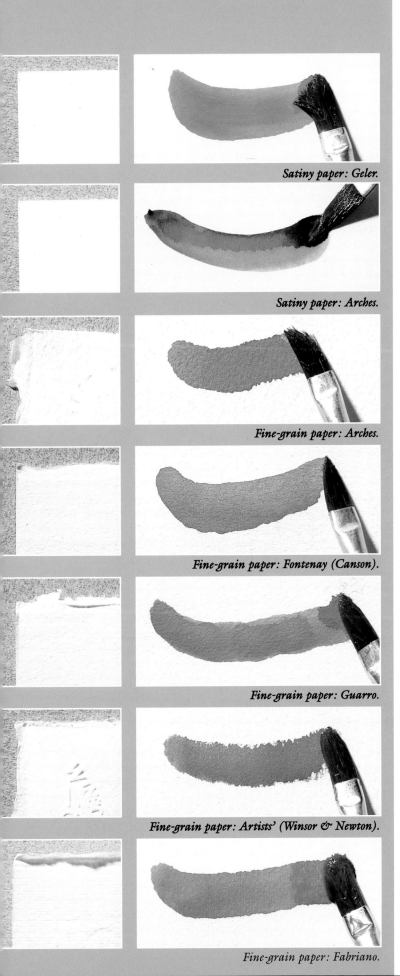

Satiny paper: Geler.

Satiny paper: Arches.

Fine-grain paper: Arches.

Fine-grain paper: Fontenay (Canson).

Fine-grain paper: Guarro.

Fine-grain paper: Artists' (Winsor & Newton).

Fine-grain paper: Fabriano.

SIZE

After pressing, paper is given a coating of glue, or size, so that its surface will retain moisture and keep the color from penetrating deep into the paper. In this way all the intensity of the color is preserved.

Certain quality papers have a thick layer of size on the surface that may interfere a little when painting. This problem can be avoided by wetting the paper first, or by wiping the paper with a damp sponge to partially remove the size before beginning to paint.

it forms puddles and causes the contours to run. If only a little water is used, the paint dries quickly and cracks.

ARCHES (3)

Arches fine-grain paper is produced with 100 percent cotton and gelatin size. It is air dried. This paper does not yellow and is ideal for mixing colors. The paint flows and blends well on its surface. The consistency of the paper preserves the intensity of the color. Because it has a lot of size on the surface, it requires wetting before painting on it.

FONTENAY (CANSON) (4)

Fontenay is made with 50 percent cotton and is sized before and after pressing. It has a medium absorption rate that is very suitable. It allows pigments to be blended, and resists repeated brushstrokes and retouches.

All the samples that appear on these pages dealing with different types of paper have been reproduced in actual size to best show the grain and the resulting watercolor brushstroke.

This fine-grain paper is the best in its category.

GUARRO (5)

Guarro fine-grain paper contains 60 percent cotton and gelatin inside and out. No acids are used. It is similar to satiny paper in that it causes the paint to separate a little and makes gradations difficult to achieve. Guarro is regarded as a good paper within its category.

ARTISTS' (WINSOR & NEWTON) (6)

Produced with 100 percent cotton and with gelatin size added before and after pressing, Artists' is a flexible fine-grain paper that blends color well and produces clean lines. It is extraordinarily resistant to retouching and maintains the intensity of the color used. This paper has a heavily sized surface.

FABRIANO (7)

Fabriano is 50 percent cotton. Lacking sufficient flexibility, this paper tends to disintegrate if overworked. Nevertheless, it is a good paper within its category.

TYPES OF TEXTURE

Watercolor paper can be satiny—that is without grain—or have fine, medium, or coarse grain. The type of paper artists choose will depend on their individual preference, working style, chosen format, watercolor painting experience, and even their choice of subject.

Almost all manufacturers sell all three types of texture. However, different brands of paper have different surface characteristics. You, therefore, need to familiarize yourself with the various types of paper and decide for yourself.

SUGGESTIONS

Keep in mind that to make the fullest use of watercolor paper, you must take into account your format and the paper's grain, weight, and composition.

For this reason it is advisable to stretch papers weighing less than 140 pounds (300 g) that otherwise would warp with the moisture. Paper for large formats, irrespective of weight, should also be stretched. As regards the texture, it is best to start painting with cold-pressed paper until you master this technique.

WHATMAN FINE-GRAIN (8)

Whatman fine-grain paper is made with 100 percent cotton. It is highly absorbent and allows the paint to spread well, making gradations easy to obtain. It yields vivid colors because the pigment remains on the surface. This paper has excessive size on the surface and must be wet before painting.

MEDIUM-GRAIN PAPER

Medium-grain paper is cold pressed and has an intermediate roughness. Its soft grain allows the artist to work more slowly because the paper holds sufficient moisture without causing pigment separation.

Texture of medium-grain paper, actual size.

Advantages: Medium-grain paper can be used for any format. The artist does not need to work quickly.

Disadvantages: Paper of medium grain does not retain as much water as coarse-grain paper; nor does it allow the detailed work possible with the fine-grain paper.

MONTVAL (CANSON) (9)

Montval medium-grain paper is made from cellulose pulp. It has low acidity and receives antifungal treatment. This paper is probably the best in its category. It can be used for large formats as long brushstrokes will not produce color breaks. Pigment expands well on the paper surface with a sharp line and vivid color.

GUARRO (10)

Guarro medium-grain paper is produced using 69 percent cotton, is sized with gelatin inside and out, and contains no acid. This is a good paper in its category. Although not highly resistant, its pigment diffusion and line sharpness are satisfactory.

SCHOELLER (11)

Schoeller medium-grain paper is made with 100 percent cotton. This is a flexible paper that allows good color diffusion and yields sharp lines, but is not suited to retouching and corrections.

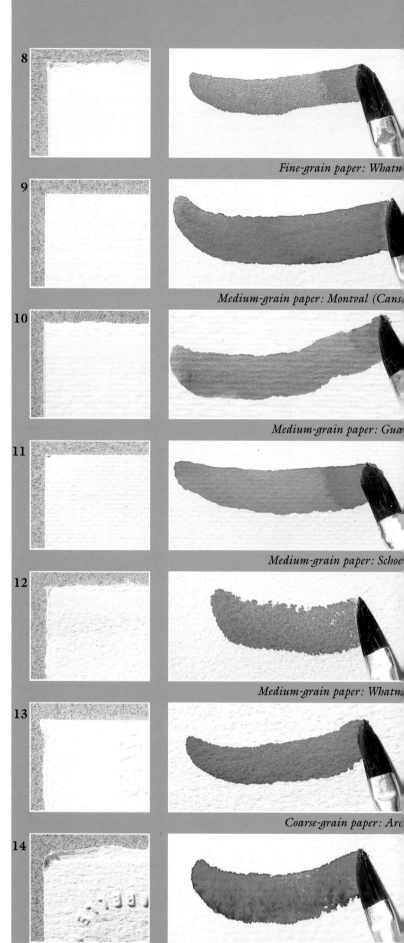

Fine-grain paper: Whatm...

Medium-grain paper: Montval (Cans...

Medium-grain paper: Gua...

Medium-grain paper: Schoe...

Medium-grain paper: Whatm...

Coarse-grain paper: Ar...

Coarse-grain paper: Fontenay (Cans...

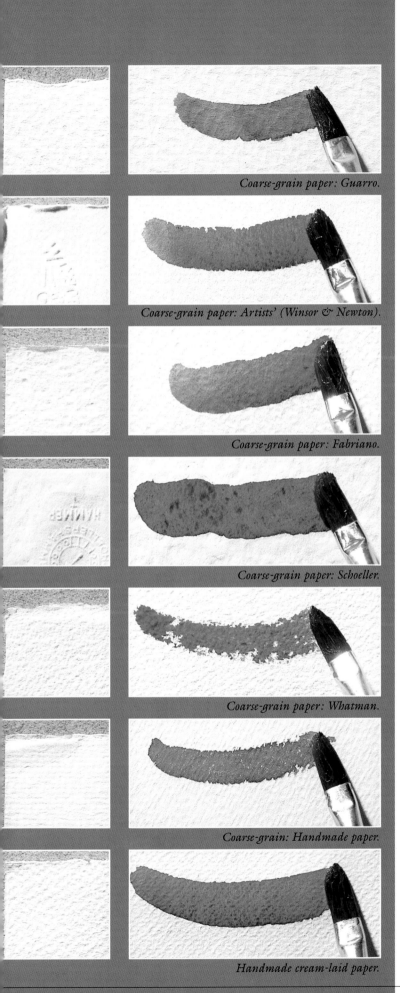

Coarse-grain paper: Guarro.

Coarse-grain paper: Artists' (Winsor & Newton).

Coarse-grain paper: Fabriano.

Coarse-grain paper: Schoeller.

Coarse-grain paper: Whatman.

Coarse-grain: Handmade paper.

Handmade cream-laid paper.

WHATMAN (12)

Whatman medium-grain paper is produced with 100 percent cotton. It has a thick coating of size on its surface; therefore, it needs to be wet before use. Pigments do not penetrate, so lines and colors are distinct and vivid. This paper makes gradations possible and allows easy diffusion of the paint. It has good absorbency.

COARSE-GRAIN PAPER

Coarse-grain paper is characterized by a notable roughness that forms small troughs in which the paint can accumulate. This feature makes it ideal for working with a lot of water.

Advantages: The texture of coarse-grain paper lets the background show through and slows down the paint drying time, thus allowing corrections.

Disadvantages: Results are unpredictable with coarse-grain paper. A beginner will find the rough surface makes contour work more difficult. This paper detracts from the brilliance of the colors because too much paint collects in the deep hollows.

ARCHES (13)

Arches coarse-grain paper is produced with 100 percent cotton, sized with gelatin, air-dried, and contains no acid. It does not yellow over time. This paper is ideal for mixing colors on its surface because the paint spreads and blends well. It is a firm support that retains color intensity and outline sharpness well. A heavy coat of size covers its surface, so the paper must be dampened before use.

FONTENAY (CANSON) (14)

Fontenay coarse-grain paper has 50 percent cotton and is sized with glue before and after pressing. It has a good rate of absorption, allows for satisfactory blending of pigments, and withstands retouching.

GUARRO (15)

Guarro coarse-grain paper contains 60 percent cotton and is sized with gelatin before and after pressing. It contains no acids. Although much retouching is not possible, the pigment spreads well and lines remain distinct.

ARTISTS' (WINSOR & NEWTON) (16)

Artists' coarse-grain paper is made with 100 percent cotton. Gelatin size is added before and after pressing. It is a pliable paper. Its surface allows color blending well and yields impeccable lines. This paper offers good resistance to repetitive work and retouching, and it preserves color.

FABRIANO (17)

Fabriano coarse-grain paper contains 50 percent cotton. Its surface diffuses color well, maintains sharp lines, and is good for creating gradations. This paper is highly resistant to retouching.

Texture of coarse-grain paper, shown in actual size.

SCHOELLER (18)

Schoeller coarse-grain paper is produced from 100 percent cotton and is sized before and after pressing.

The reverse side of this paper is not treated and is not suitable for painting. Colors gradate well and remain vivid, and lines stay sharp. Not suited to repeated brushwork.

WHATMAN (19)

Whatman coarse-grain paper contains 100 percent cotton. Size of good quality is added before and after pressing. With a heavy coat of size on its surface, Whatman paper repels paint, so it is essential to wet it before working. This paper has a good rate of absorption and is good for gradations as the paint spreads easily. Lines remain distinct and intense.

HANDMADE PAPER

Handmade paper owes its appeal to the number of different textures, formats, weights, and colors it offers.

Some really beautiful handmade papers can be found; nevertheless, it is important to note that, in general, the craftsperson or small manufacturer who produces such paper does not have the adequate means for total quality control. By comparison,

OTHER PAPERS

On this page we deal with certain types of special paper that are not exclusively used for watercolor. Some are more suitable for Japanese techniques or wash-painting. Others have a surface that is totally different from what you would expect of watercolor paper.

industrial manufacturers monitor the entire production process closely. Lacking such quality control procedures, handmade papers in the long run deteriorate more readily. In other words, they are unlikely to last more than one hundred years.

(20) Coarse-grain handmade paper allows colors to blend well and without separation streaks. It admits corrections, but lines thicken a little. (See illustration on page 15.)

(21) With handmade cream-laid paper (illustrated on page 15), colors remain vivid and lines are distinct.

(22) The handmade paper shown in the illustration at the top right of this page has a heavy coat of size on its surface, but the colors can be gradated easily. This is a rough paper that deteriorates with repeated brushwork; nevertheless, the lines remain clean.

(23, 24, 25, 26) Handmade papers include a wide range of colors and values, of which the four illustrations on this page (at right) are only a small sampling. Paint adheres well to the surface and does not run; tones and gradations can be modified. However, this paper is not suitable for opening up whites.

(27) It is apparent from the illustration to the right of this page that this handmade paper is extremely rough; it is also absorbent and resists repeated brushwork well. This is a good paper for creating effects.

(28) As the illustration at right shows, the rugged and deeply textured surface of this handmade paper makes continuous lines impossible to paint. Suitable for abstract painting or working with patches of color.

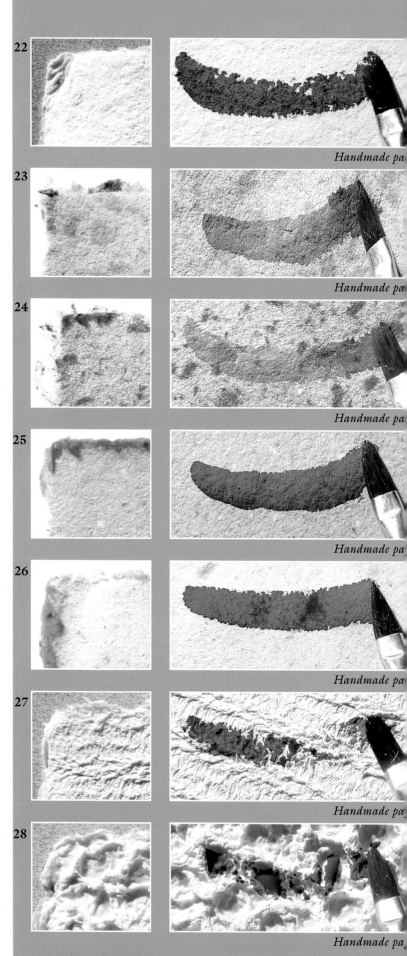

Handmade pa

Handmade pa

Handmade pa

Handmade pa

Handmade pa

Handmade pa

Handmade pa

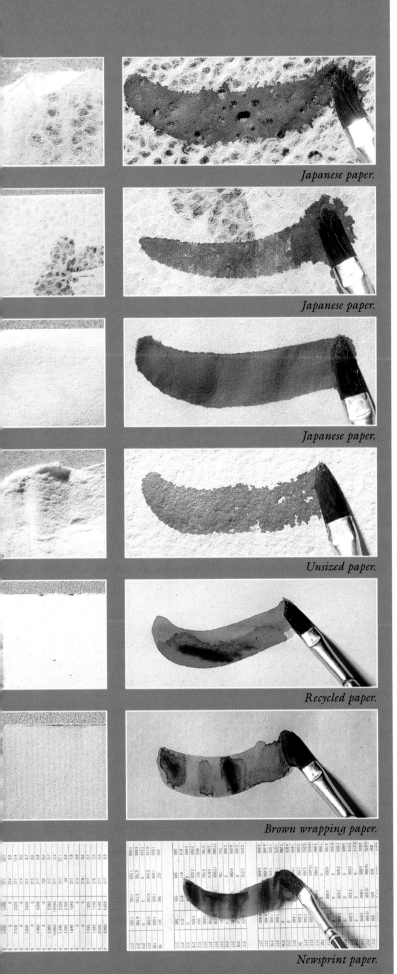

Japanese paper.

Japanese paper.

Japanese paper.

Unsized paper.

Recycled paper.

Brown wrapping paper.

Newsprint paper.

JAPANESE PAPER

Japanese paper is a beautifully handcrafted paper that is made with vegetable fibers, which are visible when the paper is held against the light. Some Japanese papers even contain small butterflies and flowers pressed within their fibers. This paper reacts differently to watercolor paint because it is a rice paper with a spongy texture. Among the best-known brands of Japanese paper are Kozo, Mutsumata, and Gambi. Many of these papers are extremely absorbent, a feature that makes manipulation of the paint impossible. For this reason, brushstrokes need to be precise. Japanese paper is intended for wash painting and is ideal for Japanese brush-painting techniques, such as Sumi-e. This is a light paper with a weight of 55 pounds (120 g).

(29) The unique Japanese paper illustrated here (top, left) takes water well. It does not allow corrections, however. The paint spreads only slightly on the surface and looks flat.

(30) The Japanese paper shown in this illustration (at left) is suitable for gradations and blending lines.

(31) A highly absorbent Japanese paper is illustrated here (also at left), but it is not for painting with large amounts of water. The paint dyes the paper and colors cannot be removed. This paper stops the pigment from spreading.

UNSIZED PAPER

(32) As the illustration of unsized paper (at left) shows, it produces flat watercolors because the absence of gelatin or other types of glue leave the surface unprotected from the penetration of color. Repeated brushwork is not possible. Because moisture penetrates to the core of the paper, it takes longer to dry than sized paper.

RECYCLED PAPER (33)

The recycled paper referred to here is of the type used in offices for taking notes or for envelopes. As it is not sized, it absorbs moisture quickly and breaks up easily.

WRAPPING PAPER (34)

Brown wrapping paper is not absorbent. Consequently, the paint remains on the surface forming tiny puddles. Despite its tendency to warp readily when dampened, many artists have experimented with it.

NEWSPRINT PAPER (35)

Newsprint paper is completely absorbent and disintegrates easily. This paper can be used only for preliminary sketches, without repeated brushstrokes.

BOARD

Lightweight board for watercolors has a cellulose core to which watercolor paper has been glued. This makes it unnecessary to mount the paper on a frame.

COLORED PAPER

Watercolor paper is generally white because this is a transparent medium whose colors depend on the background for their luminosity; additionally, the white color is provided by the paper itself. Nevertheless, some dyed handmade papers can be found. An artist who wishes to work on a colored background will usually apply washes or use other papers designed for similar techniques, such as pastel.

Brushes

handle

ferrule

hairs

The brush is the tool used for spreading the paint on the paper. It is undoubtedly the key instrument in painting and without it the history of art would have been quite different. Despite the progress made in techniques and style, the brush still plays a relevant part in artistic creation. Brushes are still hand-made in large part: the bundle of hair that fits perfectly into the ferrule has been selected and inserted by an expert hand.

A good brush must show versatility, capacity for loading and laying down paint, elasticity in its hairs, resilience for recovering its original shape, durability, and precision.

Quality in a brush is directly related to the quality of materials used in its manufacture. A good brush, if treated properly, will last for many years and will make the artist's task considerably easier. An inferior brush may make certain types of work virtually impossible.

Brushes leave the factory with a coating of gum arabic to protect the shape of the hair bundle, a practice that sometimes makes the job of assessing them difficult. To test a brush for quality, soak it in water and with one snap of your wrist shake out the water to see if the brush forms a good point; then soak it again and squeeze the water out to see what its capacity is. The springiness and flexibility of the hairs can be evaluated when dry.

Other things require consideration: Success in painting, and above all in watercolor, also depends on using the right type of brush. Brushes come in many sizes and shapes and with various types of hairs, each intended for a specific function. The size of a brush is indicated by a number imprinted on the handle.

With all these variables, the only way to determine whether a certain brush is suited to the type of painting you want to do is to know it well. This degree of familiarity can only be achieved through use, so you must try different types of brushes until you find the one you need.

PARTS OF A BRUSH

All watercolor brushes are comprised of three parts: handle, ferrule, and hair or bristles. All are important if we wish to obtain good results. The part that most determines the quality of a brush is the hairs, specifically, their shape and origin.

THE HANDLE

A brush must have a handle so an artist can hold and manipulate it. Quality handles are made of light wood that resists warping or losing its shape and that is soft enough to permit engraving of the brand name, number, and even the place of origin. Handles are generally painted with several layers of enamel and a final layer of varnish to protect them from humidity. There are also handles made from other materials, such as plastic and bamboo, as well as from swan feathers quills, which were commonly used in the past for this purpose. Even brushes with ergonomically designed handles can be found.

Handles are made long or short; brushes with the former are used for cases in which an artist needs to keep a certain distance from the work. Short-

WHAT IS A BRUSH?

A brush is an instrument for applying the paint on the paper; it has three distinct parts: the bundle of hairs, the handle, and the ferrule, which attaches the hairs to the handle.

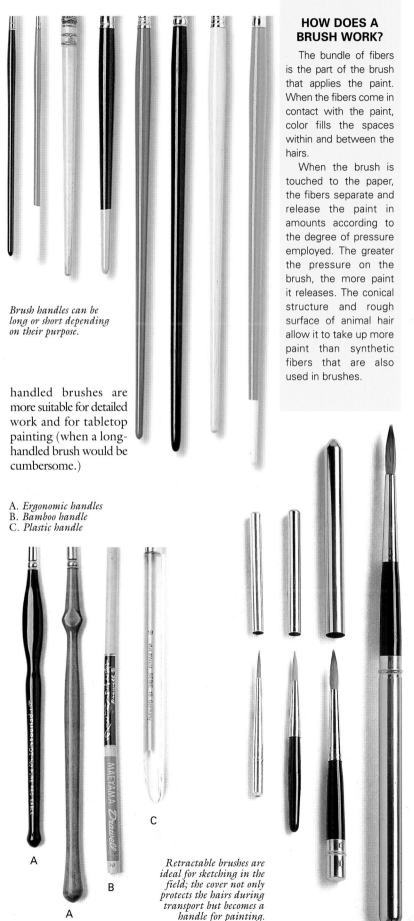

Brush handles can be long or short depending on their purpose.

handled brushes are more suitable for detailed work and for tabletop painting (when a long-handled brush would be cumbersome.)

A. *Ergonomic handles*
B. *Bamboo handle*
C. *Plastic handle*

Retractable brushes are ideal for sketching in the field; the cover not only protects the hairs during transport but becomes a handle for painting.

HOW DOES A BRUSH WORK?

The bundle of fibers is the part of the brush that applies the paint. When the fibers come in contact with the paint, color fills the spaces within and between the hairs.

When the brush is touched to the paper, the fibers separate and release the paint in amounts according to the degree of pressure employed. The greater the pressure on the brush, the more paint it releases. The conical structure and rough surface of animal hair allow it to take up more paint than synthetic fibers that are also used in brushes.

THE FERRULE

A ferrule is the metal sheath that gathers and grips the bristles and also secures them to the handle. Ferrules can be made of different materials, but the best are made with nickel-plated brass in a single seamless piece that needs no soldering. Quality ferrules have a more precise fit than others; they do not rust and, because they have no soldered seams, cannot break open. Inexpensive brushes have ferrules made of nonrusting aluminum, also without seams. The design of seamless ferrules requires meticulous measuring so that all parts of a brush can fit together perfectly.

A LITTLE HISTORY

The first brush is thought to have existed some 25,000 years ago; it was little more than a twig with one end broken up into fibers. Later, brushes with vegetable fibers made their appearance before animal hair, finally, came into use.

During a large part of the last thousand years, artists made their own brushes. They used different types of hair that they fitted into quills. The first crafted artists' brushes did not appear until the eighteenth century, in Europe.

Today, it would be difficult to find artists who make their own brushes because manufacturers offer products to suit practically every taste.

A. *Ferrule with flat and rounded tip to give the hair a stiff, fanned shape.*
B. *Flat ferrule.*
C. *Flat, extended ferrule for wide, flat brushes.*
D. *Round ferrule.*
E. *Flat ferrule.*
F. *Plastic ferrule, held by wire in imitation of the old way of attaching the hairs to the handle.*

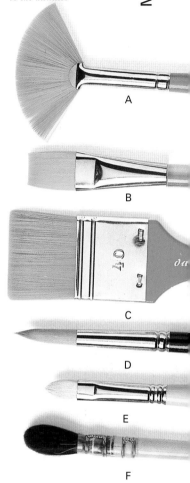

THE HAIRS

Undoubtedly, the fibers are the most important part of a brush and determine its quality. Brushes are generally made with animal hair, which is conical with small cavities where the paint can collect. The hairs pick up the paint and retain it. This characteristic is what turns a brush into an instrument that dispenses paint in accordance with the amount of pressure it receives from the hand of the artist.

TYPES OF FIBERS

Brushes can be made of natural hair, bristle, or synthetic hair. The difference in these materials lies in their respective absorbency, hardness, flexibility, and structural features. Although bristles and natural hair are similar, their structure differs at the tip: Natural hair ends in a single point, whereas bristle has several points at its tip; moreover, the latter is harder and more resistant. The choice between one type of hair and another is dictated by the style of painting and preference of each artist.

SABLE

Sable hair is the most highly prized in watercolor painting as it is the best in terms of quality. It is different from others because of its tip. This kind of hair always returns to its original shape and the tip is so fine that it can

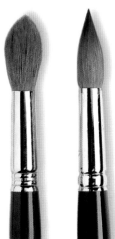

Two sable-hair brushes. One (on the right) has a coating of gum arabic to keep the hairs tidy and prevent them from losing their shape before using the brush for the first time.

hardly be seen. This feature makes sable brushes versatile because they make a fine line as well as a thick one easy to draw by simply varying the pressure on the brush. Be careful, though, as not all sable brushes are the same. The quality of the hair depends on the origin of the animal and whether it has been raised in captivity or in the wild. Low temperatures and harsh conditions imposed by a life in the wild, make these animals grow longer and stronger hair than their captive counterparts. Brushes made from the long hair of these wild animals are preferred by discerning professionals. The favored hair is that obtained from the kolinsky, an animal named after the place in Siberia where it is found. This little animal does not reproduce in captivity, thus, its hair comes at a high price. There are also other

WHICH TYPE OF HAIR?

For watercolor brushes, there is no doubt that the most suitable type of hair is that of the highest quality, namely, sable.

Sable hair, however, is extremely expensive and most painters resort to other types when buying large brushes.

Two popular alternatives to sable hair in brushes are ox hair and synthetic hair. Another useful substitute that has strength and a good point is mongoose hair, although, in actuality, it is difficult to obtain because the mongoose is a protected species.

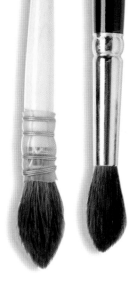

Squirrel-hair brushes.

qualities of sable hair, such as the hair obtained from the Harbin-kolinsky marten and the red marten.

SQUIRREL

Hair taken from the tail of the Canadian or Russian squirrel, sometimes called camel hair, is a good substitute for sable. Squirrel hair is more economical and has a great capacity for absorption.

The absorbency of squirrel hair makes it suitable for corrections but it can make painting difficult because it is too soft and lacks strength.

MONGOOSE

Because the mongoose is a protected species, brushes made with hair from this animal are hard to find. Due to the scarcity of mongoose hair, an artificial fiber called Teijin has been developed to replace it.

Mongoose hair is stiff but fine and has a good capacity for absorption: it also forms a good tip for painting.

GOAT

Goat's hair is similar to squirrel's hair but is lower in quality. It is used for imitations of squirrel hair brushes.

This is the hair used for the traditional flat brush of the Far East, the hake brush. Goat hair brushes are rare and cannot be usually found in art supply stores.

OX HAIR

Ox hair is light brown and is taken from the inside of ox ears.

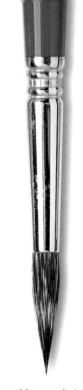

Mongoose-hair brush

Compared with sable hair, it has less spring. Nevertheless, it makes a resistant brush for continuous use and is a good alternative to more expensive hairs, especially for brushes with high numbers—or thick brushes.

Some painters actually prefer an ox-hair brush to a sable-hair one, because ox hair is a little stiffer.

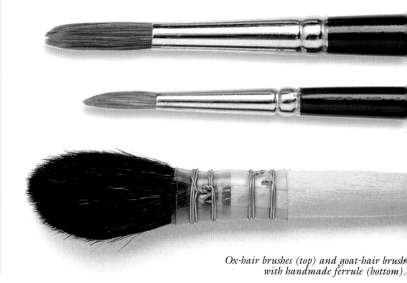

Ox-hair brushes (top) and goat-hair brush with handmade ferrule (bottom).

IMITATION SABLE HAIR

Brushes made to simulate sable hair are usually made from ox hair that has been chemically treated to resemble the color of sable hair.

Reputable manufacturers usually indicate on the brush itself that it is an imitation, although others sell it without making this important distinction.

Fan brush of imitation sable hair.

HAIR BLEND

To reduce the cost of the product and take advantage of different types of hair, brushes have been developed that combine several kinds of natural and synthetic hairs. One brush blends top-quality synthetic fibers with either sable or squirrel hair, which make up for the lack of absorption capability in the synthetic material. This produces a good intermediate product.

Brushes with a combination of natural and synthetic hair.

SYNTHETIC HAIR

It is now possible to produce fine synthetic filaments that possess the strength found in sable hair, and they are treated to give them the necessary spring for returning to their original shape.

Unfortunately, to date, science has been unable to completely replicate the structural features of natural hair. Because synthetic hair has a smooth surface, it cannot take up as much paint as natural hair.

Synthetic-hair brushes.

NATURAL HAIR AND SYNTHETIC HAIR

Leaving sable brushes aside, when choosing an alternative you must decide between natural hair and synthetic hair.

Ox hair can take up a considerable amount of paint and is soft. An ox-hair brush adapts to each artist's style of brushwork and is easily handled. On the other hand, although synthetic hair has less absorbency than natural hair, it holds a better point than ox hair, is strong, and does not distort.

Both types of hair are highly suitable and the watercolorist usually has a brush of each kind.

Top-of-the-line brushes made with a combination of synthetic and natural hair perform well because they are flexible and do not lose their tip. They give good value for the money and are available in many shapes, thus they have gained wide acceptance from artists.

PONY HAIR

Pony hair used in brushes is taken from the belly of the animal, or its legs. European ponies yield the best hair for this purpose.

The hair of this animal is soft but loses its shape easily. It is more commonly used in cosmetic brushes but is also adequate for those used in school work.

Brushes of this type are not for the professional as it is almost impossible to work with them. However economical they may be, they are unsuitable for watercolor painting.

Pony-hair brushes. You can readily see that they will not come to a good point and may be cumbersome when painting.

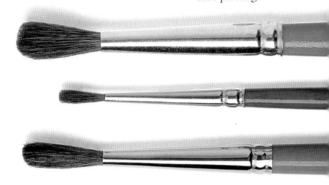

BRISTLE

Hog's hair, or bristle, is the most economical natural hair available. It is taken from the loins and back area of the animal.

China is the world's largest producer of this type of hair and classifies the different varieties by their place of origin. The best comes from Chungking.

A bleached bristle of low quality is also produced.

In principle, hog's hair is not suitable for watercolor painting, unless it is used for removing color or to obtain a special effect.

The animal's breed, its fodder, and the country's climate give Chinese bristle its special quality. Strong and thick, the hair has a special softness, and its tip splits into two or three points, or flags, a characteristic that differentiates it from the hair of any other animal. Flat, wide hog's hair brushes have been specially treated to make them appropriate for washes and covering large areas. They are extremely soft and can absorb a lot of paint.

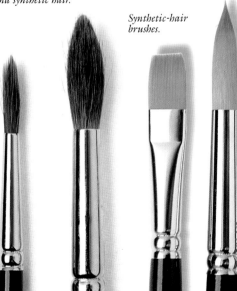

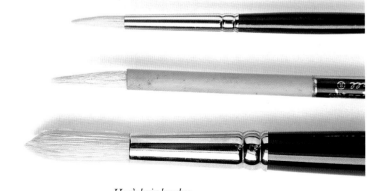

Hog's hair brushes.

TYPES OF BRUSHES

Brushes are classified by the type of ferrule they carry and by the shape of their bristles or hair.

Ferrules can be flat or round, and the hairs or bristles can be arranged into shapes that have pointed or flat tips.

Certain kinds of brushes, such as round ones, have many uses. Others, like fan-shaped brushes, have been developed for a specific purpose. Generally, however, the principal feature of a brush is versatility; its bristles should facilitate many different types of brushstrokes.

ROUND BRUSHES

Round brushes have a conical ferrule and a pointed tip. This is a classic design that lets an artist paint in any direction and draw fine or thick strokes.

The versatility of round brushes makes them particularly appropriate for watercolor painting (see page 41).

FLAT BRUSHES

Flat brushes take up less paint than round ones but are more accurate when it comes to drawing contours. These brushes come in many different types. The difference among them is

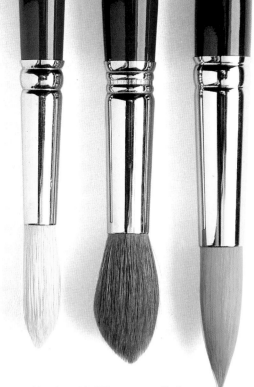

Round brushes with different types of hair.

the shape in which the hairs are arranged. They can be flat-tipped, filbert, or bell-shaped.

FLAT-TIPPED BRUSHES

A flat-tipped brush has a flat ferrule; its hairs are all the same length and perfectly ordered.

This arrangement of the hairs makes flat-tipped brushes easy to control. Because they yield predictable results, they are ideal for straight lines and outlining.

Fine lines and points are easily achieved with this brush by touching the paper with the right-angle corner of its tip. It is also ideal for quickly covering certain areas of the paper with color.

Most watercolor professionals have at least one flat-tipped brush, usually the type made with synthetic hair. Some painters even habitually work with this kind of brush.

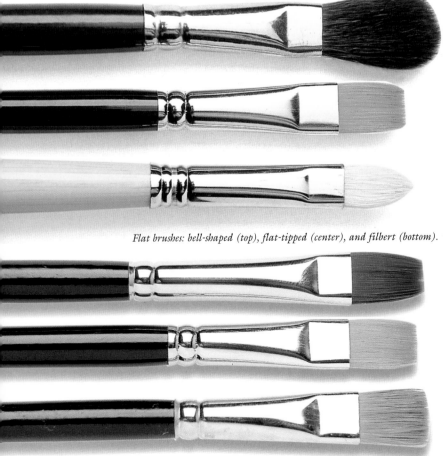

Flat brushes: bell-shaped (top), flat-tipped (center), and filbert (bottom).

Flat-tipped brushes with different types of hair.

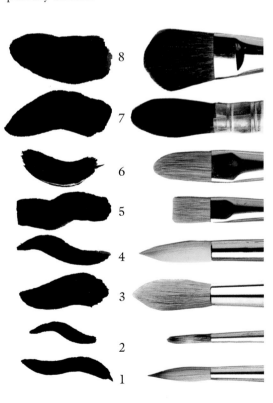

Different brushes for watercolor painting: (1) sable-hair brush; (2) mongoose-hair brush; (3) ox-hair brush; (4) synthetic-hair brush; (5, 6) ox-hair brushes, flat-tipped and filbert; and (7, 8) fitch brushes. Next to each brush is the kind of stroke it makes.

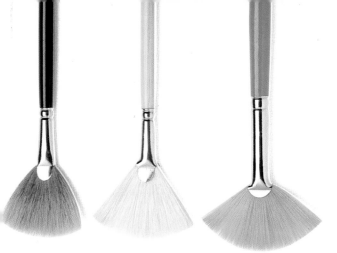

Fan brushes.

FAN BRUSHES

A flat ferrule gives the hairs of a fan brush the shape for which it is named.

Fan brushes are used for blending to obtain an even transition between colors on an already painted surface. When such a brush is dipped in watercolor paint, it creates an effect similar to that of a dry brush.

FLAT WASH BRUSHES

Flat wash brushes are used for covering large areas, such as a background, or for painting washes—for example, to suggest the sky.

These brushes have another function: after the work is finished, you can use one to apply a coat of varnish to fix the colors in the painting.

FILBERT BRUSHES

In filbert brushes, which are flat, the hairs are arranged in an arching shape. This form earned them the other name by which they are known—that is, *cat's tongue.*

A filbert combines the usefulness of both the flat and round brushes because its tip can paint like a round brush, and if the brush is held almost parallel to the paper, it acts like a flat brush. In other words, it can be used for detailed work and for covering large areas.

JAPANESE BRUSHES

Japanese brushes use soft bristle from hogs, deer, or oxen, and the bundle of hairs is attached to a bamboo handle. They are most suitable for gouache and for Japanese style painting. They are very soft.

Japanese brushes with different types of hair.

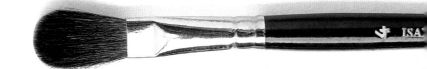

Filbert brush.

Bell-shaped brush.

Absorbent brush.

BELL-SHAPED BRUSHES

A bell-shaped brush is flat and has hairs that have been cut so that the ends do not come to a point.

These brushes are usually made with synthetic hairs of good quality.

In watercolor painting bell-shaped brushes are employed for applying broad brushstrokes and covering large areas. Additionally, they can be used for washes and, because they can take up quite a lot of water, also for absorbing moisture.

ABSORBENT BRUSHES

Some bell-shaped brushes are especially absorbent. They are generally made from squirrel or goat's hair and are used for lifting out color or for techniques requiring that the brush absorb large quantities of water.

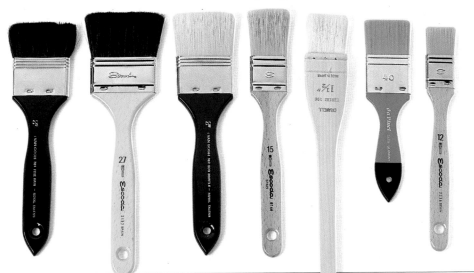

Flat wash brushes with different kinds of hair for large washes.

BRUSH NUMBERING SYSTEM

All brushes have a number stamped on the handle that indicates the diameter of the ferrule and, therefore, the thickness of the bundle of hairs. This numbering system is used internationally and is common to all brands. Nevertheless, no standard exists for sizing brushes, so you may find that a 10 brush from one manufacturer may be slightly different in size from that of another.

The numbering system is, therefore, an attempt to standardize the measurements and to provide a reference that will make the artist's work easier.

For sable brushes, the numbers range from 000 for the thinnest up to 16 or 18 for the thickest brushes. The da Vinci brand, however, has a much wider range that runs from 10/0 up to 36. Large sable brushes are not easy to find because they are particularly expensive; therefore, a number 36 sable brush would probably have to be or-

dered in advance. This is why most artist use thick brushes made with ox hair or synthetic hair.

There are no low numbers for flat brushes as this obviously would make no sense. Numbers 18 and 22 are not manufactured.

Wide brushes are sized in inches that indicate the width of the ferrule. These range from 1 inch (30 mm) to 3 inches (80 mm). Some flat brushes are sized by a different number, but this system is not followed by all manufacturers.

THIN VS. THICK

Preference for a certain kind of brush depends exclusively on individual style or the format the artist usually chooses. Artists who paint large watercolors without concentrating too much on detail will obviously prefer a thick brush that takes up a lot of paint and allows them to cover large areas with a couple of brushstrokes. Even in this case, there are always certain small areas or details to be added that would require the use of a thin brush.

2 4 6

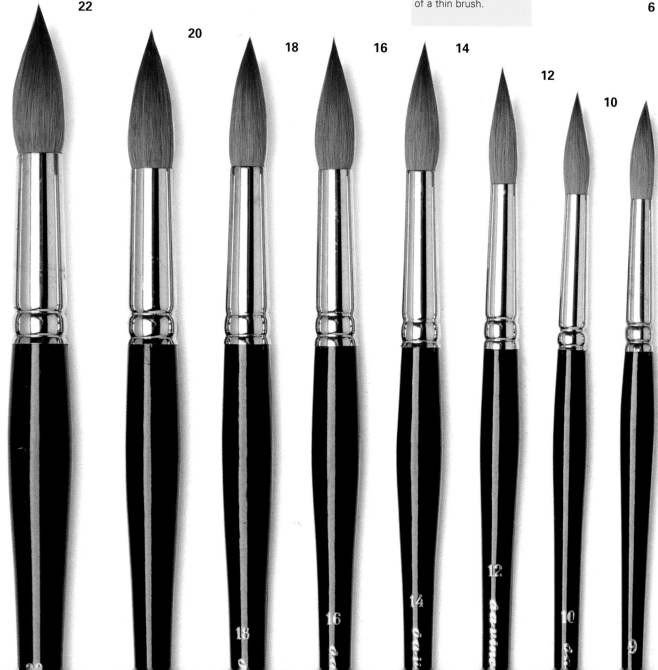

22 20 18 16 14 12 10

10

12

14

16

20

24

Complete range of flatl-tipped brushes.

7

6

5

4

3

2

1

0

0
0

0
0
0

0
0
0

0
0
0
0
0

10/0

Complete range of round sable brushes, shown in actual size.

WHY SO MANY THICKNESSES?

Manufacturers offer such a wide selection of brushes in an attempt to accommodate every artist's preference.

In practice, there is no noticeable difference between a number 8 and a 9 brush. It is also true, however, that a painter who has both sizes will tend to use one exclusively—say, the 8. So there is no sense in the artist's having a number 9. On the other hand, another artist will always opt for the 9 brush if given the same choice. This is why manufacturers produce a vast array of thicknesses.

Boards, Easels, and Cases

For watercolor painting all you need is paper, paints, a brush and a little water. There are, however, a number of additional items that simplify the artist's work. Some of these have become virtually indispensible.

BOARDS

A board is useful for supporting and securing the paper. It is best to have several boards as you will probably be working on more than one painting at the same time. If, in addition, you intend to use dampened paper, you will need more than one board because wet paper takes hours to dry; this way you can prepare several pieces of paper for painting the next day.

Use boards made of wood that will not warp or give way to the tautness of the stretched paper as it dries.

Fiberboard is light and resistant and can be used for supporting small formats. Because it is thin, fiberboard is easy to carry. However, it is not suitable for working on wet paper because its surface is not porous and it traps the moisture. Consequently, the paper takes longer to dry on this kind of surface.

The most suitable boards are made of plywood with a minimum thickness of ¼ inch (6 mm).

BOARDS AND EASELS

Boards and easels complement each other perfectly because if the board is the support for the paper, the easel is the support for the board.

Easels are essential when painting outdoors. In a studio the artist can rest the board on a table for painting with the paper in a horizontal position or place an object underneath the board to give it the right inclination. If the artist usually paints with the board almost vertical, the board can be set against the wall. An easel is, therefore, not necessary if you will not be painting outdoors.

The size of the board will depend on the format you wish to work in. It should always be about 2 inches (5 cm) larger than the paper itself. It is preferable to have several boards of different sizes: 26 by 34 inches (65 × 85 cm) and 43 by 31 inches (110 × 80 cm) for large formats; 10 by 12 inches (25 × 30 cm) for the smallest, which are the standard sizes. The board should be sturdy, but remember that if you intend to work outdoors, it should also be as light as possible.

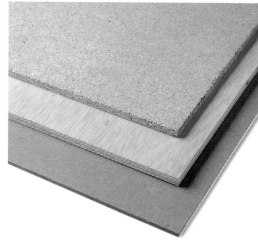

EASELS

An easel is a structure on which the board or stretcher rests. Almost all easels for oil painting are perfectly suitable for working with watercolors, especially the kind used in a studio, because their height and inclination can be adjusted to fit your needs by means of wooden pegs. There are, however, easels specifically designed for watercolor painting; these can be adjusted so that the board lies completely flat or at any other angle of inclination. Moreover, they are usually lighter than the easels for oil and are portable.

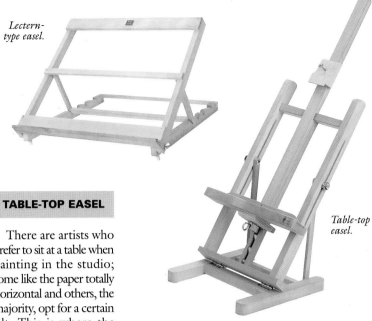

Lectern-type easel.

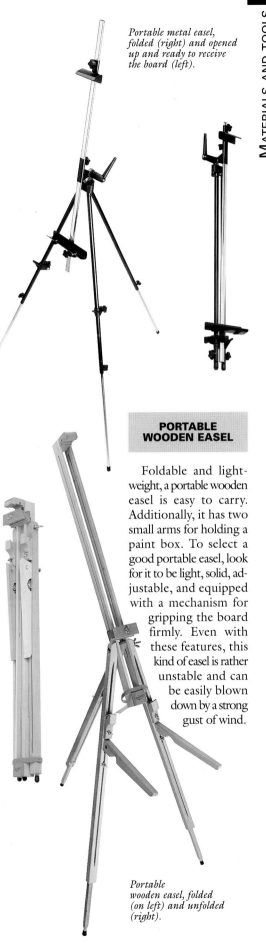

Portable metal easel, folded (right) and opened up and ready to receive the board (left).

TABLE-TOP EASEL

There are artists who prefer to sit at a table when painting in the studio; some like the paper totally horizontal and others, the majority, opt for a certain tilt. This is where the tabletop, or lectern-type easel comes into play.

The table does not require any special features, although it is always best for it to have drawers for storing paints, brushes, palettes, and so on.

Table-top easel.

With a wooden board and a couple of foldable easels, a good work table can be set up.

PORTABLE METAL EASEL

Portable metal easels are just as practical as the wooden version but less bulky. They have telescopic feet to accommodate any size board and are sturdy. This easel is made from light materials to make it easier to carry.

The easel's lightness can be a disadvantage if working on uneven terrain or if the wind is blowing hard because it is not stable. In this case, artists must use their imagination to find the solution.

PORTABLE WOODEN EASEL

Foldable and lightweight, a portable wooden easel is easy to carry. Additionally, it has two small arms for holding a paint box. To select a good portable easel, look for it to be light, solid, adjustable, and equipped with a mechanism for gripping the board firmly. Even with these features, this kind of easel is rather unstable and can be easily blown down by a strong gust of wind.

SKETCH BOX

As its name suggests, a sketch box easel has a paint box incorporated in its design. For painting outside the studio, this kind of box is very useful. It has a drawer for storing materials and a palette. Sketch boxes come in several sizes, the largest of which even includes a folding seat. This easel is carried like a suitcase.

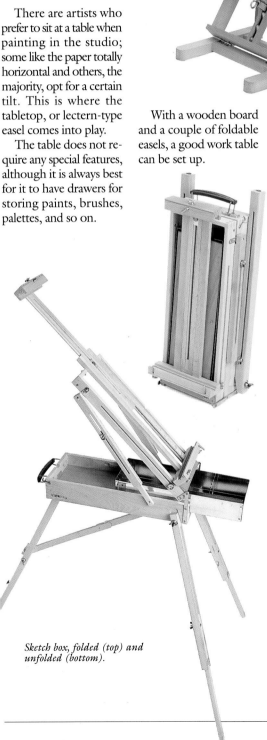

Sketch box, folded (top) and unfolded (bottom).

Portable wooden easel, folded (on left) and unfolded (right).

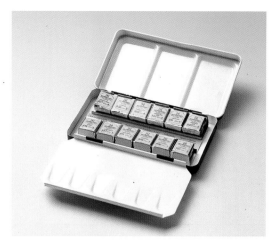

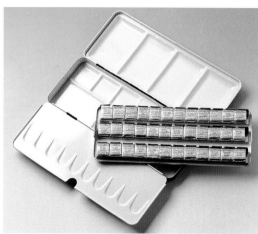

Medium-size box containing 12 pans. Has a lid with three wells for mixing colors and a foldable color palette.

Box with 36 pans, which can be removed. The entire box becomes a palette with many wells of varying capacity.

LARGE AND SMALL BOXES

As you can see from the materials illustrated in these pages, watercolor paint boxes of various sizes can be found. The large wooden boxes are more attractive but in practice can be somewhat awkward to use. To begin with, they are much more expensive than the simple metal or plastic boxes and, although they contain several accessories apart from the paints themselves, they are usually heavy and the artist needs to find a place to set them up.

Small, simple boxes, on the other hand, only have the paints and the space necessary for a couple of brushes, fit snugly into the artist's hand, and are easy to carry and use.

PAINT BOXES AND CASES

In art supply stores you can find elegant and beautiful wooden boxes for carrying and storing paints and brushes. When painting outdoors, however, they are not practical because they are not designed to hold water, rags, pencils, and so on. Several alternatives exist: a sketch box, or an oil box that can be adapted to your needs as a watercolorist. Undoubtedly, the best solution is to copy the professionals and order a custom-made box from a carpenter. This way you can decide the size and the number of compartments.

Metal boxes are similar to palette boxes but are adapted for carrying watercolor paints in tubes or pans. These are the most practical as you then have both colors and palette in one hand, an important convenience when painting standing up or in uncomfortable conditions. Together with the plastic versions, metal boxes are usually the least expensive and also the most useful because their lids can be used as a palette. They come in many sizes, with a capacity for holding from 6 to 36 colors.

Metal box with 12 tubes and a palette with wells for the paint (bottom lid) and another with larger wells for mixing (top lid).

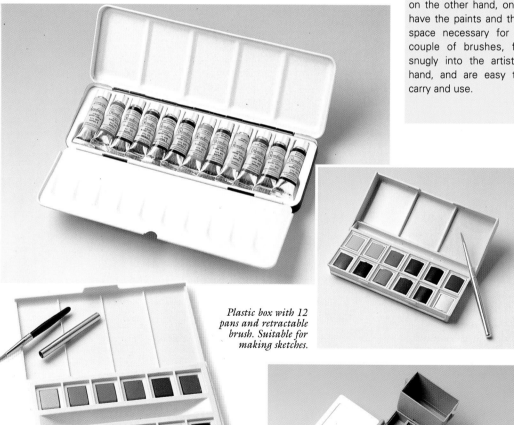

Plastic box with 12 pans and retractable brush. Suitable for making sketches.

Plastic box with 12 pans, including a retractable brush. Ideal for making sketches.

A compact and quite complete box with 12 colors for making sketches or working outdoors. It contains two foldable palettes, a brush, a small sponge, and a bottle and small cup for water.

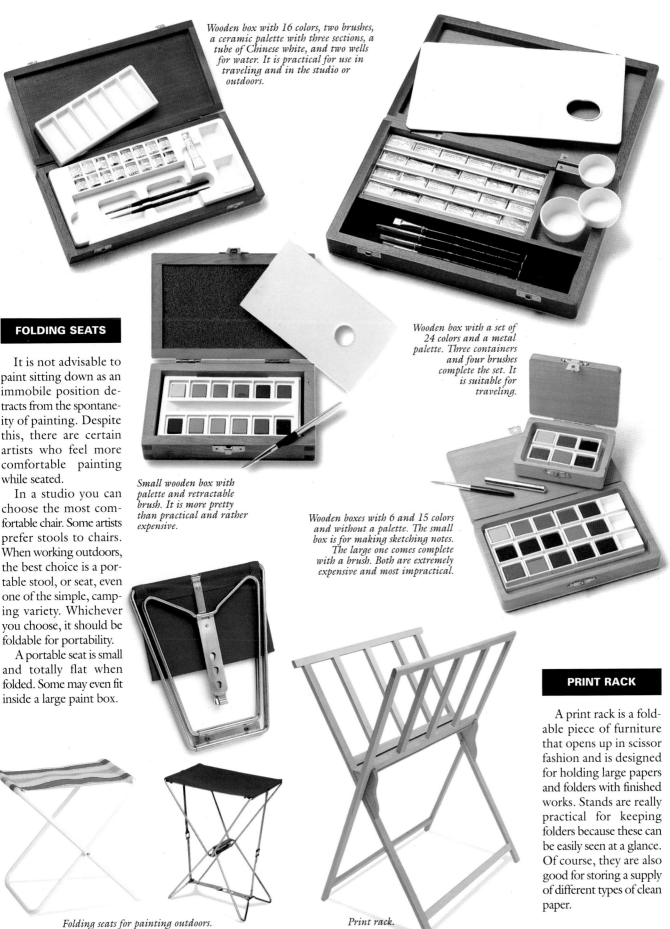

Wooden box with 16 colors, two brushes, a ceramic palette with three sections, a tube of Chinese white, and two wells for water. It is practical for use in traveling and in the studio or outdoors.

Wooden box with a set of 24 colors and a metal palette. Three containers and four brushes complete the set. It is suitable for traveling.

FOLDING SEATS

It is not advisable to paint sitting down as an immobile position detracts from the spontaneity of painting. Despite this, there are certain artists who feel more comfortable painting while seated.

In a studio you can choose the most comfortable chair. Some artists prefer stools to chairs. When working outdoors, the best choice is a portable stool, or seat, even one of the simple, camping variety. Whichever you choose, it should be foldable for portability.

A portable seat is small and totally flat when folded. Some may even fit inside a large paint box.

Small wooden box with palette and retractable brush. It is more pretty than practical and rather expensive.

Wooden boxes with 6 and 15 colors and without a palette. The small box is for making sketching notes. The large one comes complete with a brush. Both are extremely expensive and most impractical.

PRINT RACK

A print rack is a foldable piece of furniture that opens up in scissor fashion and is designed for holding large papers and folders with finished works. Stands are really practical for keeping folders because these can be easily seen at a glance. Of course, they are also good for storing a supply of different types of clean paper.

Folding seats for painting outdoors.

Print rack.

Containers, Cups, and Palettes

This tray allows you to prepare a lot of colors in advance so as not to have to interrupt your work. It is suitable for painting in small formats because the wells are small and hold little paint.

An artist needs various receptacles for both paints and water to make painting easier. Palettes, jars, and containers are essential tools in watercolor work. A wide variety of shapes and sizes is available in stores. Many containers used in the home, however, can serve the same purpose equally well.

These rectangular compartments make it easier to control the load of paint on the brush: the color collects at the deep end and the tilted base carries the paint away from the brush.

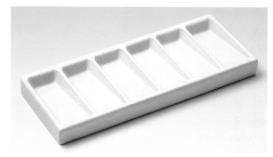

CONTAINERS

Containers are needed to keep water at hand because water is the medium used to dissolve watercolors and to clean the brushes when changing color. Both, plastic containers and glass jars will do. Although plastic is unbreakable, some artists prefer glass. Select containers that hold from 16 ounces to 1 quart (500–1000 ml); in lesser quantities the paint dirties the water too quickly.

Jars with a wide mouth are better for wetting and cleaning the brushes. Art supply stores offer an aluminum container with a spring device to suspend the brushes so that the fibers are not squashed when the brushes are left in the water. These containers are intended more for other techniques such as oil painting and have less capacity than that required for watercolors.

For outdoor painting, plastic containers are preferable as they are lighter and will not break. Some watercolorists use kitchen jars that can be hermetically closed. Even if you prefer to work with undiluted colors, you need to carry water with you as it is not always easy to find. Some artists take a bottle of mineral water with them and use it for painting and drinking; others carry a canteen.

One of the most practical containers for outdoors is a small bucket that can be hung on the easel by its handle. This lessens the risk of it spilling.

Round compartments have no corners in which the paint can collect, so it dissolves entirely in the water.

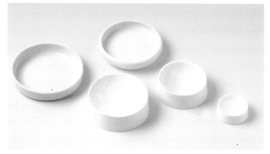

CUPS

Art supply stores carry small cups especially made for dissolving the paint in water in order to obtain the desired tones. You can also use any container you may have at home, however. The store containers can be bought as a single unit or in a tray.

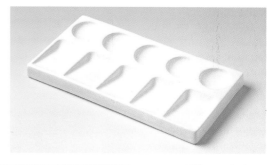

This practical tray combines round and rectangular compartments and is useful for experimenting with different densities of paint. The round wells can be used for more watery paints and the rectangular ones for thicker, pastier mixtures.

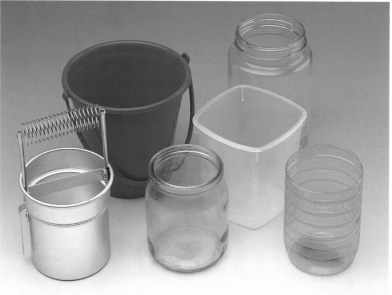

Various types of receptacles for holding the water for dissolving the paint and cleaning the brushes.

PALETTES

Palettes are used by the artist to mix colors. They generally have small compartments, (used in the same way as cups), and large ones appropriate for mixing. Many types are available, so you have to decide which one suits your style and serves your needs.

Intended for mixing and diluting colors, palettes for watercolors are made from or are coated with impermeable materials that allow the paint to run easily.

A few palettes may have a thumb hole for holding them or a ring, as some boxes do. Often, they are made of enameled metal, ceramic, or plastic. They are usually white so the colors can be seen as they really are.

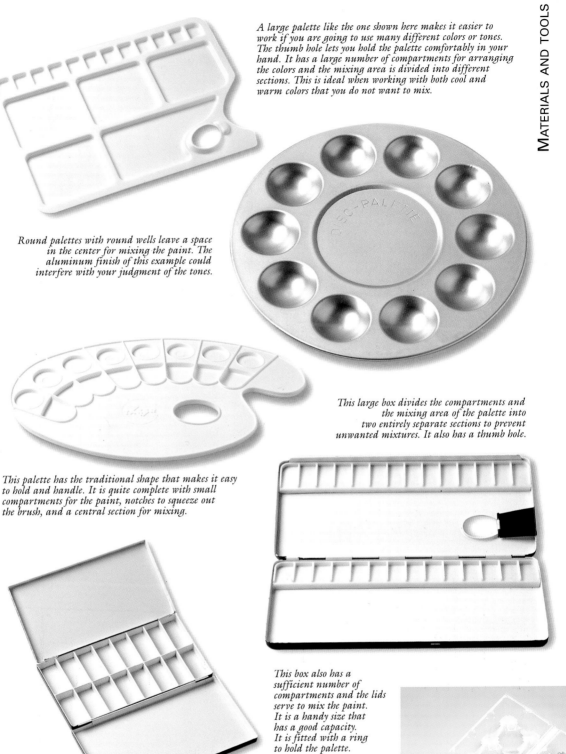

A large palette like the one shown here makes it easier to work if you are going to use many different colors or tones. The thumb hole lets you hold the palette comfortably in your hand. It has a large number of compartments for arranging the colors and the mixing area is divided into different sections. This is ideal when working with both cool and warm colors that you do not want to mix.

Round palettes with round wells leave a space in the center for mixing the paint. The aluminum finish of this example could interfere with your judgment of the tones.

This palette has the traditional shape that makes it easy to hold and handle. It is quite complete with small compartments for the paint, notches to squeeze out the brush, and a central section for mixing.

This large box divides the compartments and the mixing area of the palette into two entirely separate sections to prevent unwanted mixtures. It also has a thumb hole.

PALETTE BOXES

Palette boxes are used when painting with tubes of creamy paint. They are made of metal, enameled in white, and usually have a ring for holding them. One section is divided into compartments to hold the paint.

These palette boxes come in many different types and sizes; some designs give more prominence to the box, others allow more space for the palette.

They are very portable and practical for protecting from dust any paint left over from a painting session and for keeping the colors in perfect order.

This box also has a sufficient number of compartments and the lids serve to mix the paint. It is a handy size that has a good capacity. It is fitted with a ring to hold the palette.

If you do not have a palette, there are many objects at home that can serve the same purpose. A porcelain plate is suitable for holding the paints and mixing. The lip of the plate is ideal for squeezing out the brush.

Humble plastic egg containers can be turned into practical trays with compartments.

Other Materials and Accessories

A part from the materials discussed in the previous chapters, other accessories also form part of a watercolorist's equipment. Some are used for drawing or for preparing the paper, many are particular tools an individual artist may use for applying the paint, others are substances that alter the natural condition of the paint to adapt it to the requirements of the work.

Bamboo sketching pens.

OTHER MATERIALS

When sketching, never use a greasy medium such as wax because such materials are incompatible with watercolors. As regards other media amenable to watercolors, artists have their own preferences among the usual choices described in the following paragraphs.

PENCILS

Generally, soft lead—number 2, HB, or B—pencils are used. Some artists, however, prefer hard lead because it makes a less visible line. Others, to avoid this problem, half erase the drawing before beginning to paint.

WATERCOLOR PENCILS

The advantage of watercolor pencils is that their lines dissolve with the moisture of the paint and totally disappear.

CHARCOAL

With charcoal, you must be careful not to draw lines too thickly nor put in shadows or do any blending. The paper needs cleaning with a cloth before painting to stop the charcoal particles from mixing with the paints and muddying the colors.

FELT-TIP AND BALLPOINT PENS

Although felt-tip and ballpoint pens can be used for sketching, you must remember that the lines will show through the watercolors. Their main purpose is to outline forms that have already been painted or flesh out the details. See page 90.

BAMBOO SKETCHING PENS

Bamboo pens are used the same way as ballpoint and felt-tip pens. The lines are much stronger, but you need to be constantly dipping this pen in ink. See page 90.

NIBS

Nibs hold more ink than reed pens and are available in many types.

Some can produce lines of varying width.

Others have a sharp side for scraping back dry paint to lift out whites on the paper. See pages 70 and 87.

ERASERS

Erasers are a tool for getting rid of sketch lines in a drawing and for removing masking fluid (see page 63). There are different kinds of erasers.

Lead pencils (a), watercolor pencils (b), charcoal (c), felt-tip and ballpoint pens (d).

• *Pen-shaped soft eraser.* It is very soft and practical because it is protected and cannot be dirtied. This prevents it from smudging the paper.

• *Soft pencil eraser.* This eraser is mainly used for removing masking fluid. Although designed to erase pencil lines, it should be used gently so as not to spoil the size of the paper.

• *Kneaded eraser.* It is the softest eraser and the one that will least spoil the size of the paper. Ideal for erasing on watercolor paper that does not have hard sizing on its surface.

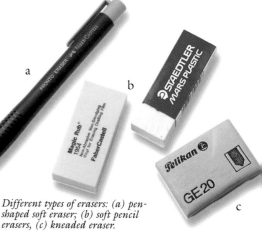

Different types of erasers: (a) pen-shaped soft eraser; (b) soft pencil erasers, (c) kneaded eraser.

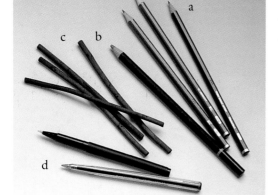

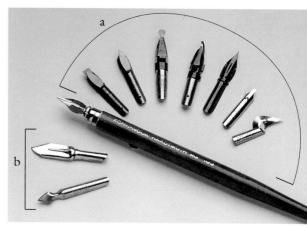

Thick nib (a) and nibs for scraping back dry paint to open up whites on the paper (b).

RULER AND DRAWING TRIANGLES

Artists need drawing triangles and rulers for tracing parallel lines and determining perspective and other common angles. Some inexperienced beginners use triangles to draw a grid when copying a photograph. The following three are basic tools of the trade:

• *Drawing triangle* with two 45-degree angles
• *Drawing triangle* with 30-, 60-, and 90-degree angles
• *Metal ruler* essential for drawing straight lines and for cutting the paper

COTTON RAGS

Cotton rags—the best as they are the most absorbent—are used for blotting off excess liquid from brushes, drying hands, and even for making corrections. See page 67.

PAPER TOWELS

Kitchen paper towels or paper tissues are necessary for removing paint from brushes, making corrections, and absorbing excess moisture. See pages 68 and 69.

BLOTTING PAPER

Blotting paper is basically used for absorbing excess moisture on the paper, making corrections, and creating effects. See page 68.

ADHESIVE TAPES

Different types and thicknesses of adhesive

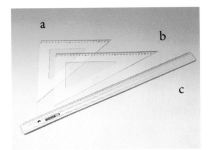

Triangles, with 45-degree angle (a) and with 30-, 60-, and 90-degree angles (b); and ruler (c).

Various types of absorbent paper.

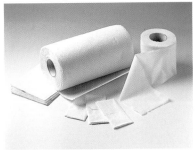

tape are available for stretching the paper (see page 36).

• Gummed tape is the type most commonly used with watercolor paper. It requires dampening prior to its use. Can be a little awkward to use but is the only tape that adheres to the wet paper.

• Masking tape of the type employed by house painters to protect certain areas from the paint can be used.

• Self-adhesive cloth tape, the kind commonly used in framing the paper and for masking, is also good because it pulls away from the paper easily.

Three types of adhesive tape.

Different types of thumbtacks.

Blotting paper.

THUMBTACKS

Attaching the paper to the board or stretching it can be done with thumbtacks as well. See page 37.

STAPLES AND STAPLER

Staples applied with a stapler are used in the same way as thumbtacks. See page 37.

Several kinds of clips for securing the paper.

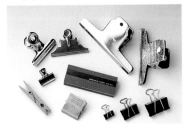

CLIPS

Paper can be secured with clips. See page 37.

SCISSORS

Sharp scissors with long blades facilitate continuous cuts and make cutting the paper easier.

CRAFT KNIVES

Craft knives are also useful for cutting paper and opening up whites.

BLADES

Razor and knife blades can be used to open whites and create effects. See pages 70 and 87.

COTTON SWABS

Ordinary cotton swabs are ideal for making corrections, opening up whites, and even for painting itself. See pages 68 and 85.

WAX

Watercolorists employ wax crayons or household candles in a wax resist technique used for opening up whites, creating effects, and suggesting shadows. See page 64.

Cotton swabs.

Blades.

Wax of various colors.

Scissors in various designs.

Different types, shapes, and sizes of craft knives.

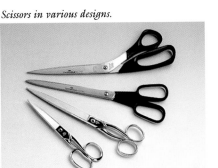

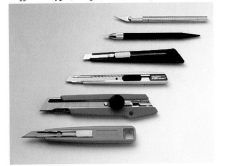

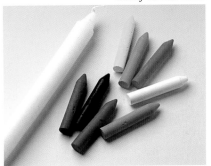

Different forms of India ink.

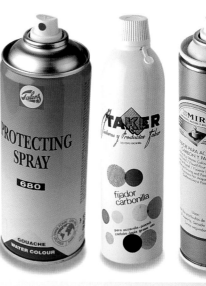

Fixative of various kinds.

INDIA INK

India ink comes in two forms: as a stick for painting with brushes and a liquid for working with nibs. In watercolor work, ink is used for outlining shapes before and after painting. See pages 90 and 91.

FIXATIVE

After the work is dry, fixative is used for fixing the colors.

ROLLER

A small paint roller can be useful for painting backgrounds and creating special effects. See page 86.

SPONGE

As a watercolor tool, a sponge has many purposes: Artists use it as an adjunct to the brush for wetting the paper, absorbing any excess water, and opening up white areas. See page 88.

OTHER ACCESSORIES

Several other products are not essential for watercolor painting but can simplify the painter's job. These are substances, some of which are added to the painting water or are used to treat the paint itself, to mask areas of the paper, or to fix the paint.

MASKING FLUID

Masking fluid is a creamy, gummy substance that forms an impermeable film when applied to the paper and protects it from the paint. Artists use masking fluid to reserve areas of the paper they want to keep white to suggest highlights or white-colored objects. This way, artists need not worry if they paint over these areas because the details are protected by the gum.

This fluid can be easily removed from the paper by rubbing gently with a finger or, preferably, an eraser. Nevertheless, it is not advisable to leave the gum adhered to the paper for too long because it becomes hard to remove and you risk damaging the paper when peeling it off.

Bottle of masking fluid.

We recommend applying masking fluid with an old brush as it can spoil the bristles. You can also use a nib pen to apply the fluid when the area you want to reserve is a fine line or small detail.

Masking fluid is sold as a transparent or colored solution. See page 62.

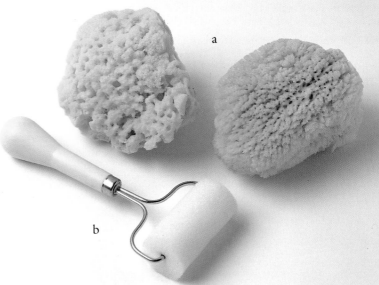

Above, sponges (a) and roller (b).

GUM ARABIC

Gum arabic is one of the main ingredients in watercolor paints and acts as a binder for the pigments.

Art supply stores sell gum arabic in liquid form. This gum can be used for different purposes. If a little gum arabic is added to the water used for painting, the paint will be a little thicker and have more consistency and body; the gum will also increase the shine and transparency of the colors. Adding gum arabic directly to the paint will thicken the paint, although too much gum may cause it to crack later.

You can also use gum arabic for making reserves because it reduces the adhesiveness of the paint.

Another use of gum arabic is to liven up colors in a dead area of a painting. Because the gum turns shiny when dry, it will add brilliance to drab colors. See page 75.

Bottle of gum arabic.

WATERCOLOR MEDIUM

Watercolor medium is a mixture of gum arabic, acetic acid, and water.

This medium is dissolved in the painting water—adding a few drops to a pint (500 ml) of water—to remove any traces of grease; increase the intensity, shine, and transparency of the colors; and give better adherence to the paint.

The use of watercolor medium is advised when repeated drawing and handling may leave greasy spots on the paper.

It can also be mixed directly with the paint to thicken it.

Watercolor medium.

OXGALL

Purified oxgall is a wetting agent. It reduces the surface tension of water, causing the paint to flow more freely and evenly. It can be added to the water or mixed directly with the paint. Synthetic wetting agents are also available.

AQUAPASTO

Aquapasto is a mixture of gum arabic and silicon. It has the consistency of gel, is transparent, and is used for applying thick layers of paint. Unlike gum arabic, aquapasto is resistant to cracking.

Bottle of oxgall.

ALCOHOL

Alcohol accelerates the evaporation of water when added to watercolors, so the paint dries quicker and requires slightly different handling. Fast evaporation makes the paint seem less plentiful on the brush or makes the paper seem more absorbent. The paint, therefore, is more difficult to control, is less workable, spreads out more over the wet surface of the paper, and accumulates less at the sides. Water with alcohol added does not produce as good a result as pure water when blending colors because tonal transitions are more abrupt. The results, when the paint dries, are unpredictable.

Alcohol is useful for painting outdoors at low temperatures as it prevents the paint from freezing.

It is mixed in equal proportion to the paint and is good for creating impasto effects and making the brushstrokes visible.

Bottle of alcohol.

Tube of aquapasto.

GLYCERIN

Glycerin is a moisturizing agent, or humectant, that prolongs the drying time. (Watercolor paint already contains a small amount of this substance for the same reason.) In addition, it helps the pigment to dissolve in the water.

Adding glycerin to the painting water, therefore, increases these effects.

It is most advisable to use glycerin when working slowly or in the open air in warm, dry conditions.

It should not be applied undiluted as this would stop the pigments from dissolving.

VARNISHES

Varnishes are used as a fixative to protect the colors, though in many cases they add a certain gloss. Many watercolorists object to this as the work then loses the characteristic matte appearance of watercolor paintings. Some artists use it only in certain parts of the painting, for example in dark areas to soften the contrasts.

Bottle of glycerin.

Varnishes can be purchased in liquid form for applying with a brush when the watercolor is completely dry. You must take care with the amount of varnish you apply as too much will lend the work an excessively shiny effect and make it look as if it has a plastic coating. Pay attention also to the pressure you apply to the brush; moreover, try to avoid repeated strokes on a particular area, because the paint could smudge and dirty adjacent colors.

Varnishes also come in sprays. These are perhaps the most practical. With sprays, it is easier to control the amount applied and to avoid any excessively shiny areas.

Various types of varnish.

Stretching Paper

Excess or insufficient moisture in watercolor painting has a considerable effect on how the pigments dissolve and on the final result of the work. The moisture that is basic to this painting technique also affects the paper.

can wet it with paint knowing that it will not warp and that when the paint dries the paper will become smooth again.

Paper is generally stretched over a rigid surface such as a piece of plywood or any other kind of board. This board should be slightly larger than the paper to allow for taping. Some

artists prefer coarse, wavy pape and do not stretch it first; or the use handmade paper that i already slightly misshapen whe sold.

There are three steps in th stretching procedure: (1) wet ting the paper, (2) attaching to a support with gummed tape (3) drying and removing it.

WHY STRETCH THE PAPER?

Paper expands when wet and shrinks when dry. After this wet-dry process, the paper does not always retain its flat, smooth shape; sometimes it warps. Small

formats usually return to their original shape, but light papers of less than 140 pounds (300 g) wrinkle and warp with the moisture of the paint. The way to prevent these distortions from spoiling a painting is to stretch the paper. This way, the artist

Wet paper that has not been stretched will usually curl as it dries.

FIRST STEP — WETTING AND FLATTENING THE PAPER

First, the paper needs to be dampened so that the fibers will swell up; this makes the paper increase in size. Some papers expand almost one-half inch (1 cm). Here we show two of the various ways to wet the paper; whatever method you use, always use cold water because hot water could spoil the size of the paper.

One way of wetting the paper is to totally immerse it in water. The paper can be left in the tray for a few minutes until properly soaked.

The paper can also be placed under an open faucet; the longer you hold it there, the more water it will soak up.

For more control, you can use a sponge to apply only the desired amount of water on the paper. Take care not to rub the paper too hard with the sponge as this would remove the size from the paper surface.
Watercolorists vary in the degree of moisture they prefer to work with. Some artists wait until the paper is completely dry after stretching it. Others start to paint when the paper is still wet and retains just the amount of moisture they prefer. There are also those who wet the paper only on the reverse, then stretch it and draw on the dry side. Wetting the reverse of the paper enables you to apply paint more insistently because the size remains intact.

Place the wet paper on the board, smooth it out well, squeezing out excess water and trapped air by running your hand on the paper from the center outward. Your touch will tell you if the paper is evenly wet (areas with a lot of water feel smooth and slippery; dry parts are rough to the touch). Before stretching the paper, give it a couple of minutes to expand.

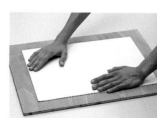

SECOND STEP — TAPING THE PAPER

Gummed tape is used on all four sides of the sheet to attach the paper to the board. When taping the paper to the support, be careful to keep the tape parallel to the edge of the paper. Otherwise, when you remove the tape, the painted edges will not be properly aligned with the borders of the paper; this may give your painting a crooked effect that will require trimming the borders to correct it.

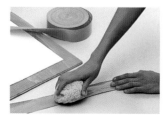

For very wet paper, you will need to use gummed tape because it is the only one that will stick to a wet surface. Precisely because it needs to be dampened, this kind of tape is more troublesome to use.

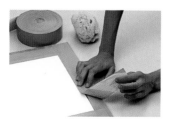

To make the paper equally taut on all four sides, attach one side and then the opposite one; repeat this procedure with the remaining two sides.

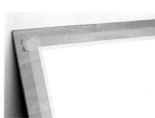

Masking tape is easier to use, but it will not stick to wet paper. It works when the paper has been dampened only on the reverse side.

FINAL STEP

DRYING THE PAPER AND REMOVING THE TAPE

If you have soaked the paper under the faucet or by submerging it in water, it will take four or five hours to dry out entirely. Drying can be speeded up with a hair dryer or by setting the board and paper out in the sun; heat makes the gum soften, however, and the tape may peel off or the gum may stick to the paper so much that you tear the paper when trying to remove it.

DON'T...

- Wet the paper with hot water as the heat would ruin the size on the surface.
- Rub too hard with the sponge when wetting the paper for the same reason.

If you used gummed tape to attach the paper to the board, you will need to cut around it with a knife to remove the tape. Alternatively, the tape can be moistened before removing it from the paper; otherwise, the paper will tear. Gummed tape usually leaves some traces of gum.

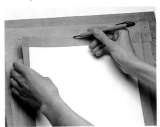

Adhesive tapes used for masking can be easily peeled off, but gently so as not to tear the paper. You should never leave them on the paper for more than a couple of days because they could leave gum residue that is impossible to remove. Masking tape also creates a white border around a painting.

ALTERNATIVES

OTHER WAYS OF STRETCHING THE PAPER

No one system is better than the rest; select one you prefer or feel is best suited to your style or requirements.

NOTE

Wet paper can also be stretched using staples or thumbtacks. They are not as effective as tape but hold well enough if the paper weighs up to 140 pounds (300 g).

The paper can be stretched on the board by taking a piece of paper larger than the board and attaching it with thumbtacks or staples to the back of the board. The edges of the paper must be carefully folded over the board, especially at the corners so that the paper fits tautly. You can remove the paper by cutting it or pulling out the thumbtacks or staples.

Paper can also be stretched over a frame, like canvas. This method does not leave a white border around the painting. The stretching procedure is the same, but remember that you cannot press hard on the paper because there is no backing in the center and it could give way or tear.

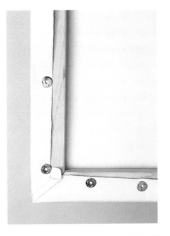

DRY STRETCHING

OTHER METHODS

Wetting and stretching the paper has become less popular as it requires time and preparation. Many artists prefer to work with the heavier papers, stretching them without wetting and then wetting them a little. The procedure for stretching dry paper is the same as that for wet paper.

Masking tape can also be used for stretching dry paper but may release its grip when the paper is wet.

Stapling the paper to the board is an easy and quick stretching method, though it does leave unsightly holes in the paper.

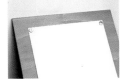

Many artists like to use thumbtacks for attaching the paper to a support, though they, too, make holes in the paper.

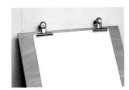

For thick paper or small formats, clips are more than adequate and have the advantage that no marks are left on the paper.

TREATING THE PAPER

GESSO

Gesso is a white, synthetic emulsion that reduces the absorbency of the paper and increases its whiteness and adherence. It is generally used as a primer for unsized paper or for creating special effects.

Gesso is applied to the surface of the paper with a spatula or a hog's hair brush and is allowed to dry.

How paint on paper treated with gesso looks. Because the surface hardly absorbs any paint, the brush slides over it and the paint collects in droplets, taking longer to dry.

Using the Brush

The brush is the instrument used for applying the paint to the paper. Its performance greatly depends on how well you handle it, understand its versatility, and maintain it.

Individual painters have their own way of holding the brush to achieve just the right result. Artists have a surprising number of different ways of gripping and using the brush. Although an ideal way of holding a brush does exist, artists end up adopting their own personal style. Making the brush respond to manipulations of the hand to achieve exactly the results we want is no easy task, but, next are some suggestions that may help.

THE BRUSH	HOW TO HOLD IT

Artists generally hold the brush as you would a pencil. Unlike in writing, however, the movements of the hand are freer and more fluid when painting; moreover, the hand moves in all directions.

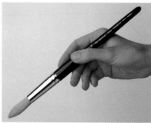

Watercolor painting requires a spontaneous style that calls for the brush to be handled delicately. Your hand must grasp the brush firmly but loosely and touch the paper with it lightly. Never press the brush down so hard as to squash the hairs against the paper. Maintain good control on the pressure you exert on the brush as the force will determine the thickness of the brushstroke and the amount of paint applied with each one.

Unless you are painting details, do not hold the brush by the ferrule as this constrains the hand. Grasp it near the end of the handle for freer, faster movement.

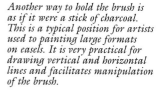

Another way to hold the brush is as if it were a stick of charcoal. This is a typical position for artists used to painting large formats on easels. It is very practical for drawing vertical and horizontal lines and facilitates manipulation of the brush.

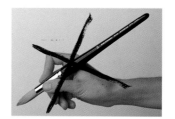

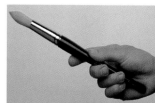

ACCURACY	THE MAULSTICK

Apart from the spontaneous, flowing brushstrokes associated with watercolor painting, in every work there are usually small details that require a steady hand for accuracy. As an aid, artists have invented a tool called a *maulstick*. However, it is not essential because the artist's non-painting hand can serve the same purpose. In fact, few artists today use a maulstick as many find it cumbersome.

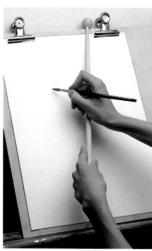

The photograph, at left, shows a maulstick in use. This tool was designed for painting details that require firm and steady control of the hand; it has been used by most of the great masters of painting. This small stick, which has a ball at one end, is rested on the frame of the board and held with the free hand. The hand holding the brush, then, has a point on which to rest and accurately paint in small details.

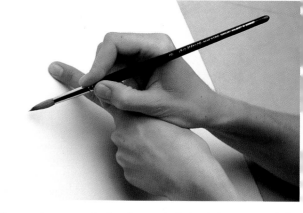

You can also use your free hand to steady the brush. Just rest your index finger on the paper to control the brushwork. It may seem difficult at the beginning but with a little practice you will incorporate this technique automatically into your painting.

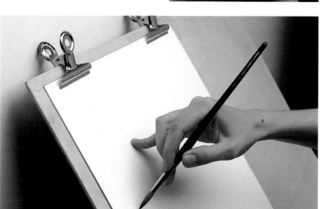

Another method, which is especially useful when working quickly, is to use the painting hand as a resting point. Just press your little finger against a dry part of the paper and use it to steady your hand for detailed painting or retouching.

MOISTURE

SQUEEZING OUT PAINT

Unless you are a skilled watercolorist, it is difficult to judge exactly how much paint or excess water is absorbed by the brush. So as not to flood the paper or dilute the colors too much, paint or water is squeezed out of the brush on an absorbent cloth such as cotton or on paper towels.

For removing excess water from the brush after it is rinsed, something the artist does continuously, a piece of cloth is the tool most useful to the painter. If it is paint you wish to extract, however, do it on a piece of paper toweling, which allows you to see exactly what the tone is.

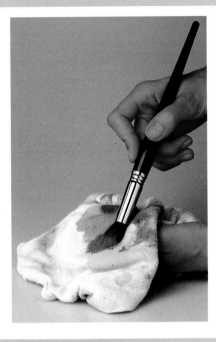

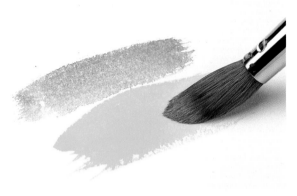

It is advisable to have a piece of cloth handy to squeeze water out from the brush before painting so as not to drench the paper. Remember that cotton cloth is more ecologically-sound than paper towels, and it does not break up when wet.

Before painting with a new color, it is a good idea to test it on a piece of the same paper you are using, because a different texture or weight would change the results.

ADVICE

HOW MANY BRUSHES TO BUY

The number of brushes an artist will need depends entirely on his or her preferences. Professional painters usually work with only a few brushes as a good brush is versatile and can serve many different purposes.

A set of five brushes is more than enough to start. The aim is to select an assortment that will let you work in any format. A possible selection is illustrated here.

a. A flat, wide brush for washes and for painting large areas. Your preferences will dictate whether to buy hair or bristle. Treated Chinese bristle is very practical and economical; it is also soft and can absorb large amounts of paint. Synthetic hair is practical, too, but absorbs less.

b. A flat-tipped brush with synthetic hair and a beveled handle for opening up white areas. Useful for filling in areas that need a sharp outline.

c. A thick, number 18 brush. For painting skies and working with sweeping brushstrokes, this is a good size; not excessively large and can be also used for small formats. If you are new to watercolor painting, this brush will be very helpful as it cannot be used for detailed work and will encourage you to handle it more freely in your treatment of forms. This is a sable-hair brush, but you can also use ox or synthetic hair which are less expensive.

d. A round, medium-size brush. numbers 12 and 14 are the most popular for painting. If you have decided on small formats, a smaller brush will also be handy— a number 8, for instance. As regards the type of hair, the best is sable, followed by ox hair, especially when dealing with brushes in the high numbers.

e. A round, number 2 brush. For details and retouching, you can choose between a 0, 1, or 2, according to the format you are working in. For the small numbers, sable hair is best as it has a better point and absorbs more paint. If it is too expensive, you can substitute synthetic hair.

NOTE

Tastes and approaches vary widely among artists. Consequently, you need to experiment with brushes of various types and with different hairs until you find those that best suit your style and requirements. An artist who works with small brushstrokes and in great detail will not use the same brushes as one who prefers large, flowing, spontaneous brushstrokes.

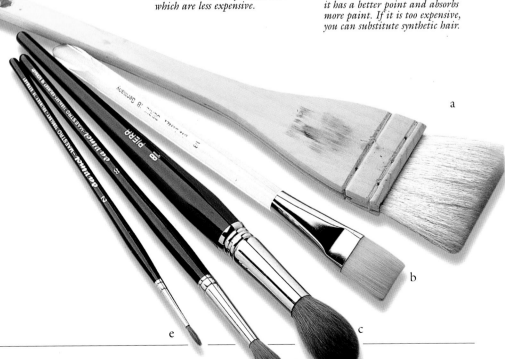

TECHNIQUES IN WATERCOLOR

CARE OF BRUSHES HOW TO CLEAN THEM

Always wash your brushes after finishing a painting session to keep the hairs from losing their shape or deteriorating.

Because watercolor paint dissolves easily in water, no chemical products or solvents are needed for cleaning the brushes.

Simply dip the brush in plenty of clean water or rinse it under an open faucet; using a little soap is recommended.

Hand soap or washing soap are the most suitable. Stores do sell a type of soap especially designed for cleaning brushes.

NOTE

After washing a brush, it is essential to restore and protect the original shape of its hairs. You can reshape the hairs with your fingers, or you can gently press them between your lips to smooth them into the proper shape.

2. Swirl the brush softly in the palm of your hand until the soap suds and penetrates the hairs.

1. Gently, rub the brush on the bar of the soap.

3. Rinse the brush well under the faucet. A brush is not completely clean until the suds are clear of color. Repeat the cleaning procedure as many times as is necessary. Use lukewarm water to wash the brush; hot water could soften the gum that holds the hairs inside the ferrule, causing them to fall out and ruin the brush. To dry the brush, squeeze the hairs between your fingers or blot them on a cloth; you can also strike the brush against your hand softly.

MAINTENANCE HOW TO STORE BRUSHES

To keep your brushes handy for regular use, after you have cleaned, reshaped, and dried them, set them in an open jar, hair-side-up. Do not dry them in an upright position, however, because water will get trapped within the ferrule and eventually cause damage. It is best to store brushes either flat position in a box or upright inside a sealed jar. If you have been painting outdoors, make sure you protect them during your trip home. Art supply stores sell cases specially designed for carrying brushes safely.

If you are not going to use your brushes, put them away dry so that they do not get moldy and in a flat or upright position to preserve their shape; the hairs should not touch anything. To store them for a long time, you can place them in a covered glass jar or any other container that guards them from dust, and add a few mothballs to discourage moths from eating the hairs.

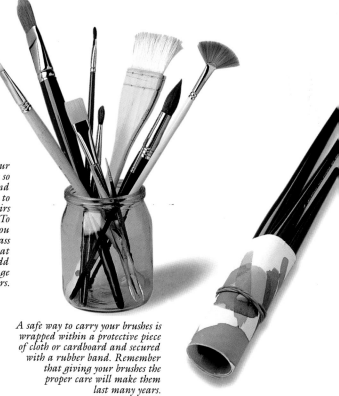

A safe way to carry your brushes is wrapped within a protective piece of cloth or cardboard and secured with a rubber band. Remember that giving your brushes the proper care will make them last many years.

BAD HABITS — THINGS NOT TO DO

In painting there are certain habits, especially among beginners, that need correcting to avoid encountering problems later.

> **NOTE**
>
> The habit of leaving a brush on a table without paying attention to whether the hairs are hitting some other object is the most common cause of bent and misshapen brushes.

Do not leave the brushes in the jar of water for hours, not even while you are painting. We have already discussed the importance of maintaining the integrity of the shape and point of a brush. Leaving the brush resting on its hairs is the best way to render it useless as this spoils its point and affects its precision. It is possible to buy aluminum spirals (see page 30) to fit the mouth of the water jar for keeping the brushes suspended by the handle, with the hairs in the water but not touching the bottom.

Do not allow the paint to dry on the brush. Even though watercolor paint is easy to dilute, when it dries on the hair it behaves like any other type of paint and tends to clump near the ferrule, separating the hairs and ruining the shape of the brush.

Do not dry the hairs of a brush without restoring their original shape. Careless drying with a cloth can sometimes cause the hairs to splay.

VERSATILITY — BRUSHSTROKES

Round brushes are extremely versatile. Here is just a small sample of what can be done with one. With the tip of a round brush, fine lines are possible; at the same time, its main body allows painting thicker lines; additionally, its absorbency and loading capacity yield a surprisingly long brushstroke.

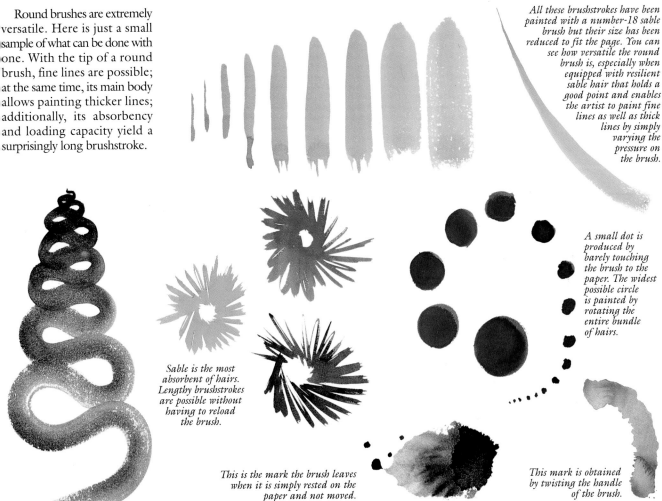

All these brushstrokes have been painted with a number-18 sable brush but their size has been reduced to fit the page. You can see how versatile the round brush is, especially when equipped with resilient sable hair that holds a good point and enables the artist to paint fine lines as well as thick lines by simply varying the pressure on the brush.

A small dot is produced by barely touching the brush to the paper. The widest possible circle is painted by rotating the entire bundle of hairs.

Sable is the most absorbent of hairs. Lengthy brushstrokes are possible without having to reload the brush.

This is the mark the brush leaves when it is simply rested on the paper and not moved.

This mark is obtained by twisting the handle of the brush.

One Color

Watercolor painting is one of the most difficult techniques because, although it can be retouched and corrected, there are mistakes that cannot possibly be eliminated. This is why learning to paint in watercolor can be troublesome.

If the overall color of the work is unbalanced and the artist has used too many dark tones, the painting may have to be discarded.

The transparency of this medium does not allow reducing the intensity of a dark tone by painting over it with a lighter one, nor does it permit concealing a mistake with white paint and then laying a new color on top. In such a case, the most common manipulations possible with watercolors are lifting out color and repainting. But paper is an absorbent material that dyes easily and has too delicate a surface to bear repeated corrections. To begin familiarizing yourself with this medium, therefore, it is best you set aside the problems of color and focus on the painting technique itself and on how to achieve consistent overall tonal values.

HOW TO APPLY A UNIFORM WASH

Wash is the term given to the technique of applying a fine layer of paint diluted with water to both large and small surfaces, though it more commonly refers to painting large areas.

A flat wash is obtained by applying only the same tone; it results in an even layer of paint with no tonal variations and no trace of brushmarks.

Flat washes are applied to vary the white of the paper, to create backgrounds such as skies, or to cover a broad area of the paper.

Although a flat wash looks deceptively simple on the paper, creating a perfect one is quite a challenge.

You can lay a wash on wet or dry paper. The advantage of doing it on damp paper is that the moisture prevents color breaks from happening; also, the paint will take longer to dry. For the beginner, it is advisable to experiment with dry and wet washes to gain experience with both types.

IN PREPARATION MIXING THE COLOR

Before starting you will need to prepare the paint in a cup. Be sure to mix a sufficient amount that will cover the entire area you have chosen. You do not want the paint to run out halfway through your work as this will require you to stop painting to prepare more paint; this interruption is very likely to result in breaks. It may even be impossible to obtain exactly the same tone as before.

Do not forget that watercolors lose their intensity as they dry. So test a color first on a separate piece of paper until you have the desired tone.

Moreover, you need to bear in mind that when applying a plain wash there is no opportunity to retouch or repaint it.

Place a small amount of paint in the mixing container.

Dilute the paint with water and stir it with the brush to mix it thoroughly. Remember that washes require light tones that allow the white of the paper to show through to begin building up the tonal variations of the light areas. A dark background would yield a limited number of possible tones, and, except for the reserved areas, these tones would inevitably be darker than the preliminary tone of the wash.

THE WASH APPLYING THE PAINT

To prepare a wash, use a generous amount of water for dissolving the paint, which needs to be in an extremely fluid state for its application. It is preferable for the paper to be stretched as the moisture in the paint could cause it to warp and make the painting difficult. In addition, the paint would gather in the wrinkles caused by the warping and not produce a uniform color over the entire area.

To acquire practice with the brush and paint, as well as with keeping the color within certain limits, it is a good idea to draw a rectangle on the paper and lay a wash inside it.

1. With the board slightly tilted and with sweeping brushstrokes, paint a horizontal stripe across the upper part of the paper. Notice how the inclination of the board causes the paint to accumulate in the lower part of the painted line, stopping the edge from drying and preventing the color from breaking when applying the next brushstroke. Work quickly to keep the accumulated paint at the bottom of the strokes from running down the paper. Otherwise, the brushstrokes will not blend and will show visible streaks when dry that will be very difficult to remove or disguise. It is important to keep the brush loaded so it will not run out of paint halfway through a stroke. If the brush you are using is not very absorbent, reload it with paint for each stroke.

2. Make the second stroke in the opposite direction, drawing the accumulated paint across the paper. Alternate the direction of your strokes as you continue.

3. When you reach the bottom edge, dry the brush on a cloth and use it to absorb any paint that has accumulated at the bottom.

4. When the paint dries, the tone over the entire surface of the wash should be uniform. Although some beginners may think that they will never need to apply a flat wash, it is important to learn how to achieve this degree of control over your work, so practice until you have mastered it. Another way of applying a wash is to draw the paint downwards, in vertical brushstrokes instead of horizontal ones. Neither system is better than the other; it is simply a case of testing each method and using the one that gives you the best results.

NOTE

The type of brush needed for applying a wash will depend on the size of the surface to be painted. Regardless of size, it is always best to use a brush with the capacity for retaining the necessary paint that will enable you to comfortably produce lengthy brushstrokes. For covering extremely large areas, we advise using a Japanese hake brush. A sponge is also a good tool for applying washes because its great absorbency makes it easy to cover large sections of a painting. Sponges are used in much the same way as brushes; the difference is that with a sponge it is not necessary to take up fresh paint as often as with a brush. A sponge also allows you more control of the amounts of paint that can be released or absorbed when pressing it against the paper.

WRONG TONE **CORRECTING A WASH**

As already mentioned, washes that are to serve as background for a painting need to be in light tones. Because each color reacts in a particular way with the water and paper, the results may sometimes be surprising to the uninitiated artist.

If you have failed to control the intensity of a tone and it has dried excessively dark, you can try to salvage the paper by washing out the color, holding the paper under the stream of a faucet, or by lifting out the color with a sponge. Remember, however, that certain pigments have greater dyeing capacity than others, in which case the paper is unlikely to return to its original color. After rinsing off the wash, you will probably obtain a tone that can be used for a painting. If not, you will need to apply another wash on the same paper, but take into account that

the color already on the paper will darken or modify the new wash. So for this second wash it is advisable to dilute the paint well and try to obtain a very pale tone.

NOTE

Before applying a wash, you must prepare sufficient paint to avoid interrupting your work and risking breaks in the paint.

If the paint runs out in the middle of a wash, it will be very difficult to obtain exactly the same tone again.

Washes must be done with pale colors to allow superimposing all the other colors in the entire tonal range planned for the painting.

Flat washes cannot be retouched or repainted.

Washes that have not produced the desired tone can be corrected by removing some of the paint with a damp sponge.

Washes can also be rinsed off by washing the paper under a faucet.

GRADATED WASHES

In a gradated wash, the color gradually pales from a dark value, usually in the upper part of the paper, to the merest expression of the same color in the lower part where it merges with the color of the paper.

Gradated washes have many uses, the basic one being to represent the background or sky in landscapes.

There are two methods of gradating: on dry or on wet. In both cases it is advisable to stretch the paper and tilt the board about 30 degrees, the same as for a flat wash. Gradating can be difficult, so it is best to experiment first on a piece of scrap paper before attempting it on your final sheet. Testing lets you work more freely and saves on needless expenses.

To succeed, gradated washes should be done quickly and decidedly. Avoid the temptation of retouching with the brush so as not to alter the tone. Proper dilution of the paint is also important because too much or too little water can change the tone and produce a grainy effect.

ON DRY

STEPS FOR A GRADATED WASH ON DRY PAPER

Gradations on dry paper yield brilliant areas of crisp color. Although the following procedure is generally used for making on-dry gradations, it can also be employed for working on paper that has been dampened beforehand.

Paint is applied to the upper part of the paper. Then, instead of loading the brush with paint for the strokes that follow, clean water is used. The brush, therefore, carries less and less pigment with each succeeding brushstroke, and the tone gradually pales until it blends with the color of the paper.

NOTE

Although the on-dry technique appears very simple, it is not as easy as you might imagine. The limitations of the area to be covered with the gradated wash make it necessary to calculate the speed at which the color needs to be diluted with water so that when you reach the bottom boundary of the paper or area the tone will merge with the color of the paper itself.

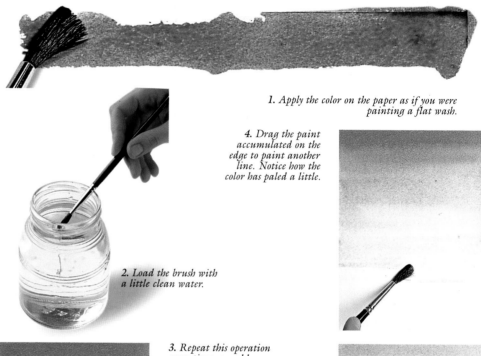

1. Apply the color on the paper as if you were painting a flat wash.

2. Load the brush with a little clean water.

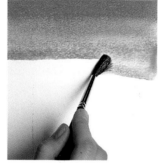

4. Drag the paint accumulated on the edge to paint another line. Notice how the color has paled a little.

3. Repeat this operation every time you add a new band of color. The proportion of water in relation to pigment increases each time the brush is dipped in clean water. Thus, the tone gradually loses intensity.

5. This operation is repeated until the color merges with that of the paper.

ON WET

A GRADATED WASH ON WET PAPER

Laying a gradated wash on dampened paper produces a soft, uniform gradation of color that has no breaks. This method requires you to first wet the paper. Next, load a lot of paint on the brush and spread it on the paper from top to bottom so that the color pales as the brush works its way down the paper.

The amount of water necessary for this technique depends on the type of paper you are using and external factors that can speed up or slow down the drying time.

1. First, dampen the paper. According to the size of the area to be painted, this can be done with a brush or sponge.

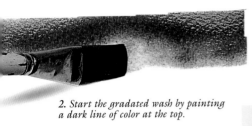

2. Start the gradated wash by painting a dark line of color at the top.

3. Slowly, spread the paint down the paper with sweeping horizontal brushstrokes.

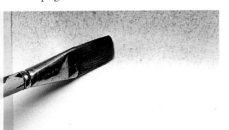

4. As you progress, the brush carries less and less color, so the tone gradually becomes paler. Apply more or less pressure on the brush to control the amount of paint released onto the paper. The greater the pressure, the more intense is the color. The amount of pressure you apply must be slowly reduced so that when the tone merges with the color of the paper, the hairs of the brush barely touch the surface of the paper.

NOTE

It is important to remember not to go back over previous strokes with the brush when you gradate because subsequent areas decrease in intensity given that the brush carries less pigment and returning it to a dark area would, then, create abrupt openings in the tone. Additionally, the brush would also pick up more pigment from the dark area, thereby altering the tone when applying a new stroke farther down. A gradation must be done gradually and successively, from beginning to end.

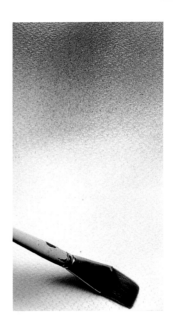

WHAT IS TONE?

A *tone* is each degree of intensity in a value scale that is applicable to any color. This scale ranges from light to dark. That is, each color has an entire spectrum of tones that ranges from minimum to maximum intensity.

The various intensities of a color allow us to build a work in monochromatic tones to create forms where each tone represents a degree of light for each area.

Proper control of the tonal potential of each color is essential for building up the overall tonal balance of the work. Tonal values mark the difference between a weak, lifeless painting and a strong, vibrant work.

BUILDING TONES

Two basic systems exist for creating a range of tones from a single color. They are quite different but can produce the same results. One is to dilute the paint and the other, to superimpose glazes.

It is advisable to create value scales using different colors of the palette as each has special characteristics and reacts in a different manner. This way beginners can discover for themselves that opaque colors, such as chrome oxide, for instance, can never become as transparent as sap green, however much the tone is lightened.

Additionally, the difference between the various tones of the same watercolor can be so great that they can appear to be two entirely different colors.

TONES — LIGHTENING VALUES BY DILUTING THE PAINT

To create a scale or range of tones in most pictorial techniques, the color white is used. White is mixed into a pure color to reduce its intensity. The greater the amount of white, the lighter the tone.

White is never used for this purpose in watercolor painting.

In watercolor, a color is lightened by simply adding water. The greater the proportion of water contained in the paint, the more transparent it becomes and the color appears less intense.

Thus, a scale is constructed from dark to light, as the most intense tone is that with the largest proportion of pigment, or the least amount of water. The lightest tone is obtained when the paint has been diluted as much as is possible.

The procedure is simply to gradually add more water until you have achieved the palest tone possible.

1. Paint any shape you want on the paper in a given tone.

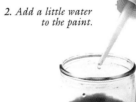

2. Add a little water to the paint.

3. Paint another figure next to the first using the second tone. Note the difference in intensity between the first and the second figures. This operation is repeated until you have a tone that barely shows on the paper. Always add the same amount of water to the paint so that the gradation is even and continuous.

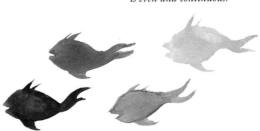

4. Here, different value of Hooker's green have been obtained, although this color could produce many more than these.

TECHNIQUES IN WATERCOLOR

TONES | CREATING A TONAL SCALE BY SUPERIMPOSING GLAZES

If by diluting the paint, we can create a series of tones ranging from dark to light, the opposite is true when we apply glazes. In glazing, we work from light to dark.

A *glaze* is a layer of transparent color. As watercolor is a transparent technique by definition, it is easy to understand that a large part of this technique consists of superimposing glazes. Applying one glaze over another of the same color changes the color, increasing the intensity of the tone.

Although the principle of glazes is simple and easy to understand, it is advisable to do a few exercises for painting tonal scales so as to familiarize yourself with glazes. This way you can discover the potential of each color and will realize that transparent colors have a wider variety of tones than opaque ones.

Before starting this exercise on glazes, take into account that the quality of the paper plays an important role as too many layers of paint can lead to catastrophic results if the paper is not suited to repeated wettings.

For a successful glaze, it is essential to wait until each layer is dry before applying the next.

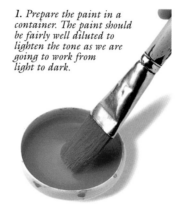

1. Prepare the paint in a container. The paint should be fairly well diluted to lighten the tone as we are going to work from light to dark.

NOTE

To change tones using glazes, it is essential to wait for each layer to dry before painting the next. When creating tones by diluting the paint, you begin with a mixture that contains a large proportion of pigment. With glazes, the paint is highly diluted and the pigment builds up on the paper with each succeeding layer.

2. Lay a fairly long brushstroke of flat wash.

3. Once it is dry, load the brush again with the paint and superimpose a second layer of paint over the first, but leave a small section of the first wash uncovered.

4. Continue superimposing glazes until your scale resembles this attractive range of tones.

PAINTING WITH WASHES

The wash method of painting involves using watercolor paint or diluted ink on paper. It generally employs only one or two colors. So a form in this style of painting is developed using the white of the paper and the tonal range of the color.

The beginner needs to understand how the lack of white paint affects watercolor work. It is the only way of seeing the importance of tonal values before starting to apply colors.

Poor use of tones or insufficient planning before starting to paint usually leads the artist to paint excessively dark areas. Consequently, it becomes necessary for the painter to darken the rest of the painting to maintain the same tonal relationship.

A beginner may try to avoid risking this mistake by using only intermediate tones, but this strategy will result in a plain, dull, and unexpressive painting.

The application of washes is a basic skill you must acquire with practice if you wish to master the technique of watercolor.

A painting executed with this technique is usually monochromatic and forces the artist to use the tonal values of the model, translate color into tones, and use these tones to build up the form.

Based on the classic watercolor procedure, the wash method of painting builds color from light tones to dark ones.

It is advisable to use dark colors as they are more suitable for creating a wider range of tonal variations.

The various tones are obtained by diluting the paint. Remember that the greater the proportion of water, the less intense is the tone.

ONE COLOR | SMOKE BLACK

When painting from nature, it is important to make sketches as the light can change, or the clouds in the sky can change shape or position. Sketches enable you to decide the composition and the tonal balance of the subject. Take care not to become too involved with details at this stage; simply reduce the model to a series of light, dark, and intermediate tones.

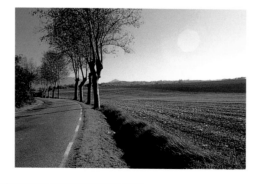

We are going to create a monochromatic-wash painting in smoke black, using this landscape as a model.

. Light gray is used for the sky.

2. A fairly dark value is used to paint the shadow area that sets off the horizon.

3. A medium value is used for painting the field, letting the direction of the brushstrokes suggest the furrows in the plowed field.

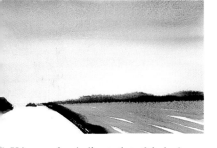

. Using a value similar to that of the horizon ine, we set down the limits of the road ditch nd of the trees on the left.

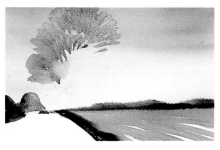

5. Light tones are then used for suggesting the foliage of the trees and for the patch that represents the mountain in the background.

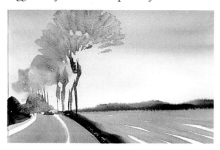

6. The road is added reserving the white to indicate the broken line, and the tree trunks are developed.

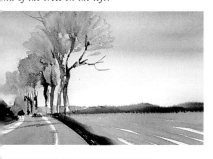

7. We finish by painting the details of the branches on the trees and the shadows on the road, and we add the dark point at the end of the road that produces an interesting contrast.

NOTE

Building up values by superimposing glazes should not be used as the main method of painting as too many glazes can rob a painting of the sparkle and transparency that are characteristics of watercolor.

COLOR

UNDERPAINTING

Underpainting is a term that escribes the monochromatic ainting used as a base for a efinitive work.

It is a sketch painted in a sin-le color that forms the basis or the tonal balance of the final vork. This preliminary sketch revents irreversible errors and voids needless corrections.

An underpainting is generally one in a pale, neutral tone that vill not alter the colors that are o be applied as glazes later. Pale ray would be good, or blue, vhich in the case of a landscape vould be more suitable.

This preliminary painting de-ermines the shadows, because vatercolor paints are transpar-nt and the darker areas of the nderpainting will show through he colors applied subsequently.

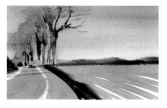

1. We first paint the sky using a gradated wash in cerulean blue and cobalt blue.

This sketching method is a good alternative to making a pencil drawing as pencil lines can darken when color is applied over them.

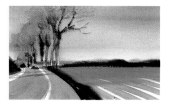

2. With a permanent pale green we suggest the color of the grass in the field.

For this exercise we are going to use the previous monochro-matic-wash painting as an un-derpainting.

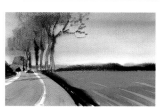

3. A mixture of ochre and burnt sienna gives an earthy color to the soil; notice that the transparency of the paint allows you to see the furrows painted in gray from the monochromatic-wash stage. The tree foliage receives a blend of burnt sienna and vermilion.

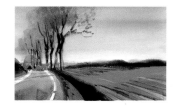

4. We add the grass at the side of the road and suggest the shadows and textures of the field using a more intense tone.

5. A few last touches complete the foliage and the mountain in the background.

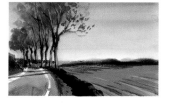

Two Colors

As mentioned earlier, washes are usually applied to create backgrounds. So far we have referred to plain and gradated washes, but another kind of wash can be obtained by mixing more than one color on the paper, that is, a *variegated wash*. This is a wash with a vast, almost infinite number of applications.

WHAT IS A VARIEGATED WASH?

A variegated wash is one that blends different colors.

Variegated washes have as many uses as the artist's imagination can devise and are a commonly used technique. Generally, however, they are resorted to when the background is, say, a multicolored sky at dusk, or a stretch of beach with wet sand that carries reflections of neighboring colors.

For variegated washes it [is] essential to wet the paper first s[o] that the pigment diffuses mor[e] easily and the colors blen[d] together smoothly. The mixtu[re] of colors in a variegated was[h] and the final result are unpr[e]dictable and only become ap[-]parent after the paint has drie[d].

In gradations using two co[l]ors, the change from one to th[e] other must be very gradual.

EXERCISE — HOW TO PAINT A GRADATED, VARIEGATED WASH

To paint a gradation in two colors so that one merges with the other, the lighter tone must first be gradated on wet paper and the other, darker color immediately gradated until both blend in the area where both tones are lightest.

NOTE

So that both colors gently merge together it is important you wet the paper first. Otherwise the transition from one color to the other would be too abrupt.

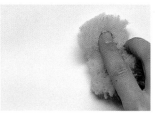

1. First dampen the paper.

2. Apply the lightest color and gradate it.

3. Apply the darker tone and gradate this too. (This may be easier if you turn the board upside down.)

4. The little paint left in the brush must be gently dragged over the paper to blend the colors.

ANOTHER METHOD — A WASH WITH SEVERAL COLORS

Another way of obtaining a wash with more than one color is to apply a wash with the first color and paint the other color over it. For this method it is not necessary to wet the paper first because the first wash already provides sufficient moisture for both colors to smoothly blend together without breaks.

When painting a variegated wash in this way, do not forget that it is best to apply the palest tone first because both colors will blend at their boundaries to create new hues.

1. The background is painted with the paler tone.

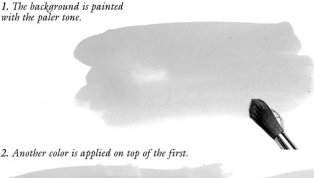

2. Another color is applied on top of the first.

3. More colors can be added [to] this background, even, as show[n] here, with suggestive brushstroke[s.] Variegated washes can ta[ke] numerous forms. The artist ca[n] either blend them smoothly togethe[r] or create sharp contrasts of colo[r.]

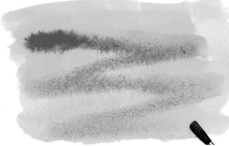

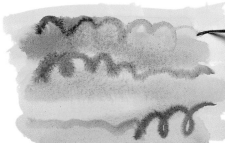

ORANGE AND BLACK

We referred to the wash method of painting in the previous chapter. As we explained, this type of work is not always done merely in monochrome; nevertheless, the best examples are paintings that contain a minimum range of colors.

In this exercise we are going to paint a tuna fish salad with two contrasting colors which, when mixed, will produce a surprising and attractive tonal range.

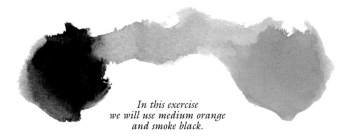

In this exercise we will use medium orange and smoke black.

The subject has a wide chromatic variety that should be represented using only two colors.

. Lay a pale wash for the background; se a darker tone for the shadow of the plate nd pure orange for the carrot and pepper.

2. To paint the peas, mix the two colors to obtain a tone with a hint of green. Use a similar tone to suggest the curved shadow of the plate, reserving the white in certain areas. With a lighter orange, outline the tuna. Pure black is used for the olive and the handle of the fork.

3. Add the other olive and use intermediate tones to suggest the mound of food in the center of the plate. You can define the peas using small, contrasting shadows. Also, retouch the plate and shadow.

. With a light tone, develop the shape of the iece of tuna in the foreground; once more, etouch the shadow of the plate to increase he contrast.

. We now have completed the main shapes of he food on the plate and have set down the redominant tones. The shadow of the plate gain needs retouching to make it more intense.

6. Finally, define the peas on the left and add more detail on the tuna to fully develop its texture. Draw a fine line to indicate the thickness of the plate. Notice how we have concentrated on the darkest section of the painting throughout the entire process: the shadow of the plate. This gradual intensification allows you to experiment with the overall tonal impression without making it too dark from the beginning. You only darken a tone when the motif calls for it.

Three Colors

Without light, color cannot exist. The color of an object is the color of the light it reflects. When we refer to colors, we must distinguish between *light-colors* and *pigment-colors* as they react in totally opposite ways.

LIGHT-COLORS

White light comprises the three primary light-colors: green, red, and blue violet.

As these three primary colors are composed of light, not pigment, mixing them produces more light; that is, other, brighter light-colors.

Combining primary light-colors produces the secondary light-colors: yellow, cyan, and magenta. Superimposing beams of the three primary light-colors results in light's maximum brightness—white light. This phenomenon is called *additive synthesis.*

Additive synthesis: superimposing beams of the three primary colors produces the maximum brightness of light.

PIGMENT-COLORS

Pigment-colors are those the artist uses; because they are not composed of light, combining them produces a totally opposite phenomenon to that of the additive synthesis of light-colors. When dealing with pigments, mixing colors signifies *subtracting* light as pale colors cannot be obtained by mixing dark colors. Quite the contrary, mixing pale colors produce darker ones. So when we blen pigment-colors we are usin *subtractive synthesis.*

The mixture of the thre primary pigment-colors resul in black, or the total absenc of light.

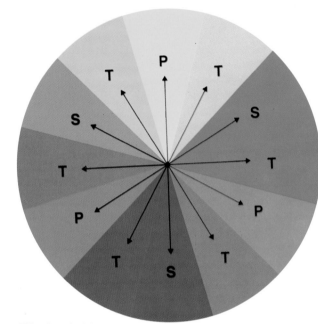

This color wheel shows the three primary pigment-colors: blue, red, and yellow. Mixing these colors produces the secondary colors: green, orange, and violet. Combining the primary and the secondary colors produces the tertiary colors. The colors of this wheel are not exactly the same as those of watercolor paints so the tones are slightly different. Pigment-color designations may vary from manufacturer to manufacturer— as well as from the name used in this book.

PRIMARY COLORS WATERCOLORS

Primary colors are the three basic colors that can be mixed to obtain the entire range of colors that are visible to the human eye. White cannot be produced by mixing because the mixture of pigment-colors acts by subtractive synthesis and produces darker colors.

The primary pigment-colors are blue, red, and yellow. The most similar watercolors to these are cerulean blue, alizarin crimson, and medium cadmium yellow.

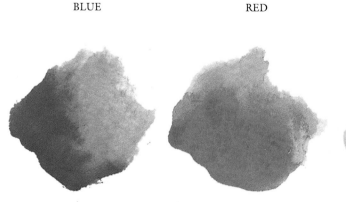

BLUE

RED

YELLOW

CERULEAN BLUE

ALIZARIN CRIMSON

MEDIUM CADMIUM YELLOW

SECONDARY COLORS A MIXTURE OF PRIMARY COLORS

The secondary pigment-colors, green, orange, and violet, are produced by mixing the primaries.

In theory, the resulting secondary colors are obtained by adding each color in the same proportion. In other words, this orange has been obtained by mixing 50 percent alizarin crimson and 50 percent medium cadmium yellow. This is an important fact to remember as different proportions will naturally result in different tones.

Bear in mind that the degree to which the paint has been diluted will change the intensity of the tone, so a highly diluted color may appear to have different hues.

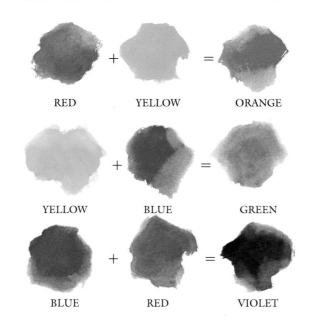

RED + YELLOW = ORANGE

YELLOW + BLUE = GREEN

BLUE + RED = VIOLET

NOTE

The result of a color mixture depends on the proportions used. Adding a larger quantity of one color than another will produce a considerably different result. Remember also that the more a paint is diluted, the lighter is the resulting tone.

It is advisable to experiment with these mixtures before starting to paint in watercolors as they will provide you with important information on how these colors behave.

TERTIARY COLORS A MIXTURE OF PRIMARY AND SECONDARY COLORS

The six tertiary colors are obtained by combining the three primary and secondary colors; the tertiary colors are: yellow-green, blue-green, blue-violet, red-violet, red-orange, and yellow-orange.

In this way, all the colors present in nature can be obtained by mixing the three primary pigment-colors.

NOTE

If you study the colors used for these blends, you will notice that certain combinations are missing. These are the complementary colors that, when mixed, produce gray tones. There is more information about these colors on the next page.

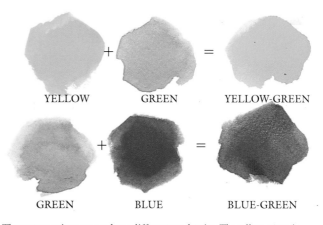

YELLOW + GREEN = YELLOW-GREEN

GREEN + BLUE = BLUE-GREEN

These two tertiary greens have different tendencies. The yellow-green is somewhat warm because it contains yellow. The blue-green has a cool tendency produced by the blue.

Tertiary red-orange and yellow-orange are the warm colors in this group as they are the result of mixing other warm colors.

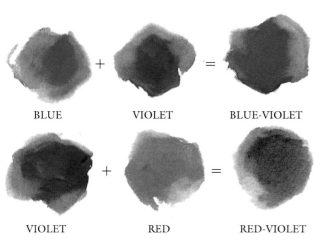

BLUE + VIOLET = BLUE-VIOLET

VIOLET + RED = RED-VIOLET

The cool tertiary colors are blue-violet and red-violet, although the latter is considered neutral because it has a proportion of red, a basically warm color.

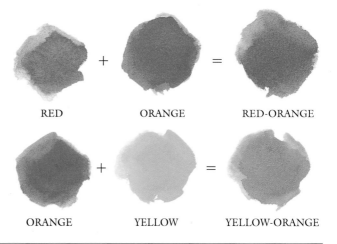

RED + ORANGE = RED-ORANGE

ORANGE + YELLOW = YELLOW-ORANGE

CONTRAST	COMPLEMENTARY COLORS

Complementary colors, or complements, are those that, when juxtaposed, instead of reducing their shine and intensity, mutually intensify each other to produce maximum contrast.

All colors have a complementary color, which is the one positioned directly opposite the first color, and is always composed of a primary color or colors the first one lacks.

If you look at the color wheel you will see that each of the primary colors has a complement and that this complementary color is the result of mixing the other two primaries. That is to say, the complementary color of a primary color is a secondary color. So when two complements are mixed in equal parts, the result is black.

It is worth knowing how to use the complementary colors to achieve the maximum degree of contrast when juxtaposing them and to build a range of neutral colors obtained by mixing unequal proportions of complementary colors.

ORANGE (Secondary)

BLUE (Primar

VIOLET (Secondary)

YELLOW (Primary)

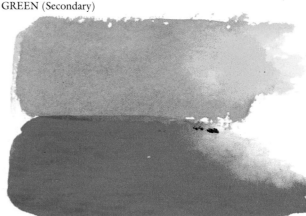

GREEN (Secondary)

RED (Primar

REMEMBER THAT...

- Mixing light-colors means adding light.
- Additive synthesis is the sum of the light produced when mixing beams of light-colors.
- Mixing pigment-colors means subtracting light in a phenomenon known as *subtractive synthesis*.
- White reflects all the light that strikes it and is the sum of all the light-colors.
- Black absorbs all the light that strikes it and is the total absence of light.
- Juxtaposed complementary colors create the maximum contrast of color.
- The complementary color of yellow is violet; of red, green; and of blue, orange.
- Only practice will enable you to master the use of color.
- It is easier to darken a color than to lighten it, so color should be added very gradually when mixing.
- In watercolors, the primary colors are: medium cadmium yellow, cerulean blue, and alizarin crimson.

ALL THE COLORS

We have already said that it is essential to mix colors if we wish to work with a wide range of hues to reproduce the subject accurately.

Apart from being an inevitable part of the technique of painting, mixing colors is also a highly enriching experience.

In mixing, artists discover how each color behaves in relation to the others, how unimagined new tones can be attained, how to arrive at a unique palette of colors that will become a personal characteristic of each artist's work.

It is important to be able to mix colors confidently when painting with watercolors. The medium demands that a painting be completed quickly and with the right degree of moisture; the artist, therefore, must know what to expect of a color mixture and not lose time with too much testing for the work to progress. Do not forget that color can only be mastered through constant practice; mixing colors must become something you can do almost instinctively. A good exercise for beginning to understand how pigment-colors work and for learning how to create oth mixtures is to develop a range colors using the three prima colors. As previously mentione in watercolor painting the co ors that correspond to the thr primary colors are medium ca mium yellow, cerulean blue, a alizarin crimson.

As it is always easier to dark a color than to lighten it (ligh ening it is often impossible before starting remember th to mix the colors successfull the paint should be added a li tle at a time. Otherwise, you ri oversaturating the color, a mi take that can result in an u wanted neutral tone. Gradu additions will also help yo control the intensity of the col and the tonal potential of t mixture.

RANGE	COOL COLORS

Colors are said to have a temperature. This temperature is a value derived from natural light. To understand what this means, simply imagine a landscape at different times of the day. A beach at dawn has a cool light, whereas the same beach at noon will have a warm light.

Cool colors create a sensation of coldness, openness, lightness, and distance.

Cool colors make up half of the color wheel and are basically those with a blue tendency.

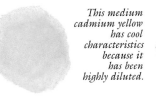

This medium cadmium yellow has cool characteristics because it has been highly diluted.

This cool green has been obtained by mixing equal parts of cerulean blue and medium cadmium yellow.

NOTE

Yellow-green and red-violet also fall into the range of warm colors because both are neutral and, according to the influence of other colors present in the painting, may be warm or cool.

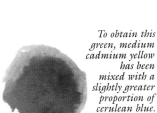

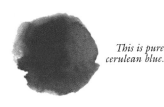

To obtain this green, medium cadmium yellow has been mixed with a slightly greater proportion of cerulean blue.

This is pure cerulean blue.

Intense blue is created by mixing cerulean blue with a little magenta or alizarin crimson.

Mixing equal parts of cerulean blue and alizarin crimson creates this violet.

If we increase the proportion of alizarin crimson in the previous mixture we obtain this red-violet.

This gray has been obtained with a highly diluted mixture of the three primary colors, with a predominance of cerulean blue.

This brown is the same mixture as the violet (equal parts of cerulean blue and alizarin crimson) but with a touch of yellow.

RANGE	WARM COLORS

Warm colors, as their name implies, are those that transmit a sensation of warmth, weight, and nearness. They are the colors of sunlight and of the light in enclosed, intimate spaces. Warm colors make up the other half of the color wheel and they have either red or yellow in them.

Greens and violets that have the same proportion of cool tones as warm ones appear neutral and their tendency will depend on the surrounding colors.

Of the three primary colors, two are warm: red and yellow. The color that contains most light is yellow; red, as far as temperature is concerned, is situated between yellow and blue. This is why yellow and red, are the main primary colors found in the range of warm colors; otherwise, the color would be neutral or have a cool tendency.

Using the three primary colors we show here a small range of warm colors where the dominant tone is medium cadmium yellow.

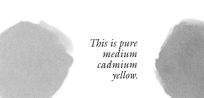

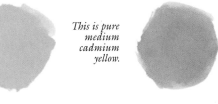

This is pure medium cadmium yellow.

Adding a touch of alizarin crimson produces this brilliant orange.

NOTE

Red-violet, gray, and brown fall into the category of cool colors but can also be considered neutral as they contain the three primary colors.

Increasing the proportion of alizarin crimson we obtain this vermilion.

Increasing the proportion of alizarin crimson gives orange a darker tone.

For this red, equal parts of yellow and alizarin crimson were mixed.

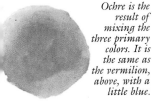

Ochre is the result of mixing the three primary colors. It is the same as the vermilion, above, with a little blue.

Olive green is obtained by mixing cerulean blue and yellow with a touch of alizarin crimson.

This burnt umber is simply orange darkened with blue.

This brown is the result of mixing the three colors in almost equal parts.

RANGE | NEUTRAL COLORS

Neutral colors are created by mixing two complementary colors in unequal parts. They, therefore, contain all three primary colors. Neutral colors are a little difficult to define, but are constantly present in nature.

This ochre was obtained by mixing the three complementary colors. In fact, it is the same ochre as that shown in the warm colors on page 53, but more diluted.

This brown was obtained using the same mixture as for the ochre, but with a predominance of cerulean blue.

Slight increasing t proportion blue the previou mixtu produces th gree

If instead of increasing the proportion of blue in the previous mixture we increase that of the alizarin crimson, we obtain this tone.

This neutral gray was obtained by mixing the three primary colors in similar proportions.

We obtaine this sienn by mixin orange an cerulean blu

NOTE

Ochre, olive green, burnt umber, and brown are warm colors because of the greater presence of yellow; yet, they also fall into the group of neutral colors as they are produced by mixing together the three primary colors.

This tone was created using the same mixture as for the previous color but slightly increasing the amount of alizarin crimson.

The three primary colors mixed in the same proportion produce this violet.

If we ad yellow the previou mixture w obtain th greenish ton

GLAZES | MIXING COLORS

In watercolor painting, the colors can be mixed in different ways. The first, most common method, and also the most likely to produce successful results, is that of mixing colors on the palette. This way allows you to obtain the right tone without running any risks. If the right color does not result from a mix, you need simply clean the palette and try again. Always, first test the suitability of a mixed color on a piece of scrap paper.

Mixing colors directly on the paper is a second method, although an extremely risky one, of arriving at a desired color. We must emphasize that to do this successfuly you need to have great mastery of the technique and know the correct proportions of each color in the mixtures or you might ruin your work or alter its overall tonal balance.

A third method for mixing colors is to use the traditional glazing technique. In the same

way that the tone of a color is intensified by applying a glaze of the same color on top, a new color can also be created by super-imposing a glaze of a different color on the painted background. This, too, is a widely used technique, but it does have its dangers if you are not sufficiently familiar with it. Before starting, it is essential that the background color be dry prior to applying the glaze as otherwise the colors would mix on the paper the same as on the palette. In addition, you have to know the colors well to foresee the final results. Moreover, do not forget that the beauty of watercolor is the sparkle of its transparent colors and too many layers of paint would detract from this effect.

Mixing colors by applying glazes is a technique that can greatly enhance your work, but it should not be overused.

This light burnt sienna wa obtained by applying fairl diluted alizarin crimson ove permanent light green.

SUPERIMPOSING

As we mentioned earlier, in watercolor painting you cannot superimpose a light color over a dark one to lighten it. This technique, however, is employed to obtain a third color or modify the tones of the two colors.

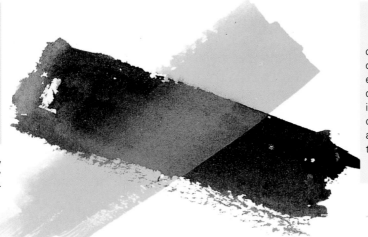

An olive green is achieved by superimposing yellow over Payne's gray.

NOTE

In using glazes for mixing colors, remember that to obtain an even tone it is essential to let the first layer dry completely before applying a second. Otherwise, the colors would mix on the paper and probably result in a small tonal range.

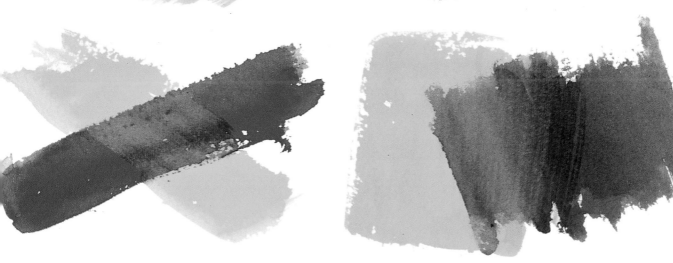

A glaze of medium yellow over cerulean blue creates this permanent green tone.

A dark sienna can be obtained by superimposing yellow over mauve.

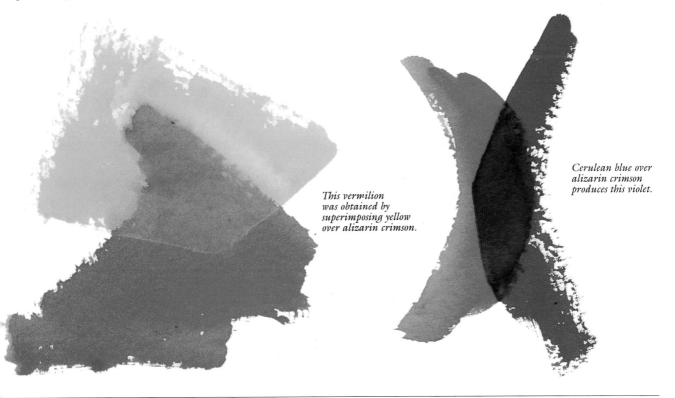

This vermilion was obtained by superimposing yellow over alizarin crimson.

Cerulean blue over alizarin crimson produces this violet.

FIFTEEN COLORS SUGGESTED PALETTE

As mentioned earlier, in theory you can obtain any color using the three primary colors.

Artists do not, of course, limit their palette to these three colors as this would only complicate their work. On the other hand, a palette with too many colors is not practical for several reasons. An artist usually works with a certain number of colors and those he or she does not use take up space in the paint box and can lead to confusion. In addition, there is no range of colors on the market that includes the infinite number of tones existing in nature. So the artist is eventually forced to resort to mixing for obtaining a given tone.

It is advisable for you to select a collection of colors that without being too extensive will permit you to develop a wide range of tones.

Later, as you gain practice and establish your own working style you can enlarge your palette or substitute certain colors with others.

We recommend you start with a palette of fifteen basic colors that will enable you to paint virtually any subject. A typical choice of colors is illustrated on this page.

NOTE

A great many of the colors—for instance, orange—in this palette can be obtained with simple mixtures. Nevertheless, because they are commonly used, buying them already mixed will save you time and palette space.

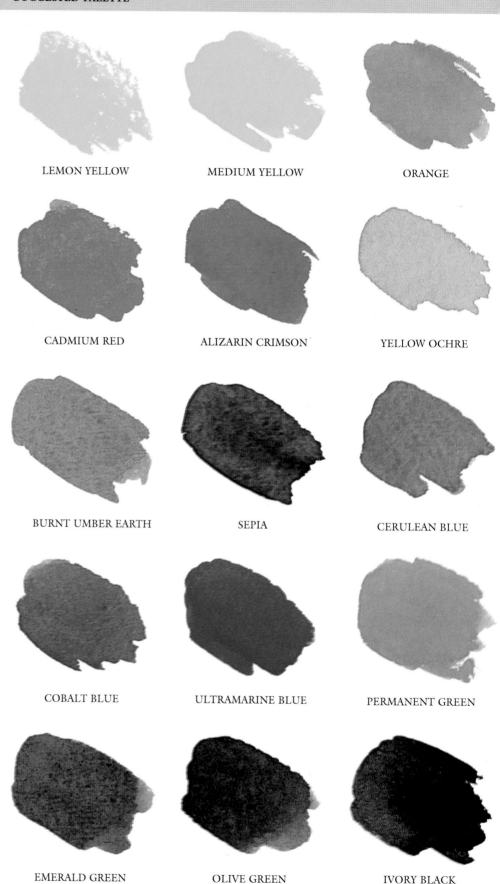

LEMON YELLOW MEDIUM YELLOW ORANGE

CADMIUM RED ALIZARIN CRIMSON YELLOW OCHRE

BURNT UMBER EARTH SEPIA CERULEAN BLUE

COBALT BLUE ULTRAMARINE BLUE PERMANENT GREEN

EMERALD GREEN OLIVE GREEN IVORY BLACK

PRIMARY COLORS EXERCISE IN THREE COLORS

As stated earlier, no artist paints using only the three primary colors; artists need a palette of about fifteen colors. Nevertheless, next, we are going to do a step-by-step exercise using the three primary colors because this is excellent practice for controlling the mixtures and learning how colors behave. In addition to medium cadmium yellow, cerulean blue, and alizarin crimson we are also going to use smoke black. You may wonder why we are not mixing our own black color in this exercise. The reason we are using smoke black for the background is that, contrary to theory, mixing the three primary colors in equal proportions usually results in a dark brown color that is interesting but not purely black.

Pay attention to how the background develops throughout the painting process.

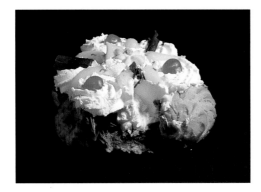

This pastry will serve as a model with an interesting variety of colors.

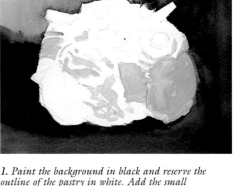

1. Paint the background in black and reserve the outline of the pastry in white. Add the small shadows of the whipped cream with highly diluted gray and neutral green, mix both colors from the three primaries. The ochre in the pastry can also be mixed from the three colors.

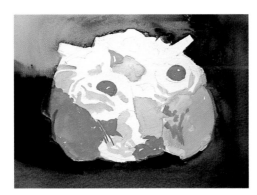

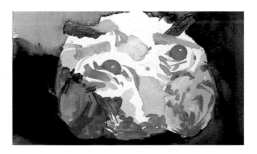

2. Use the same ochre, but more dense and with a touch more magenta, for the shadowy area of the pastry. Paint the cherries and the small central flower in well-diluted alizarin crimson. For the medium green of the leaf, mix blue and yellow.

NOTE

It is advisable to practice using only the three primary colors so as to get into the habit of mixing colors to become familiar with them.

3. Retouch the shadows on the body and the cream of the pastry lightly intensifying the tones. For painting the chocolate curls, mix the three primary colors with a predominance of magenta.

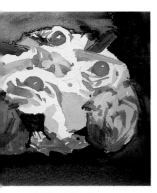

4. Continue to work on the shadows to develop the shape and add the third cherry.

Our artist used this plate as a palette. You can still see the three clean primary colors around the border of the plate and the smoke black that was used exclusively for the background.

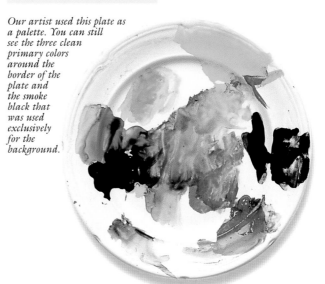

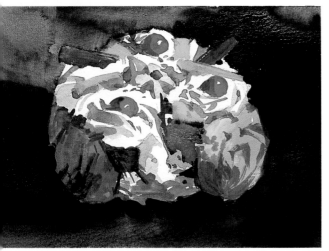

5. Complete the painting by retouching the darkest shadows and putting in details such as the blue spot in the flower at the center of the pastry.

Wet and Dry

Although watercolor is a wet technique by nature because the paint is diluted in water, we should distinguish between *wet-on-dry* and *wet-on-wet* watercolor techniques. The first consists of applying new washes over previous ones after they have dried; and the second, of applying new colors before the previously laid ones have dried. These two techniques produce very different results and each can be adapted to different subjects in such a way that both can be used within the same work.

the right amount of paint with the brush. If you are preparing the colors in cups, make sure to prepare enough to cover the entire area you wish to paint. It is preferable to prepare more paint than is necessary, because if you mix too little paint, you will have to stop to make more. During this interruption, the painted area will undoubtedly dry and when you resume painting you will create hard edges.

Correcting hard edges in dr watercolor is not always possi ble. The procedure is simple bu cannot guarantee success be cause the result depends on hov wet the paint is when correct ing, the type of pigment used and the quality of the paper. A we mentioned in an earlier chap ter, there are certain pigment with a great dyeing capacity a well as watercolor papers on which it is not easy to make cor rections. In any case, there i always a chance of smoothing out a hard edge.

WET-ON-DRY WATERCOLOR

Wet-on-dry technique is the classic way of building up tones in watercolor. The dry method of painting yields well-defined and precise contours and sharply edged color boundaries. Forms appear clearly outlined and the brushstrokes and changes of tone are quite visible with this technique.

Do not forget that watercolor is a water-based medium and any excess or lack of moisture can play an important role in the final result of a watercolor painting. The artist must, therefore, maintain constant control of the dampness of the paper not only in the wet-on-wet but on the dry method as well.

Painting wet-on-dry, the paper absorbs the paint easily, is impregnated with it, and dries quickly. This is why gradations on dry paper are more difficult to achieve as hard edges may appear. On the other hand, watercolor paint is easier to control on a dry than on a wet surface.

WHAT ARE HARD EDGES?

In watercolor painting, a hard edge may form when a brush-stroke of the same color, or a different one, is applied over a previously painted area that has already dried. The result may be an intensification of the color or an abrupt variation of the tone. A hard edge is really an un-wanted glaze that breaks up the gradual transition of a tone. At times, hard edges can suggest unintended contours. An artist, how-ever, may purposely use this effect to insinuate vol-ume, shadows, or irregu-lar surfaces.

To avoid unwanted hard edges in your work, it is neces-sary to paint quickly and pick up

A hard edge is an abrupt change in tone. When not intended, this effect generally occurs when the first brushstroke is allowed to dry before applying the second one.

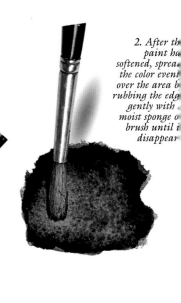

1. One way of correcting a hard edge is to wet the area slightly with water, preferably before it has dried, and wait for the paint to loosen up.

2. After th paint ha softened, sprea the color event over the area b rubbing the edg gently with moist sponge o brush until i disappear

3. The result of this correction will not be apparen until the paint has dried. In the illustration, th hard edge has virtually disappeared; nevertheless, yo will notice how the paint has collected around th outline of the patch due to the moisture. To preven this from happening, take up the accumulate. paint with the brush before it drie.

WET-ON-DRY WATERCOLOR

PAINTING ON DRY PAPER

Here is a wet-on-dry exercise that will let you see how sharply the forms are outlined, how intense the colors are, and how glazes can build up the darker tones.

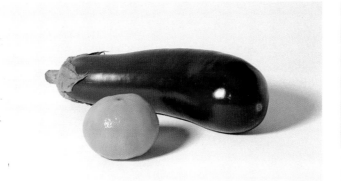

1. First, apply the darkest colors to the dry paper. Note that the paint stays where applied because the dry surface does not allow the pigment to spread.

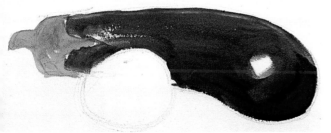

2. Paint the tangerine and apply a glaze with a darker tone for the shaded area of the fruit. With glazings in darker tones also suggest the texture in the stem of the eggplant and the part of the fruit that is shaded. Notice how the colors do not blend together and are abruptly divided.

NOTE

For superimposing glazes, it is essential to use the wet-on-dry technique; otherwise, a wet surface would cause the two colors to merge on the paper yielding quite different results. See Wet-on-Wet Watercolor, page 60.

We are going to paint this simple still life of a tangerine and an eggplant with the wet-on-dry technique.

MORE . . .

Another method for erasing hard edges is to remove all the paint from the area and wait for it to dry before repainting it. For how to remove color from dry paper, see pages 69 and 70.

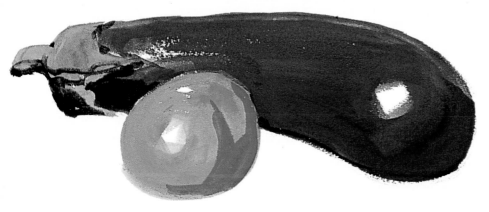

3. Detail of the superimposed glazes used to intensify the tones.

WET AREAS

When painting wet-on-dry, there may be parts of the subject that need to be painted wet in wet—such as a group of trees enveloped in mist, a cloud, or reflections in water. To combine both these techniques, simply wet the paper on the areas to be painted wet-on-wet and leave the rest dry. To wet small or intricately shaped areas, it is best to use a clean, finely pointed brush and clean water.

4. To finish, paint the remaining details: the cast shadows of the tangerine and eggplant on the surface and the shaded areas of the fruits. (Work on these areas before the paint dries to blend and soften the color edges so the subjects look more realistic.)

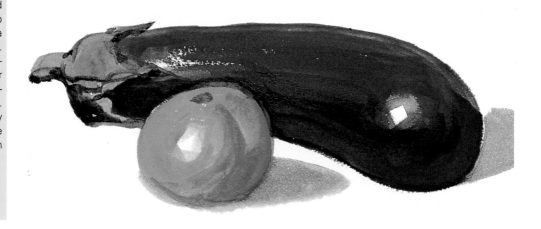

WET-ON-WET WATERCOLOR

Wet-on-wet is the technique of painting with watercolors on a support dampened with water. That is, paint is applied to a painted surface that has not yet dried or to blank paper that has been dampened prior to painting.

The results of this wet technique are quite different from those obtained using the dry method. On a wet surface the brush slides easily and the paint runs and spreads out freely in all directions. Unpredictability, to a certain extent, is a built-in feature. As the pigment spreads, the color fades and the outlines of the brushstroke become fuzzy and unclear. This produces a vaporous effect in which the forms are not clearly separated because the colors merge into each other.

DEGREE OF MOISTURE

The amount of moisture present in the paper that is to receive the paint is an important factor that can change the result completely.

The paper can be dampened slightly with a sponge or brush, or thoroughly soaked under a faucet. The method you use will depend on the desired degree of moisture. Remember that the wetter the paper, the more the pigment will spread and result in larger patches of color with vague and fuzzy outlines.

The appropriate degree of moisture for the wet-on-wet method, therefore, depends entirely on the individual preferences of the artists and the results they want to achieve. Some painters feel that paper that shines, when you look at its surface from an angle that catches the light, is too wet. By comparison, other artists prefer to soak the paper.

Additionally, the type of paper used and environmental factors, such as the light source and the heat, have a direct effect on the amount of water required for working wet in wet and on the length of time the paper will retain the moisture.

Naturally, the degree of moisture is not constant but decreases as the water evaporates. External light sources such as sunlight or a powerful spotlight can speed up the drying process. So when painting on wet paper it is necessary to continually assess its dampness and add or remove water in accordance with the desired effect.

To add moisture while painting, a clean brush is generally used as it is more precise than a sponge. It is important to use clean water and a brush that is completely free of paint to maintain the purity of the colors.

Only practice will enable you to control the amount of water that best suits your style. To become more familiar with this technique and better understand how it works, we suggest you try it out on a piece of scrap paper (use paper you have discarded but still has one side unpainted, for example). Until you gain experience with how watercolor paint behaves on wet paper, the results will always be uncertain.

Another aspect of wet-on-wet results requires practice. You will notice that the diffusion of the pigment diminishes the intensity of the color. There is a marked difference between the values of dry and wet paint and only experience will enable you to foresee the result of a color after it dries.

Wet-on-wet technique is ideal for painting skies and for recreating the volume and vaporous quality of clouds; gradations are also more easily attained.

Some work may require a combination of the wet-on-dry and wet-on-wet methods. Say the overall effect of a given painting demands working on wet paper, yet there are certain areas that need well-defined outlines. To achieve this effect, simply maintain these areas dry or wait for them to dry before working on them.

MORE . . .

If there is too much water present, you can wait until some of it evaporates. To save time, however, many watercolorists remove the excess water with a brush that has been dried on a cloth, with a sponge, with paper towels, or with blotting paper, etc.—in other words, the same instruments used for removing color from wet paper. See pages 67 and 68.

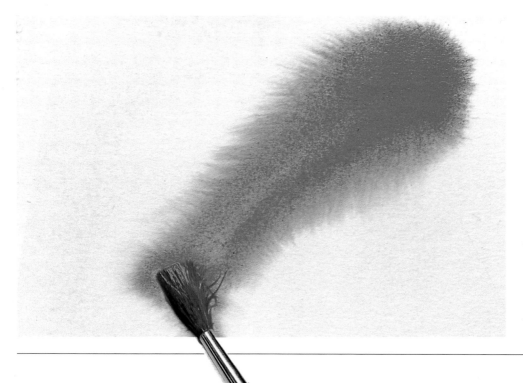

Applying a brushstroke to a predampened piece of paper will let you feel the paint glide easily on the surface and show you how the pigment continues to spread out on the paper after removing the brush from the surface. The color will stop running as the paper dries with the evaporation of the water, which is what allows the pigment to diffuse.

WET-ON-WET WATERCOLOR PAINTING ON DAMPENED PAPER

Next, you are going to paint the same still life as before but with the wet-on-wet technique. You will see that, in this case, tones cannot be intensified by applying glazes.

NOTE

With the wet-on-dry method you need to work quickly and prepare enough paint so as to avoid hard edges.

By comparison, when applying paint to a wet surface, the results will always be unpredictable, although experience will let you gain some control over the process. When painting wet-on-wet, you must try to foresee how the pigment will spread. The damper the surface of the paper, the more the pigment will spread out.

Both, wet and dry, methods of painting can be combined in the same work.

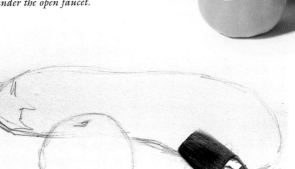

1. First, wet the paper. Here, we have used a brush for this, but you can also use a sponge. If you want to soak the paper thoroughly, hold it under the open faucet.

3. Now add the tangerine as well as the stem of the eggplant. Has the paint of the eggplant diffused on your paper? Here, it has made this patch of color considerably larger.

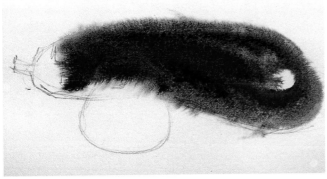

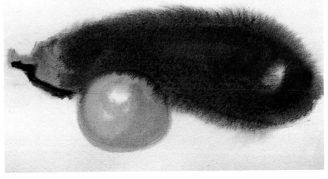

2. Apply the darkest tones first. Note how the brush slides easily over the surface due to the moisture, and the paint begins to spread out on its own.

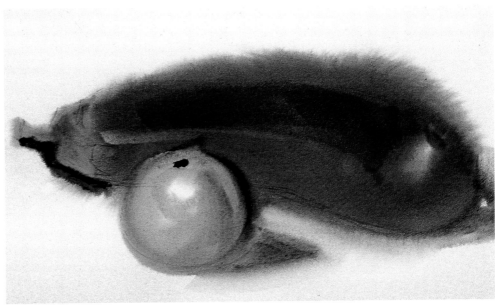

4. Last, paint the cast shadows and retouch the shaded areas of both forms to give them volume. If you look at the illustrations in quick sequence, you will see how the stain of color for the eggplant has continued to spread out to the very last image. This occurred because this part was damper than the rest of the paper. The tangerine, although also slightly enlarged, is not as exaggerated.

White

As already mentioned, in watercolor technique you build tones from light to dark. The layers of paint are superimposed starting with the palest colors that can later be darkened as necessary. This requires planning your work in advance—knowing what you are going to do and how and where you are going to begin. The lightest and most delicate color of all is white, and it should be the first one you take into account.

As a transparent medium, watercolor does not generally use white paint as it is not a pure color. In its place, traditional watercolorists use the white of the paper. This is why it is necessary to plan and organize the work before you actually start.

TWO METHODS

Basically, two methods exist for using the color of the paper. One is to mask certain areas; the other, to open white areas in the paint you have already applied by lifting out some of the color. The first method produces the purest, cleanest, and most intense white because it preserves the color of the paper itself. The second can be used to correct mistakes and create effects.

The white of the paper can be used to suggest the color of a wall or of the petals of a flower, for example; reserving white areas is also a way to create effects such as highlights on seawater, on a bottle, on a piece of fruit, wet skin, and so on.

Creating white areas by lifting out color requires rubbing the paper. If this technique is to work, therefore, it is important to use quality paper with a good size that will not deteriorate during the process. The artist can then retouch, and even repaint the work if necessary.

RESERVES

In watercolor painting, a *reserve* is an area of the paper left unpainted to use the white of the paper as a color in itself. Reserving involves deciding which areas of the painting are to retain the color of the paper—say, for creating highlights or the wall of a house—before you start work. Reserves can be realized in different ways.

RESERVES | DURING PAINTING

A large part of a good watercolorist's skill lies in his or her ability for planning the work in advance and for painting around the reserved white areas, giving them shape as the work progresses.

1. Paint carefully around the areas you want to reserve.

2. Use the white of the paper to outline the shapes of your objects.

RESERVES | USING MASKING FLUID

Some reserved areas, however, may be so complicated or restricted—long fines lines, for instance—that they may prevent artists from painting quickly and freely for fear of "invading" the spaces they need to leave white. Such cases, call for the use of masking fluid.

Masking fluid is a liquid substance you can apply to the paper to protect the reserves, and you can easily remove it after it has dried. Because it is impermeable, masking fluid will prevent the

This is what a brush ruined by masking fluid looks like after the fluid has dried on the hairs.

paint from coloring the paper in the areas protected by it.

Generally, masking fluid is applied with a brush and is either allowed to dry naturally or is dried with a hair dryer to save time. The fluid is usually gray or cream colored. Although transparent masking fluid is sold, it is not commonly used because it is hard to see. Take into account that, whatever color the mask is, it will interfere with the tonal balance of the watercolor, so you need to remember what the true color of the reserved shape will be.

If the area has been well masked, you can paint safely on top of this substance because it repels water and the paint cannot filter through. Moreover, the area you have treated will be clearly visible.

Masking fluid can also be used on already painted areas, but the paint needs to be completely dry. Even so, there is a risk of the fluid removing some of the color. You can paint safely on any area that has been masked with fluid.

Bear in mind that, depending on the quality of the paper, you can damage it when removing the dry fluid. It is best to remove the fluid as soon as the paint is dry because if it is left on the paper for days it can be extremely difficult to remove.

Use an old brush or an inexpensive synthetic one for applying the masking fluid because small particles of dry fluid always remain in the hairs of the brush and can accumulate around the ferrule, thereby spoiling it. Otherwise, protect your brushes: Beforehand, rub the hairs on a bar of soap; then, wash them as soon as you finish using tepid water and more soap. Never let a brush soaked in masking fluid dry. Even when you use an old brush you must wash it between applications.

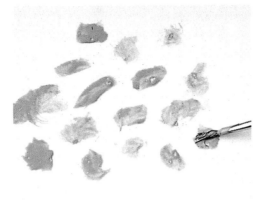

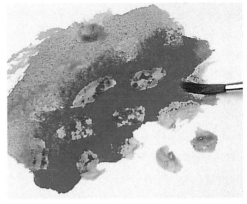

1. Dip an old brush into the masking fluid.

2. Apply it over the area to be masked shaping the whites as if you were painting. Then wait for it to dry or speed up the process with a hair dryer.

3. Now you can paint freely as the impermeable mask will not let the wet paint through in the reserved areas.

4. After the paint has dried, it is best to wait until the last moment to remove the dry mask so as not to spoil the white. You can simply rub off the mask, gently, with an eraser taking care not to erase the adjacent colors. If there are any, you may also remove the pencil lines at the same time.

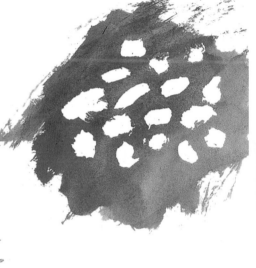

5. With the mask removed, you can see how the color of the paper remains intact. In applying the masking liquid, you can let an odd brushstroke break up a straight line or leave hair marks. Brushmarks made with masking fluid can be as expressive as those done with paint.

A very fluid wash can sometimes form pools around the masked area or in other places; it can be interesting to let these denser areas of paint dry to sharpen the contrast and outline the masked area.

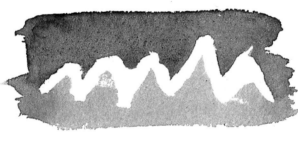

RESERVES — USING A NIB

When the outline of the area to be masked is too convoluted for using a brush, a nib can be ideal for masking fine or intricate lines. The brush can then be used to fill in the larger areas with masking fluid.

3. Paint over the area.

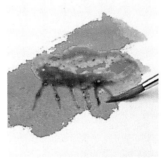

NOTE

Remember that the color of the masking fluid can temporarily alter the overall tonal balance of the work.

Do not remove the dry fluid before you have finished painting or you may dirty the masked area; neither should you leave the dry masking fluid on the paper for too long as it can become difficult to remove.

Use gentle pressure to take off the dry mask to avoid spoiling your work or damaging the paper.

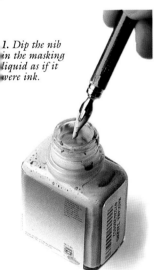

1. Dip the nib in the masking liquid as if it were ink.

2. Draw the details with the nib as you normally would. Bear in mind that the mask is a thick substance and the nib will not glide as smoothly as it would with ink.

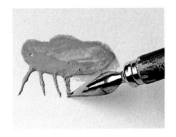

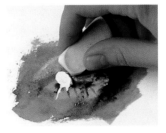

4. Wait for the paint to dry. After, you can rub off the mask gently with an eraser. Note that, here, the masked area is free from paint and has sharp and perfectly defined lines.

RESERVES

USING WAX ON FINE-GRAIN PAPER

As wax is an oily substance that repels water, it can be useful for masking reserved areas. This wax-resist technique, however, is mainly employed to create texture, pattern, and other imaginative effects.

You can use anything from a wax candle to special wax pencils of the color you think most suitable. For white areas you should, of course, use a white pencil or crayon.

The procedure involves, first, covering the area to be masked with a wax pencil and, then, applying the watercolor wash. Wax is difficult to remove once it has been applied so it is important to plan where you are going to use it and draw the lines accurately. The effects produced by wax vary according to the grain of the paper and the pressure you apply when drawing with it.

Areas masked with wax on fine-grain paper are better defined and more compact.

1. First, draw on the fine-grain paper with the wax.

2. Then apply the paint as usual, without repeating your strokes excessively.

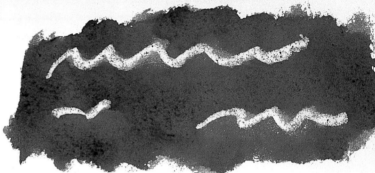

3. You can see, here, how the wax repels the moisture although some tiny droplets of paint do remain on the surface. These lines are well defined because they have been drawn by bearing down on the wax and also because the surface of the paper is smooth.

RESERVES

USING WAX ON COARSE-GRAIN PAPER

On coarse-grain paper wax deposits only on the ridges of the grain, giving you the option of filling the unwaxed troughs of the surface with watercolor. When masking with colored wax, you need to remember that watercolor paint is transparent; it will, therefore, allow the wax color to show through when applied. Nevertheless, this effect can actually be used to advantage in painting such things as shadows or blades of grass and in suggesting the texture of any rough surface.

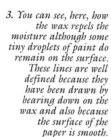

1. Draw your lines with colored wax on the coarse-grain paper.

2. Paint over the waxed area as you normally would.

NOTE

Wax does repel water, but use it with caution. After repeated washes, the wax can absorb part or even all of the paint.

Wax requires that you plan your reserves beforehand because it can be difficult to remove after it is applied to the paper.

3. The transparency of the watercolor and the repellent feature of the wax allow the wax colors to emerge. Note how the rough surface of the paper results in wax lines that are broken and interspersed with watercolor.

4. Unlike masking fluid, wax cannot be removed once it has been applied. The most you can do is try to scrape it off the surface with a razor blade; even then, some wax will always remain.

RESERVES

USING GOUACHE

Gouache or tempera can be used instead of masking fluid, although it is more laborious and cumbersome to apply. The results are also slightly different.

Paint the areas you want to reserve with gouache. It is best to use white gouache or a color similar to that of the paper because small traces of this paint usually remain after removing it.

1. Dip the brush into white, or Chinese white, gouache.

2. Paint the required shape with the gouache and wait for it to dry.

3. When the masked area has dried, you can begin to paint carefully so as not to displace the gouache and stain other parts of the paper.

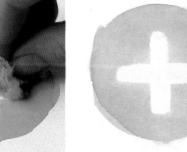

NOTE

When applying the watercolor paint over the gouache, be careful not to press too hard with the brush, otherwise the gouache will dissolve and muddy the color. Also, take into account that the sponge used in removing the gouache will also rub off part of the watercolor paint so apply a more intense tone than you actually need.

4. Wet the sponge slightly before using it to remove the gouache.

5. When the watercolor has dried, remove the gouache with the damp sponge. With this step, it is inevitable that you will drag some of the paint surrounding the reserve.

6. The result is a perfect outline of the masked shape.

RESERVES

USING MASKING TAPE

Masking tape can help enormously when reserving areas with straight lines, such as the wall of a building or the sidewalk of a street, especially when the unmasked area is to be painted in a series of darkly toned washes. The only trouble with this tape is that its color is distracting when assessing the overall tonal balance of the painting.

This tape can be removed as soon as you have finished, but be careful. When the barrier is removed, wet watercolor may spread into the reserved areas.

Masking tape can tear poor-quality paper if it has adhered too firmly. Even if the paper is of good quality, do not leave the tape for longer than is necessary as it could leave traces of glue.

NOTE

Do not expose masking tape to heat sources—such as sunlight or strong artificial lights—because the glue will stick to the paper and traces will remain when the tape is removed.

When working with wet-on-wet watercolor, wait until the paper has absorbed the moisture before taking off the tape; if the tape is removed any earlier, the paint is free to expand over the masked area.

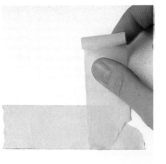

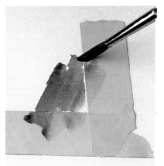

1. Use the masking tape to outline the desired shape on the paper.

2. Paint as you normally would, and wait for the paint to dry a little.

3. Remove the tape carefully making sure not to tear the paper.

4. Now you have well-defined, straight lines.

RESERVES · USING PAPER

A plain piece of paper can be used for masking, especially if the area to be covered is a large one.

The paper can be cut to obtain well-defined forms or torn to produce irregular shapes such as the horizon of a landscape, for example.

1. Place the paper you are using as a mask, or stencil, on top of the watercolor paper.

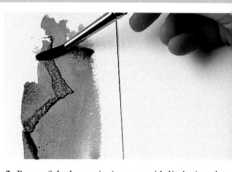

2. Be careful when painting to avoid displacing the stencil.

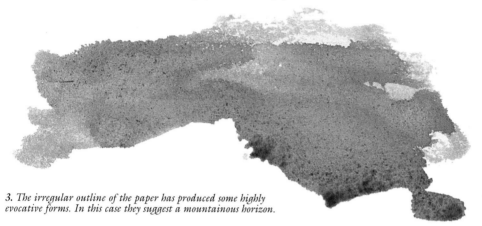

3. The irregular outline of the paper has produced some highly evocative forms. In this case they suggest a mountainous horizon.

NOTE

When working with large formats, attach one piece of paper on top of another with adhesive tape to fix it in place.

Any type of paper can be used for this masking method, but the paper should resist water well and not disintegrate.

RESERVES · USING GUM ARABIC

Gum arabic dissolved in an equal part of water or applied directly with the paint reduces the adherence of the paint. This characteristic of gum arabic makes it suitable for the removal of paint already applied to an area.

This method for lifting out paint to create highlights or other light effects involves adding gum arabic to the paint you intend to remove or modify. (When dry, a layer of this mixture of gum and paint is slightly shiny; this gloss is produced by the gum arabic.) To remove paint that has dried on the paper, rewet a small area with a brush dipped in water (a damp sponge may be better for lifting paint out of large areas). Then, with a paper towel lift the water along with the loosened particles of paint off the surface.

This technique is useful for creating effects of light and shadow—for example, to suggest the dappled light in the foliage of a tree.

1. Dip the brush into a little gum arabic.

2. Next, dip it into the desired color.

3. Paint the area that will later be lightened.

4. Now dip the brush into clean water.

5. After the paint has dried, dampen the parts where the color is to be removed. The water partially dilutes the paint on the paper and loosens the pigment particles.

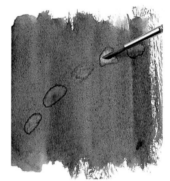

6. Wait a few seconds for the water to soften the paint and absorb the moisture with a paper towel.

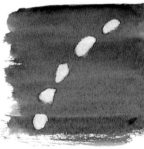

7. Here, this technique opened up small areas that let the white of the paper show through.

LIFTING OUT PAINT

Lifting out color means removing paint in an attempt to open up areas that let the color of the paper show through. Unlike reserves made with masking fluid that preserves the purity of the color, in this technique, the paper is first painted and then cleaned.

The success of this method depends on the quality of the paper and the color to be removed because there are pigments (almost every type of green, for example) with a great staining capacity that are difficult to remove. If you use quality paper and follow the procedure properly, you can obtain a white as pure as that of the paper. This, however, is not usually what the artist wants from this method; the whites and highlights obtained by lifting out color are softer and more subtle than the effect achieved with masks. Whites can be opened up as you work, with the paint either wet or dry.

Aside from being a good method for making corrections, the techniques described here can be used for obtaining gradations and producing different tones.

Obviously, clean water and clean brushes are essential for the success of this technique.

LIFTING OUT WET PAINT — WITH A CLEAN BRUSH

Opening whites on wet paint is basically accomplished by absorbing some of the paint before it has dried. Different tools can be used for this, from the brush itself to a piece of blotting paper.

You need a clean brush to lift out the paint; it can be the brush you are already using, but rinsed in clean water and blot-dried on a piece of cloth. This method is always more effective on fine-grain paper because on coarse-grain paper the paint collects in the surface's small troughs and is more difficult to lift out.

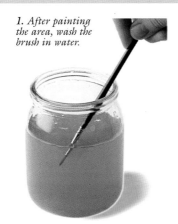

1. After painting the area, wash the brush in water.

NOTE

Do not use a dirty brush for lifting out paint because you would obtain the opposite effect. A dirty brush could only stain the paper.

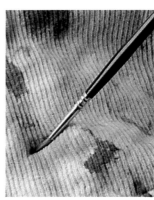

2. Use a piece of cloth to blot the water from the brush.

4. Here, the white of the paper shows through the paint, although with a soft hint of the color that covered it before removal.

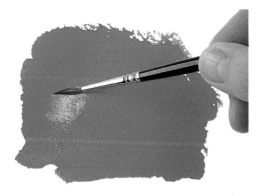

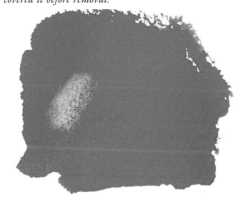

3. Next, use the brush to retouch the painted area trying to lift out some of the paint. If you want to remove more color, wash the brush again and repeat the process as often as necessary. With sufficient effort, you can obtain an almost perfect white.

LIFTING OUT WET PAINT — WITH A SPONGE

You can obtain similar results by removing the paint with a natural or synthetic sponge. The difference between using a sponge and a brush is that the sponge leaves a different mark on the paper and the outlines are not as well defined as with the brush. In addition, it is not easy to use and is not suitable for detailed work, but it is highly practical when dealing with large areas.

The sponge should be free of all paint before starting work and should be rinsed out each time you repeat the process.

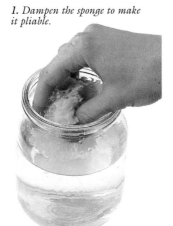

1. Dampen the sponge to make it pliable.

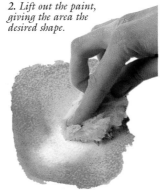

2. Lift out the paint, giving the area the desired shape.

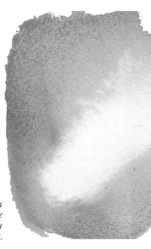

3. A sponge makes it possible to obtain whites as pure as the one shown here because you can press it down gently against the paper to remove the pigment.

TECHNIQUES IN WATERCOLOR

LIFTING OUT WET PAINT — WITH A COTTON SWAB

A cotton swab can be used like a brush and blotting paper at the same time. Always try to keep some swabs handy for making corrections and for detailed work. They can only be used once because they cannot be cleaned. If you need to use repeated strokes on a certain area of the paper you will, therefore, need several.

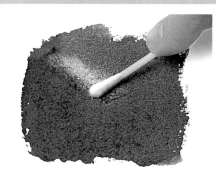

1. Gently rub the cotton swab over the surface of the paper to lift out the west paint and at the same time create the desired shape.

2. Removing paint with a cotton swab will not usually produce a pure white but rather a white with a hint of the previously applied pigment.

LIFTING OUT WET PAINT — WITH ABSORBENT PAPER AND BLOTTING PAPER

Absorbent paper—in the form of disposable paper towels and tissues—and blotting paper are both useful for removing paint from the surface of a painting. Blotting paper is more absorbent but both can be used imaginatively to create different effects.

Paper towels and tissues are soft and can be easily crumpled or folded to create a handy tool of a desired shape and size.

Blotting paper is tougher and draws more moisture but is not as flexible nor as easy to handle as absorbent paper.

NOTE

To create textural effects do not press down too hard on the paper or you will be removing all the paint and be left with the white of the paper.

The same cotton cloth you use for wiping brushes can serve as a tool for this purpose.

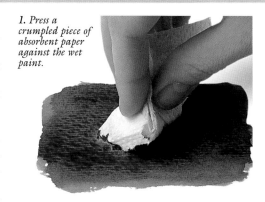

1. Press a crumpled piece of absorbent paper against the wet paint.

2. This type of paper creates a textural effect that can suggest certain vegetation or, in a blue background, clouds.

1. With blotting paper, you need to apply some pressure to make it absorb the wet paint.

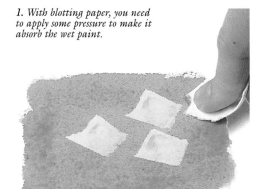

2. The result you obtain will depend on the degree of pressure you apply and the shape of the piece of paper you use to remove the paint.

LIFTING OUT WET PAINT — WITH A CREDIT CARD

A credit card or any similar hard and rigid plastic card can be used to drag the paint across the paper as with a squeegee. With it, you can slide the paint horizontally and vertically or draw lines, circles, and semicircles. For instance, a landscape of tilled fields is easily created with this instrument.

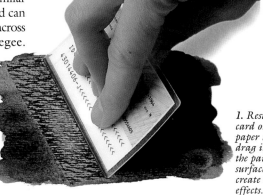

2. A card is useful for creating geometrical patterns consisting of straight lines. The texture obtained here might suggest the trunk of a palm tree.

1. Rest the card on the paper and drag it across the painted surface to create different effects.

LIFTING OUT WET PAINT — WITH OTHER OBJECTS

Any object—your fingernail, the handle of a brush, a toothpick, comb—can be used for removing wet paint from the surface of he paper.

1. A brush with a beveled-edge handle has been designed to remove paint when wet; the handle of any other type of brush could also be used for this work, however.

NOTE

When lifting out color by scraping a line on the wet paint, wait a short time to allow the moisture to evaporate a little. If you scrape off the color while the paint is still fluid, it will be able to spread over the area again. Moreover, because your scraping will have also removed the size on the surface of the paper, the color will be able to penetrate deeper.

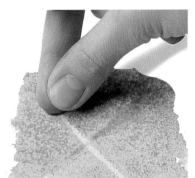

2. Note the difference in the lines illustrated here. The darkest ones were made when the paint was too wet so the color spread over the line again; also, because the size of the surface was scraped off by the brush handle, the paint soaked into the paper and darkened the tone. The lighter lines were made with just the right amount of moisture.

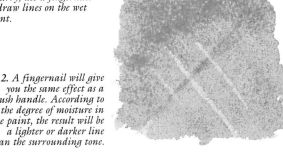

1. When you do not have the right object at hand, or when you are working in a hurry, use a fingernail to draw lines on the wet paint.

2. A fingernail will give you the same effect as a brush handle. According to the degree of moisture in the paint, the result will be a lighter or darker line than the surrounding tone.

LIFTING OUT DRY PAINT — WITH BRUSH AND ABSORBENT PAPER

With watercolor paint, it is better to make corrections or color modifications while the paint is still wet. Otherwise, creating a gradated effect can be much more complicated. After the paint has dried, however, obtaining different hues, reducing the intensity of the colors, and even opening up pure whites are not such difficult tasks. Nevertheless, the technique of lifting out paint when dry does require a lot of care.

Success depends to a large extent on the type of paper you are using. Paper of poor quality could easily disintegrate during the process.

For opening up white areas on dry paint, dampen the surface with a brush and then remove the paint with absorbent or blotting paper.

3. Lift out the paint with absorbent or blotting paper and repeat the procedure until you obtain the right tone.

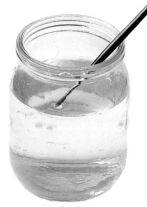

1. Dip the brush into clean water.

2. Wet the area with the brush to dilute the paint; dampening will make the paint easier to remove from the paper.

4. The result will depend on the number of times you repeat the process and the staining capacity of the pigment you used.

LIFTING OUT DRY PAINT — WITH A BRUSH

You can also lift out paint using only a brush. The procedure is similar to the previous one, but here you do not use absorbent paper. You simply wet the area, wait for a few seconds and remove the wet paint. With this method it is best to use a synthetic-hair or bristle brush as they are tougher and more effective at removing the paint.

1. Load a clean brush with clean water.

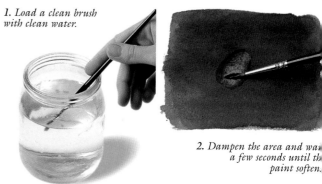

3. Rub off the paint with the brush. Repeat Steps 1 to 3 until you have the desired tone.

2. Dampen the area and wait a few seconds until the paint soften.

4. If you are careful with your brushwork, you can create shapes with a clear outline.

NOTE

Of course, lifting out paint when dry with only a brush is more work than doing it with the help of absorbent paper. Additionally, using paper also results in a purer white.

5. To achieve an even purer white you can add an equal part of bleach to the water used for removing the paint; however, it will be more difficult to create gradated transitions because the bleach will produce a hard edge. Additionally, it is preferable to use a synthetic-hair brush as bleach can damage natural hair.

LIFTING OUT DRY PAINT — SCRAPING WITH A BLADE

Removing paint by scraping inevitably involves spoiling the surface of the paper, if only slightly. It is, however, an excellent method for creating certain effects when the paint is dry. It also allows you to paint over the scratched areas to alter the white.

You can use a knife, blade, or even a nib to scrape the surface and remove the paint.

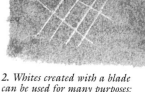

1. Begin scraping the surface of the paper gently, until you find the right pressure for removing the paint down to white without damaging the paper.

2. Whites created with a blade can be used for many purposes: to create the effect of grass, for example, or suggest the structure of a window.

1. A knife can also be used to gently remove small areas of paint to let the white of the paper show through.

2. If you are careful and patient, the results will be satisfactory and the correction will not be apparent.

1. You can obtain an interesting effect by scraping the surface with the entire edge of a blade.

2. The result is similar to that obtained with sandpaper. Coarse-grain paper yields the best results with this method.

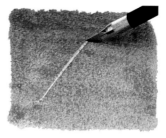

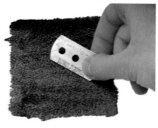

LIFTING OUT DRY PAINT

By scraping the watercolor paper gently with sandpaper, you can remove the color when dry or lighten the tone to paint over it. This technique lets you create effects such as the reflections of light on water. The texture of the paper is important here because with coarse-grain paper, the paint will remain in the troughs and you will only be able to remove it from the ridges. The result also depends on the type of sandpaper you are using. Fine sandpaper will produce an even effect, whereas coarser sandpaper will remove more paint and leave more paper visible. Remember to control the amount of pressure you apply on the sandpaper; if you rub too hard, you could damage the paper and, therefore, the painting.

NOTE

Do not rub hard on the watercolor paper as it is delicate and tears easily. The results will depend both on the texture of the watercolor paper and on the coarseness of the sandpaper you use.

USING SANDPAPER

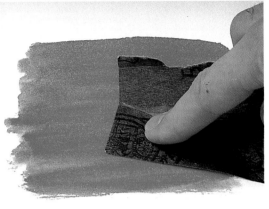

1. On fine-grain paper, rub gently and control the degree of pressure you apply until you obtain the desired effect.

2. Here, the paint has been removed from the ridges of the fine grain; the coarseness of the sandpaper has produced small lines and gashes.

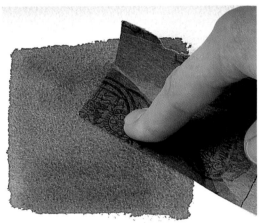

1. Coarse-grain paper is more resistant than fine-grain, so you can rub with a little more pressure.

2. The result is a textured effect, which can be used to suggest light reflecting on water, for example.

WHITE BY OTHER TECHNIQUES

You can also use other techniques to create whites and highlights. In theory, when painting in watercolors, these methods should only be used as a last resort. We are referring to using gouache, white watercolor pencils, pastel, and any other material similar to watercolor to add small touches of white to the work once it is almost finished. We say "small touches" because these other media are opaque, and when you are working with transparent watercolor, the contrasting densities would be too noticeable and would spoil the overall balance of the work if too much is used.

GOUACHE OR CHINESE WHITE

1. Load the brush with a little gouache or Chinese white.

NOTE

Large areas should not be treated with white paint or other opaque media as it would create too great a contrast with the transparency of the watercolors and unbalance the entire work.

2. Paint in the small white areas or highlights.

3. It is best to use these additional techniques in only small spots such as these.

Tricks of the Trade

Many professional watercolorists simply use paint, a couple of brushes, and a jar of water. This is because they have mastered this technique, work quickly, and prefer to work in an orthodox manner.

Purists aside, a series of tricks exists that can be very interesting to the beginner because they provide great potential for creating interesting textures.

USING UNTRADITIONAL TECHNIQUES

Besides enabling us to experiment with the paint and create effects, experimental techniques can often help us to correct parts of a watercolor we are not satisfied with—say, that corner that requires more light, or the other that is too shiny and does not blend into the overall effect of the work. The fact that some artists resort to these methods of painting does not necessarily mean they have not mastered the traditional technique of pure watercolor, even though these tricks were frowned upon for many years by watercolor purists. Nowadays, they are commonly used because when it comes to increasing the expressiveness of a work, any means is valid. So experiment with all of these methods and do not hesitate to invent new ones.

Before you start to put these ideas into practice you must take into account that most of them produce uncontrollable effects so the results are usually unpredictable and will depend on the type and quality of your materials as well as on the degree of moisture, and so on.

Nevertheless, do not fear surprises; they are, after all, characteristic of the medium and part of its appeal. If, for example, you produce a wash that is not entirely flat or use too much salt that results in excessive texture, do not despair and throw the work away; if you study your mistake carefully, you will probably see that you have created a new, special effect that can be used to advantage in another painting.

In any case, the element of surprise is also a good reason to approach these techniques slowly; experiment before using any of these procedures in a painting as there is always the risk of spoiling your work.

WATER

Water is, of course, basic to watercolor painting. The condition of it, the substances added to it, the excess or lack of it—all these are factors that affect the result of each brushstroke. This characteristic can be used by the artist to create effects.

Some artists are scrupulous about the purity of the water they use as it relates to the conservation of their paintings; they prefer to work with distilled water. To notice the difference requires an excellent knowledge of watercolors. It becomes more apparent over time because paint mixed with water that is free from impurities lessens the risk that the work will deteriorate. Most painters use ordinary water from the faucet, but be aware that too much chlorine can rob paint of its color.

Opinions vary regarding the frequency for changing the water and the number of jars needed for maintaining clean colors. Some artists dip their brushes into a single water container both for loading and cleaning them; they believe this method allows all their colors to blend a little for an overall, homogeneous tone in their work. Others have one water jar for loading and another for cleaning the brushes. Still others change the water constantly to maintain the purity of the colors. A few even use separate rinsing containers for cool and for warm colors. In any case, it is mostly a matter of personal

Adding a spoonful of sugar to the painting water will extend the drying time

preference and the desired tonal effect. (The same applies to the palette; some artists clean theirs several times during a session, whereas others can go years without cleaning theirs.)

Although most commercial watercolors already contain humectants, sometimes it is a good idea to dissolve about half a teaspoonful of sugar in the painting water. This delays the drying time and prevents hard edges and irregularities in underpaintings, flat washes, and gradations. A couple of lumps of sugar can also be added to a glass of water for dampening the paper, especially in the summer or in heated places that will cause the water to evaporate more quickly. Do bear in mind that sugar can make the paint a little shiny.

MORE . . .

Other substances that can be added to the water are discussed on pages 34 and 35.

It is advisable to use one jar for cleaning the brushes and another for dampening them if you want to keep the colors pure

WATER | LIFTING OUT COLOR

If clean water is applied to a painted area that is almost dry, the paint particles will separate and collect at the edges.

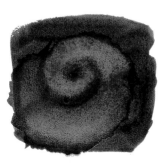

1. Dip the brush into clean water.

2. Let a drop of water fall on the painted area when the paint is almost dry.

3. The color fades as the pigment spreads out and the particles of color will collect around the edge of the wet spot forming a halo.

WATER | RETOUCHING WITH WATER

Loading the brush with water and working it over painted areas where the paint is still wet is a retouching technique for manipulating the paint to obtain a given texture or other suggestive effect.

NOTE

Remember that when two painted areas have the same degree of moisture, the pigment will tend to mix with the water. You will not see the final result until the paint has dried.

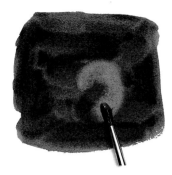

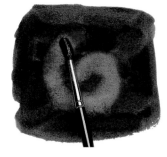

1. Load a clean brush with clean water and work on the wet paint removing the color until you have obtained the desired tone and shape.

2. It is important to clean the brush as you work and use clean water. Otherwise the paint may mix with the water and the two areas would end up having the same tone.

3. The pigment particles collect around the edges of the dampest parts, creating a more intense tone.

COMPLICATED EDGES | A PENCIL LINE AS A BARRIER

To avoid the use of masks, there are other methods to stop the paint from running beyond desired limits.

You can stop the paint from spreading by keeping adjacent areas dry as the paint will expand into any wet paper surfaces.

Another way to stop the paint from spreading over a wet area is to mark the limits in pencil. The graphite and the pressure applied when drawing the line alters the state of the fibers and a small barrier is created that stops the paint from spreading across it.

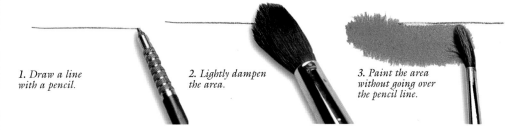

1. Draw a line with a pencil.

2. Lightly dampen the area.

3. Paint the area without going over the pencil line.

NOTE

Bear in mind that if the area to be painted is too damp, the excess water can cross the graphite barrier carrying the pigment along with it.

4. The pencil line acts like a barrier, preventing the pigment from spreading. Here, the ends of the painted red stripe have spread out as they normally would.

COMPLICATED EDGES OUTLINING THE EDGE

When you are painting large areas and want to avoid painting over others you have already completed, you can use the following method.

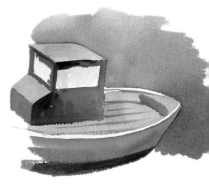
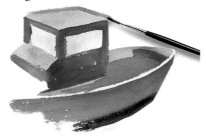
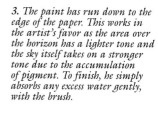

1. Once you have painted the shape you wish to protect, outline the area with the background color using a small brush.

2. Then you can work without worrying about painting over that certain shape; be quick, however, because if the thin outline were to dry before you were done, hard edges would appear when painting with the thicker brush.

3. You have succeeded if your background wash is without hard edges as the one illustrated here.

COMPLICATED EDGES PAINTING UPSIDE DOWN

If you are working with a tilted board, when laying a wash on the upper part of the paper the paint may trickle down and muddy the lower half.

2. Even if the paint runs down the paper it does not matter as there is nothing painted in this lower half.

3. The paint has run down to the edge of the paper. This works in the artist's favor as the area over the horizon has a lighter tone and the sky itself takes on a stronger tone due to the accumulation of pigment. To finish, he simply absorbs any excess water gently, with the brush.

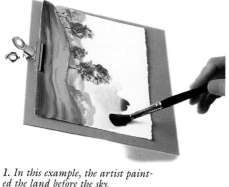
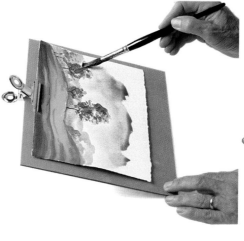
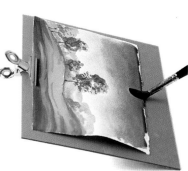

1. In this example, the artist painted the land before the sky. So he turns the board around and works first on the area touching the painted section, that is, the horizon.

COMPLICATED EDGES STRAIGHT LINES

To draw a straight line of color, you can use a ruler or any long, straight object. If your hand is not very steady we recommend you tilt the ruler at an angle so that the edge serving as a drawing guide is lifted away from the paper; otherwise paint may seep between the ruler and the paper and create a smudge when removing the ruler.

You can make the line appear less rigid by painting over it again freehand, but bear in mind that the tone will probably become stronger.

1. We recommend holding the ruler at a slight angle to the paper.

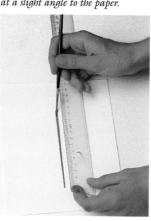
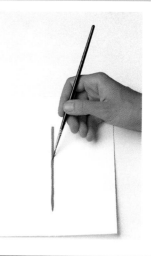

2. You can paint over the line again freehand to make it appear less rigid.

NOTE

If you do not want to hold the ruler at an angle, be sure to keep the hairs of the brush from touching it. In the event the paint comes in contact with the edge of the ruler, try not to slide the ruler over the paper because it would then smear the paint.

COMPLICATED EDGES

SOFTENING EDGES WITH A BRUSH

After the paint dries, edges that are too sharply defined can be softened with a brush. This technique is handy for blending the tones when continuing later with a painting that had been set aside half-finished.

1. Wet a clean brush in clean water.

2. Gently rub the edges to soften the paint and reduce the contrast between the colors.

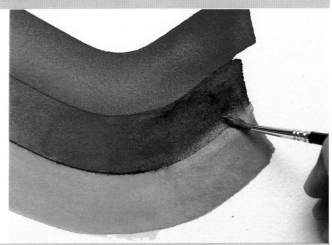

COMPLICATED EDGES

SOFTENING EDGES WITH A COTTON SWAB

Complicated hard edges can also be softened using something as simple as a cotton swab.

1. Wet the cotton swab in clean water.

2. Gently rub the edge to remove part of the paint.

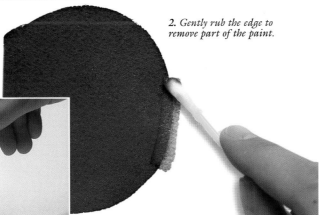

NOTE

As the illustration shows, if you are not careful with the cotton swab, you could smudge unpainted parts of the paper. If you are going to paint over such areas right away there is no problem; if not, make sure not to stray over the edge with the swab. This can also happen when using a brush.

GUM ARABIC

INTENSIFYING COLORS

As it is an ingredient of watercolor paint, we have already discussed gum arabic on page 34.

This substance can be very useful when doing detailed work and laying paint in small brushstrokes because it prevents the colors from mixing together; it also intensifies them.

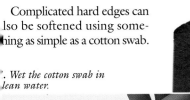

3. Adding a little gum arabic to the water will lend body to the paint and make it more fluid and easier to use and control, especially at the edges.

Gum arabic can put back some of the sparkle in an area dulled by too many glazes. Just apply a fine layer of gum over the chosen spot.

1. Dip the brush into a little gum arabic and apply it directly over the dry paint.

2. As you can see in the photograph, the right half of each color strip has been treated with gum arabic and is slightly more vivid and glossy.

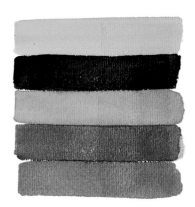

NOTE

In the gum arabic mixture used for intensifying the color, the proportion of water must be far greater. Take into account that the larger the proportion of gum arabic, the shinier the results. You need to experiment to obtain the desired effects. Dissolving a few drops of gum arabic in 1 pint (500 ml) of water will produce almost unnoticeable effects, so calculate the amount carefully.

TECHNIQUES IN WATERCOLOR

GUM ARABIC — DEFINED BRUSHSTROKES

To keep the brushstrokes sharp and make them more consistent, you can use gum arabic to stop the pigment from spreading.

1. Dip the brush into gum arabic. You can dilute it slightly with water if you want.

2. Next, dip the gum-loaded brush into the paint, from either the pan or the palette.

3. Paint several lines with different colors. Note that brushstrokes do not blend together nor do the colors.

This example was painted without adding gum arabic. Compare the previous example. The brushstrokes are not as sharp and well defined, the pigment spreads and the colors mix together creating smudges.

GUM ARABIC — BODY AND CONSISTENCY

When it is applied directly to the color, gum arabic thickens the paint without making it less transparent. Additionally, lines take on more volume and brushmarks are more apparent. This effect enables the artists to suggest textures.

NOTE

Undissolved gum arabic may cause the paint to crack when dry.

1. Dip the brush into gum arabic.

2. Now load it with paint from your palette.

3. Paint as you normally would. Observe how the hairs make a visible mark in the brushstroke.

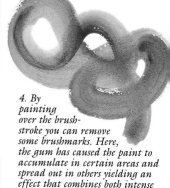

4. By painting over the brushstroke you can remove some brushmarks. Here, the gum has caused the paint to accumulate in certain areas and spread out in others yielding an effect that combines both intense and weak tones.

SOAP — TEXTURES

A mixture of soap and paint produces effects similar to those of gum arabic; soap lends body and consistency to the paint, though not luster. As the paint becomes less liquid, the brushmarks remain visible so they can be used to imitate textures.

1. Load up the brush with paint from pan or palette.

2. Next, take up a little soap from a bar.

3. Apply the paint by rubbing the paper gently with the brush in a circle. This produces bubbles of varying sizes that when dry create interesting, though unpredictable, ringlike effects. Liquid soap is not recommended because it makes excessive suds, but you may want precisely that for a certain result. The color will collect where there is most foam. The interesting patterns obtained with this technique do not become apparent until the paint dries.

OPAQUE COLOR — EFFECTS

Opaque white gouache or Chinese white are paints that are also diluted in water but lack the fresh appearance of watercolor. Due to the binders that are added to them, they are more dense and become opaque when dry. An opaque color can therefore be obtained by mixing one of these paints with a watercolor. This technique can be used to obtain effects such as mist in landscapes or the texture of velvet. It can also be used to reduce the luminosity of the colors, remove excess paint, or soften a color.

The proportions of opaque medium to use will depend on the desired effect.

NOTE

Remember that excessive use of this technique can destroy the inherent transparency of watercolor paint and spoil the colors.

1. Dip the brush into the paint.

2. Add a little white gouache to the brush.

3. Paint and blend the colors on the paper. The density of the gouache enables you to paint over an already painted area without the background color affecting the superimposed color.

SOLVENTS USING TURPENTINE AS RESIST

Wood turpentine and pure gum spirits of turpentine contain oils that repel water. These solvents can produce interesting effects when combined with watercolor paint. You can brush them on the paper before starting to paint. After the paper has dried and you paint on it, the turpentine resists the paint, which takes on a marbled appearance.

1. Dampen the brush with turpentine.

2. Paint the area you wish to texturize.

3. There is no need to wait for the turpentine to dry before you start painting. Note how the oil from the solvent repels water and causes the paint to accumulate in droplets on the area you have treated. It also prevents the pigment from spreading.

SOLVENTS OPENING UP COLORS

Another way of experimenting with both varieties of turpentine is to apply them to a painted surface. They can be used to suggest textures like that of wood or of a rough wall or to produce sweeps of color. These areas can then be painted over easily.

NOTE

It is advisable to use an old brush or one with synthetic hairs when applying turpentine solvents because they could damage natural hair brushes. Never leave a brush immersed in these substances for hours as the hairs would be destroyed entirely.

1. Paint the area you want to treat.

2. Dip the brush in turpentine.

3. Apply a brushstroke on the wet paint. The turpentine opens up the color by separating the paint.

4. To get the full effect, you must wait a while because the turpentine will continue to work on the patch of color after you remove the brush.

SALT DIFFERENT TEXTURES

Salt is used in watercolor painting to achieve textures similar to the four examples shown here. More complex textures can be created by repeating the process twice.

If a few grains of salt are sprinkled on top of the wet paint they absorb it as it dries creating intriguing shapes that suggest snowflakes. The result will vary depending on the amount of salt you apply and the proximity of the salt grains.

Moisture also plays an important part. The more moist the paint, the larger will be the patches produced by each grain. This example was created on a very wet surface.

A large amount of salt will produce effects that imitate the texture of a porous rock or of certain types of vegetation.

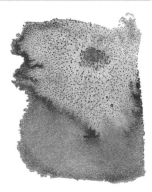

In this example we have used a lot of salt on a fairly dry surface; most of the salt remains on the surface. Removing it is only a matter of rubbing the grains off gently with a finger. For those cases where you would want to keep the grainy texture, you can apply gum arabic over the salt.

SPATTERING — SPLASHES OF COLOR

Results of spattering depend on several factors: the consistency of the paint, the distance of brush from paper at the time of splashing the paint, the tilt of the paper, the steadiness of the artist's hand, and the presence or absence of moisture in the paper. This technique can be very useful for creating floral effects and suggesting the texture of a tree, a pebbled ground, a porous rock, or a surface corroded by rust.

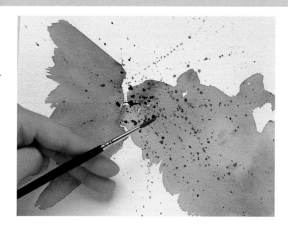

NOTE

In spattering paint, bear in mind that you cannot fully control the size of the drops that fall on the paper; this factor will largely depend on the thickness of the brush.

To achieve this effect, simply tap the hand holding the brush. Here, these small splashes have been used to suggest the explosive force of a small volcano and the debris it spews up.

LARGE SPATTERS — MOUTH-BLOWING METHOD

The unpredictable technique of spattering the paint can give rise to spontaneous shapes that are very suggestive. Here, however, is a blowing method that allows you a certain degree of control over the effects achieved.

1. Squeeze paint from the brush onto the paper until you have a drop of the desired size.

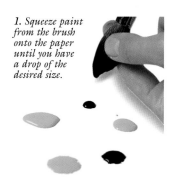

2. You can combine different colors, but plan how to distribute them on the paper.

3. Through a straw, blow a puff of air on top of the paint to spread it out in all directions. The differently colored droplets will blend together. You can blow without using a straw, but a straw does help you to control how the paint spreads. These blots of color can be used to suggest marine vegetation or a rugged landscape.

NOTE

It is essential to wait for one tone to dry before applying another if you do not want them to mix. The blotting effect can also be obtained with a hair dryer.

LARGE SPATTERS — HAIR DRYER METHOD

Many artists use a hair dryer, or even a butane lighter, to speed up the drying process of certain areas or the entire painting. A hair dryer can also be used, however, to blow the paint over the paper.

NOTE

You need to control the direction and the force of the hot air from a blow dryer, because, if you overdo it, the paint will spread out in unwanted directions.

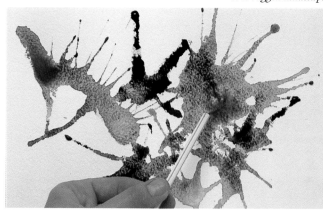

1. Paint a patch of fluid color so the paint will run easily over the paper.

2. Apply the stream of air in the direction you want the color to spatter. This illustration shows lighter tones where the paint has dried sooner as these areas were closer to the dryer. You can also see irregular lines within the painted patch that have resulted from accumulations of pigment as the paint moved with the force of the airstream.

3. Directing the dryer toward a drop of paint causes it to run over the paper.

4. Here, the drops that collected in the upper part have split into two, creating two thin lines. This method can be used for painting a sky, a surface of water, or the damp sand of a beach.

SPATTERING

WITH A TOOTHBRUSH

Spattering minute flecks of paint on the paper can be an aid in creating an infinite number of textural effects. This is also used to apply a darker color to areas that appear rather thin so as to create the sensation of contrast. If, on the other hand, the area is too dark, you can balance it by applying a lighter color to unify the tones. This method consists of applying paint to a toothbrush and then flicking the hairs with your finger, a knife, or any other object. A comb can be used in the same way. This will deliver countless tiny droplets of paint to the surface of the paper. Sprays can also be used for the same purpose.

NOTE

Flecking is unpredictable and can result in unwanted blobs of paint. To succeed, use paint with a slightly thick consistency, though it should not be so thick that it sticks to the brush. Of course, you will need to practice first on a piece of scrap paper to avoid the risk of ruining your work.

1. You will need to prepare a stencil to mask any areas you want to protect from the paint. Here, a white stencil covers a small area that will retain the original color.

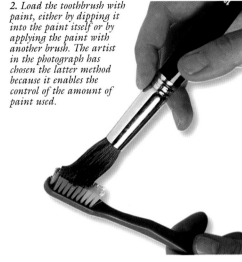

2. Load the toothbrush with paint, either by dipping it into the paint itself or by applying the paint with another brush. The artist in the photograph has chosen the latter method because it enables the control of the amount of paint used.

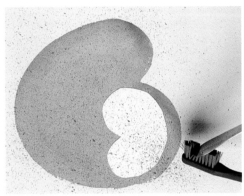

3. Use a knife or any other suitable object to flick the hairs on the brush.

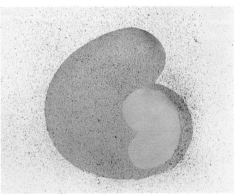

4. Apart from the porous texture we have obtained, you can see the difference in tone between the spattered area and the spot protected by the stencil.

POINTILLISM

COLOR IMPRESSIONS

The technique of painting small dots with the tip of the brush is called *pointillism* and was developed by Georges Seurat. Based on the Impressionist theory, it has been used to produce effects unlike those of any other technique. If you closely examine any advertising billboard, or the illustrations in this book, you will realize that images are printed following the same principle underlying this technique: The colors come together in the eye of the viewer, not on the paper itself. As with traditional watercolor painting, in pointillism you work from light to dark, beginning with the lightest tones and then adding the darker ones. It is a method

that requires patience, a great capacity for observation, and a keen sense of color.

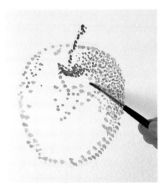

1. Outline the form working with the lighter tones and, at the same time, assessing the general tonal range of the object.

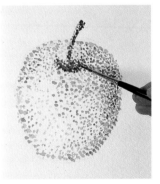

2. Next, apply the intermediate tones.

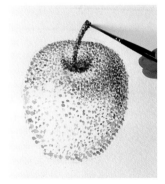

3. Finish with the darker tones and paint more dots in the areas that are still too light.

NOTE

Results using the pointillist technique depend on the size of the dots and the distance between them. When painting in this style, you must remember that the color of the paper is an additional color.

TRANSFERS

TRANSFERRING TEXTURES

Transfers are a simple method of creating different textures. This is done by applying paint to a highly textured object—a piece of cloth or the leaf of a tree, for example—and using this painted object to imprint the pattern of its texture on the paper. Almost any object can create interesting and surprising results using this simple technique.

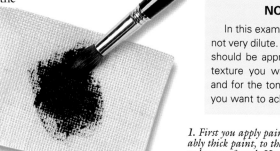

NOTE

In this example, the paint is not very dilute. Paint thickness should be appropriate for the texture you want to transfer and for the tone and intensity you want to achieve.

1. First you apply paint, preferably thick paint, to the surface to be transferred. Here we have used a piece of burlap.

2. Place the textured object on the paper, painted side down, and press down gently but firmly. Be sure not to move the object or you will smudge the paint and the image will be blurred.

3. Remove the textured object

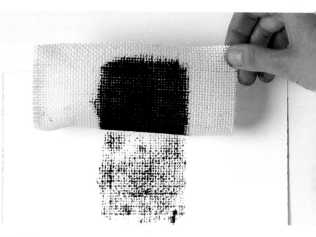

TRANSFERS

TRANSFERRING COLOR

Transfers can also be used to carry the imprint of a wet, freshly painted subject from one surface to another.

1. Paint the desired shape using fairly thick paint. You can dilute the paint a little more if the receiving surface is absorbent enough and the size on the surface is not too thick.

2. Place the other paper over the painted area and press down with both hands.

3. Separate the two pieces of paper. In the illustration, the designs have not transferred completely because too little pressure was used.

NOTE

When not enough pressure or paint has been used or when the surface of the paper is too hard, the forms transferred by this method will not be perfect.

TRANSFERS

DISTORTING THE IMAGE

As with textures, moving the paper that contains the image during the transfer will distort the form. Some artists move the paper deliberately in order to obtain smudged outlines and undefined forms.

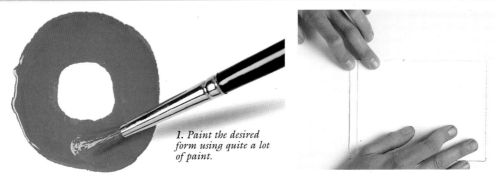

1. Paint the desired form using quite a lot of paint.

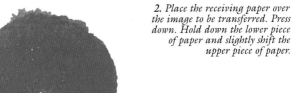

2. Place the receiving paper over the image to be transferred. Press down. Hold down the lower piece of paper and slightly shift the upper piece of paper.

3. The illustrations show that the paint has shifted on both pieces of paper, distorting the original image. Unlike the previous example, this design has been entirely transferred because sufficient pressure was applied all over the paper.

DRY BRUSH

LACELIKE GLAZES

Painting with a brush that is almost dry is another technique for creating imitative texture, such as the roughness of tree bark or graininess of stone. Dry paint can be applied directly to the paper, allowing the paper to "breathe," or to a painted area as a glaze that lets the underlying color show through, creating a lacelike texture.

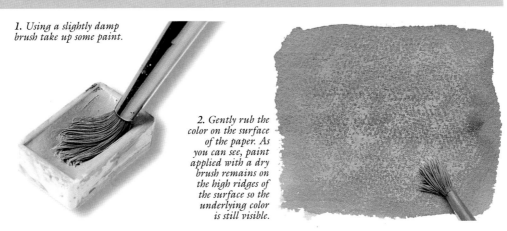

1. Using a slightly damp brush take up some paint.

2. Gently rub the color on the surface of the paper. As you can see, paint applied with a dry brush remains on the high ridges of the surface so the underlying color is still visible.

DRY BRUSH

FANNING OUT THE HAIRS

Painting with a dry brush with its tip squeezed between the fingers to splay the hairs, will produce a series of parallel lines that suggest hair or grass. Do not use too much paint or paint that is too thick because you will only get a solid patch of color. If you do not use enough, the brush will leave no marks on the paper. So experiment first in the margin or on a piece of blotting paper before you start.

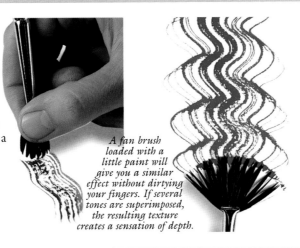

A fan brush loaded with a little paint will give you a similar effect without dirtying your fingers. If several tones are superimposed, the resulting texture creates a sensation of depth.

NOTE

It is unwise to use a sable-hair brush for dry painting as it is too soft and, besides damaging it, you would not obtain the desired results. Use one with fairly tough bristles. The best results can be obtained using coarse-grain paper as the rough surface allows the color of the paper to show through the paint.

WASHING — INK AND COLOR

An enormous variety of effects can be obtained using the washing technique. It is rather slow, tedious, and highly unpredictable yet the results are truly interesting and attractive.

Washing consists of applying impermeable ink over painted paper and then washing it off under a faucet. The ink will adhere to the unpainted part of the paper and rinse off the painted areas. It is important you use good quality paper, preferably coarse-grain, that can resist being washed under the faucet. Make several experiments before using this technique in your work. Remember that the inked part of the paper cannot be altered later. If you are in a hurry, you can use a hair dryer to dry both the paint and the ink.

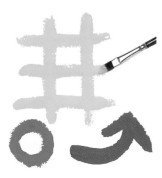

1. Paint the colored designs on the paper. Use fairly thick paint because it will dissolve in the water and some of it will be lost. In addition, ink will be less likely to penetrate a layer of thick paint. To prevent paint from being lost, you can add oxgall, which increases the paint's adherence. Even so, when the paper is washed the colors always fade slightly.

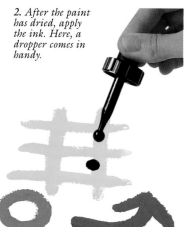

2. After the paint has dried, apply the ink. Here, a dropper comes in handy.

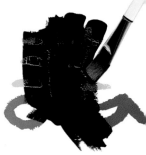

3. Extend the ink over the paper. Do this with great care so that the underlying watercolors are not run and stain unwanted areas. The photograph shows the ink breaking away from the areas that contain color paint.

NOTE

Remember that when the ink is washed off, the watercolors will lose intensity.

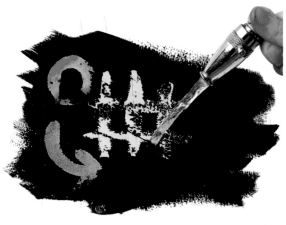

4. When the ink is dry, wet the paper under the faucet, preferably with warm or hot water. You can also rub gently with a sponge or your fingers at the same time, but take care not to rub away the watercolors.

5. Allow the paper to dry, but take into account that when wet paper dries it can curl if not stretched.

PAINTING WITH . . . — BLOTTING PAPER

There are many kinds of everyday objects that can be used to apply paint to paper. There are as many such items as the artist can imagine. Some are particularly suited to painting backgrounds or imprinting designs.

A piece of blotting paper can be used as a stamp for creating symmetrical forms such as a group of houses or the movement of a kite.

1. Shape the tip of the blotting paper and dip it into the liquid paint.

2. Then, press it on the paper to imprint the image.

Handy painting instruments can also be improvised from a piece of watercolor paper or cardboard with which you can easily paint straight lines that could represent a fence or an area paved with stone.

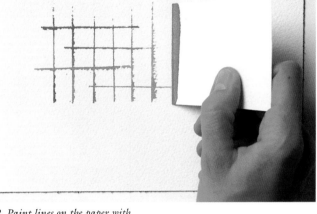

1. Dip the edge of the applicator into the paint.

2. Paint lines on the paper with the applicator.

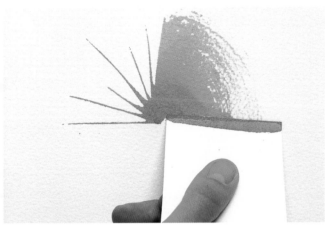

By experimenting with the same piece of cardboard you can create many designs. On the left, one corner of the applicator was kept against the paper and the free edge was pivoted and brought into contact with the paper at intervals to draw the lines in the first half of the arc. For the second half, the entire edge of the cardboard was kept against the paper as it was rotated.

NOTE

Remember that moisture softens paper. If a single piece of it is used repeatedly to apply paint, it will probably lose its shape; a makeshift paper applicator, therefore, works best when painting small areas. For more extensive work you will need to prepare several different paper applicators before starting.

PAINTING WITH . . . **A POTATO**

Something as common as a potato can provide you with an endless number of designs. Simply carve the potato into different shapes and use it as a stamp.

1. Cut a potato into halves. Dip the cut side of one half in the paint.

2. Press the painted side of the potato down on the paper. Here, several imprints were made with varying pressures and amounts of paint to show that the same shape can yield different designs by modifying the procedure.

1. Carve a star in the other half of the potato, then dip this design into the paint.

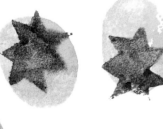

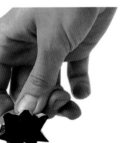

2. Press it down onto the paper as before. Here both forms have been combined; the first design was not completely dry when the star was imprinted on it.

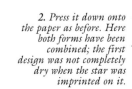

PAINTING WITH . . . **YOUR FINGERS**

The artist's fingers can play an important part when it comes to painting. Whether it be to stop a drop of paint from running down the paper or to actually do some painting, you should not be afraid to use your hands to create effects. Your fingers are like any other instrument and the mark they leave will depend on the surface and the movements you make.

1. With your index finger, take a dab of paint from the pan or the palette.

3. Why use only one finger? Dip several fingers into diluted paint at the same time.

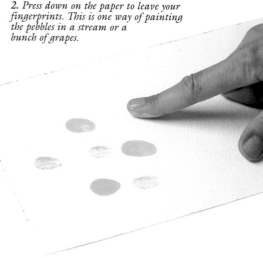

2. Press down on the paper to leave your fingerprints. This is one way of painting the pebbles in a stream or a bunch of grapes.

4. After fingerprinting an area with color, try dragging your paint-moistened fingers on the paper to draw a few lines.

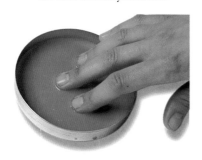

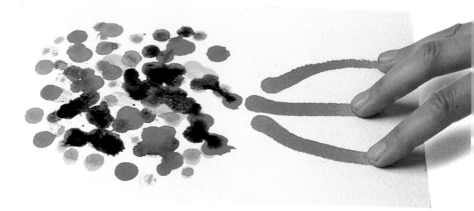

NOTE

When using the finger-painting technique, remember that, unlike the bristles of a brush, fingers do not absorb paint; consequently, you will have to continuously dip them in the paint.

PAINTING WITH . . . **A TOOTHPICK**

A toothpick and paint can be used to produce broken lines. The same effect can be achieved with the handle of a brush sharpened or cut to size on purpose. This kind of line is ideal for imitating rough surfaces such as the bark of a tree or uneven ground.

NOTE

A similar effect can be obtained by shredding the tip of a toothpick and using it like a rudimentary brush.

2. Use it to add textural detail on a dry color—in this example, the branch of a tree.

3. Put in some precise shading with the darker tones.

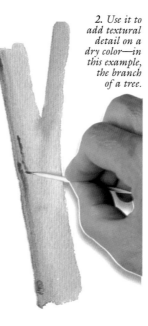

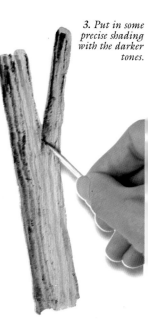

1. Load the tip of a toothpick with paint from the pan or the palette.

PAINTING WITH . . .	**A STRIP OF WOOD**

Strips of wood can also produce useful effects. Patterns will depend on the size of the strip and how roughly it is cut. Prepare a sufficient amount of paint if you are going to cover a large area because wood is porous and it will absorb more paint than it will release. Consequently, you will have to dip the wood strip in the color repeatedly.

1. Dip the strip of wood in liquid watercolor. In this case, the edge of the wood has been cleanly cut with a knife.

NOTE

With a strip of wood as a tool, you can apply any kind of watercolor paint, not only the liquid type.

2. Experiment with as many different marks as you can possibly create. With a corner, you can paint thin lines; with the entire edge, thick, broken stripes. You can even recreate the textural effect of a dry brush by rubbing the paper with the flat side of the strip after lightly loading it with paint.

1. Now try painting with a strip of wood that has a rough edge. Again, moisten it with liquid paint.

2. Experiment with the amount of paint to create different effects. In the illustration, these marks are more irregular in width.

PAINTING WITH . . .	**COTTON SWABS**

A cotton swab can be used in the same way as a brush or a thick felt-tip pen. It can also be employed for making corrections or for absorbing excess paint. Always keep some swabs handy as they are an excellent aid in creating certain effects.

1. Load the cotton tip with paint.

MORE . . .

Cotton swabs have many uses in watercolor painting. See Whites, page 68.

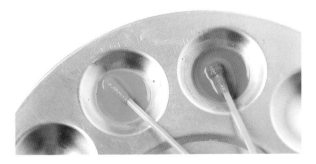

2. Draw the desired lines.

NOTE

Cotton swabs absorb more paint than they release. Do not expect them to function as brushes. You should also remember that the cotton tip can easily lose its shape when you press down on it.

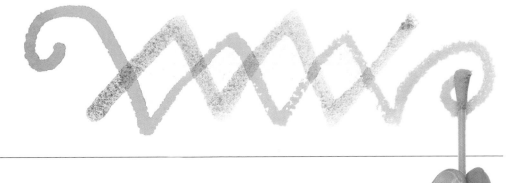

TECHNIQUES IN WATERCOLOR

PAINTING WITH . . . **A ROLLER**

Rollers are a tool for coloring backgrounds, but painting a stripe of color is also possible with this instrument. As always, results vary according to the amount of paint and the pressure that are used. Though less versatile than a brush, a roller can be used to paint an entire work in a large format.

1. Load a roller with liquid paint.

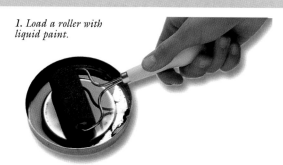

2. Run it over the paper surface. If you apply adequate and constant pressure, you will obtain an effect similar to the first band of even color shown below. The second example, is the result of using too little pressure.

A roller overloaded with paint has produced this evocative trail of blue tones.

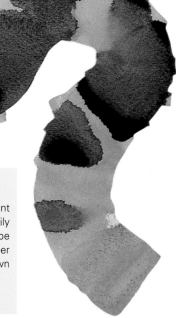

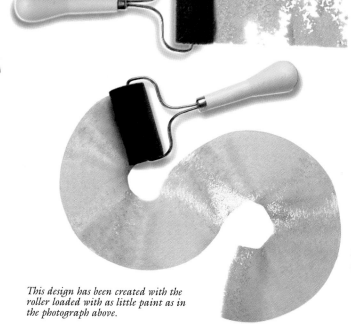

NOTE

Rollers absorb a lot of paint and release their load easily with little pressure, so be careful not to flood the paper with paint by bearing down too hard on the roller.

This design has been created with the roller loaded with as little paint as in the photograph above.

PAINTING WITH . . . **A COMB**

A comb is another everyday object that enables an artist to create effects. The teeth of the comb leave regular marks in the paint that can imitate the texture of hair, grass, or fabric.

1. Cover an area with thick paint.

NOTE

By thickening the paint with gum arabic, you can achieve a certain degree of high relief with the use of the comb. If the paint is not sufficiently thick, however, the lines the comb opens up in the paint will later reclose. To succeed, remove some of the paint or wait until the paint dries a little. A similar line pattern can be made using a fork.

2. Run the comb over the painted surface in one direction.

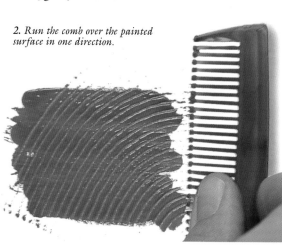

3. Repeat the operation in another direction.

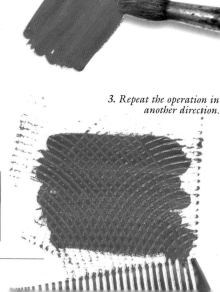

PAINTING WITH . . . | **A TOOTHBRUSH**

A toothbrush can also be used to suggest the texture of vegetation or hair and the force of the wind, or to create a sensation of speed.

1. Load the toothbrush with diluted paint.

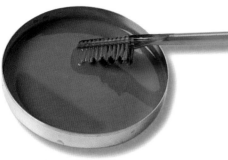

2. In this photograph, the serrated bristles of the brush made these irregular marks.

A toothbrush is easy to manipulate and allows you to paint in all directions.

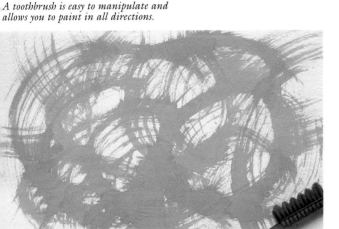

Light pressure on the toothbrush leaves a trail of parallel lines from the pointed bristles, whereas more pressure produces a patch of color.

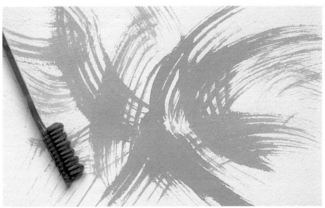

PAINTING WITH . . . | **A KNIFE**

Surprising though it may seem, a small knife can also be used to paint. Scratching a pattern in the uppermost layer of the paper with the sharp point of a knife will allow the paint to penetrate the paper to the core and intensify the tone. The cutting can be done both before and after painting.

1. Paint the area to be scratched.

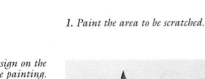

2. Scratch the lines of your design while the paint is still damp. The pattern will begin to show right away.

1. Scratch your design on the paper before painting.

NOTE

Using a knife for painting requires a steady and delicate hand as there is a risk of ruining the paper. The aim is merely to scratch it. The tone of the scratched lines will gradually deepen within a few minutes.

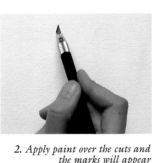

2. Apply paint over the cuts and the marks will appear immediately as the paint penetrates them.

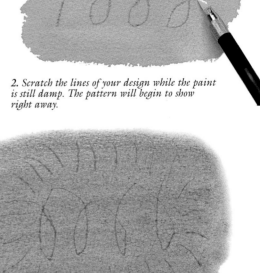

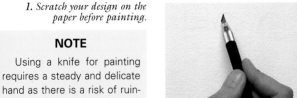

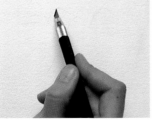

TECHNIQUES IN WATERCOLOR

The Sponge

With its great capacity for absorbing and releasing paint, the sponge is an essential accessory in watercolor painting because it serves many functions. It can be used for dampening the paper and is also practical for lifting out paint and for removing excess moisture.

Natural sponges are preferable to synthetic ones as they are softer, more absorbent and their irregular surface produces more interesting textures and patterns.

For painting, it is best to have several sponges of different sizes and roughness.

USES

A sponge has practically the same utility as a brush. It can be used for applying washes, painting designs, suggesting textures, creating effects, dampening the paper, absorbing water, correcting, and removing paint.

It can also replace a cloth for drying the brush and can even be used instead of blotting paper, if necessary.

To serve these various purposes, however, it is essential that your sponges are cleaned as carefully as your brushes!

MORE . . .

Sponges can replace brushes or absorbent paper in most of the exercises under "Whites." See page 67.

Any kind of sponge can be used for watercolor painting, although we do recommend natural sponges as they are more flexible and produce more interesting effects. Select a size for the sponge that will match the job you plan for it. In any case, it is a good idea to have several different ones. Tiny sponges for detailed work can be cut from a larger one.

PAINTING LARGE AREAS APPLYING A WASH WITH A SPONGE

A sponge is more practical than a brush when it comes to painting large surfaces because it can hold more paint. Additionally, a large sponge can cover the paper with paint in just a few strokes.

To apply a wash with a sponge, first prepare sufficiently diluted paint in a container. Remember that it is better to prepare more paint than is necessary rather than less. Stopping to prepare more paint would interfere with the uniformity of the wash because the interruption would give the paint time to dry on the paper and cause hard edges when you resumed painting. If, in addition, the diluted paint was a mixture of colors, it could be difficult to obtain exactly the same tone again. You can apply this wash directly or wet the paper first with the same sponge.

Always wash the sponge thoroughly with soap after each use to remove any traces of color that could leave stains on the paper.

1. Dip the sponge into diluted paint. This instrument lets you control the amount of paint it absorbs. By squeezing it you can unload any excess or even most of the paint. The sponge should be fairly damp but not soaking wet.

2. Lay your wash on the paper, working from top to bottom the same as you would with a brush. The amount of paint the sponge dispenses will depend on the degree of pressure you apply. Use only gentle pressure to avoid creating puddles.

NOTE

The only trouble with applying washes with a sponge is that it stains your hands. The advantage is that you can work much more quickly. On page 42 we describe how to apply a wash with a brush.

EFFECTS **SUGGESTING FORMS AND TEXTURES**

Given their shape, sponges are not suited for outlining forms or doing detailed work. They are, however, excellent for creating textures and can be used to represent different kinds of vegetation. You can paint an entire work with them or use them only for adding touches of color or suggesting forms.

Each type of sponge produces a different effect. Natural sponges have an irregular texture, so look for the side or edge that best suits your purpose.

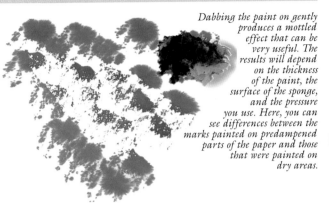

Dabbing the paint on gently produces a mottled effect that can be very useful. The results will depend on the thickness of the paint, the surface of the sponge, and the pressure you use. Here, you can see differences between the marks painted on predampened parts of the paper and those that were painted on dry areas.

You can combine several colors. If you want the sponge to mark the paper with its particular texture, however, you need to wait for the first color to dry or the paints will blend. You can dilute the paints in containers or wet the sponge and rub it on the undiluted paint from a pan or a palette.

Synthetic sponges leave a more consistent mark, though this, too, can be interesting.

You can create a vast number of effects by combining different textures.

This pattern was obtained by using a rolled-up sponge.

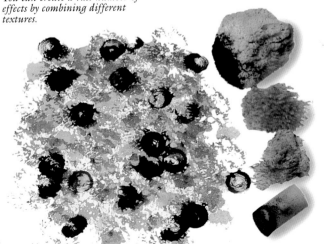

Line Drawing

Drawing not only is the fundamental part of a painting that arranges the forms on the paper but also has its own, incomparable expressive strength and value. That is why so many artists employ it in their works either as the major element or as a way of complementing the colors. A simple line can appear out of place and ruin an entire work. That same simplicity, however, can, on other occasions, cause the line to be forceful and full of expression. The artist uses lines to define the basic structure of the subject, outlining the forms or suggesting them. An artist who combines the technique of watercolor with drawing can make use of the best each medium offers.

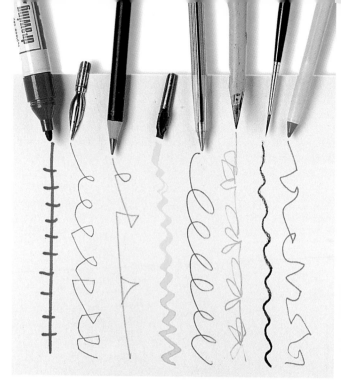

You can use anything from a thick felt-tip pen to a fine nib for drawing lines, not forgetting the pencil, of course.

MATERIALS

Lines are usually drawn using India ink diluted with water or colored inks, although any medium can be used. Some artists use a felt-tip pen, diluted watercolor, or even a ballpoint pen. Most inks are impermeable; that is, if they are applied before the paint, they remain unaltered. There are others that fade with the moisture, the outlines paling as they are painted.

For applying ink you can use steel nibs, reed, or bamboo pens, which improve with use. Both instruments come in different types and the basic difference among them is the thickness of the lines they draw. They are inexpensive, so try several until you find the one that best suits your work.

If you have decided on a reed or bamboo pen and cannot find anything suitable in the stores, you can always make one yourself. Before drawing with this pen, it is best to check the thickness of the lines by testing it with ink on a piece of paper. When ink is applied to a dry surface the lines are broken and appear darker.

A fountain pen that uses India ink can also be used for drawing lines and is particularly useful for straight lines.

Felt-tip pens and ballpoint pens are handy because you do not have to lift them from the paper to refill them. They can draw continuous lines and are easy to handle.

TECHNIQUE

Drawing lines in ink freehand requires considerable mastery and fluency.

It can be done before, during, or after painting the colors on the paper.

When the drawing is done first, the aim is to either set down small shadow areas or outline shapes. Lines that are drawn before laying down the watercolors always run the risk of fading with the moisture, thereby losing their sharpness. Even more risky is to draw the lines in watercolor as too much water could make them merge with the paint and disappear entirely.

Artists sometimes develop the lines at the same time as the colors because they actually want the lines to merge, so they take advantage of the moisture in the paint.

Applied as a finishing detail, a line may be used, for example, to reinforce the steps up to a house or a set of railings. On occasions, the line drawing is not a complement to the painting but the main element of the work. Once the paint is dry, you can draw over it with any kind of ink without worrying about the ink diffusing.

AFTER PAINTING

DRAWING OVER THE PAINTING

A way to integrate the line drawing with the watercolor painting is to add it after the paint dries on the paper.

With this method the artist need only suggest the forms with the tones because the definition of the outlines will be done later with pen and ink.

This challenging exercise entails reproducing a detail of the work Regency House in Tunbridge Wells, *by George W. Hooper.*

1. Begin by painting the background and applying lighter colored washes to the house.

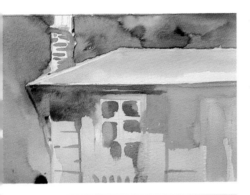

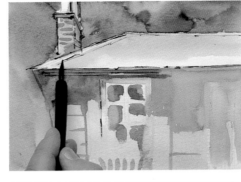

2. *Lay the last washes of color on the house, develop the bricks of the chimney, and reserve the white area of the window frame. As illustrated here, your brushwork must be flowing and need not be precise, you will develop the details later using ink and nib.*

3. *Begin by defining the chimney in ink, let your lines suggest the two sides.*

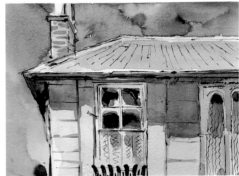

4. *Keep fleshing out the details. Here, a few trial lines have been drawn on the roof and others have strengthened the structure of the window frame and the balcony. The tone of the window panes has also been built up a little.*

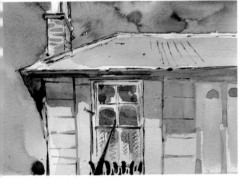

5. *Complete detailing the lines on the roof and the balcony on the right.*

BEFORE PAINTING PAINTING OVER THE DRAWING

To use a drawing as the basic component of the work, you can reverse the previous process—that is, draw first and paint later. Nevertheless, it is important to be aware that it is a matter of painting over the drawing, not coloring the outlined spaces as this would give a wooden rigidity to the work.

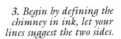
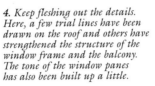

For this exercise, the model is the image of the boy sitting on the cart.

1. Make a preliminary drawing of the model in pencil and then develop it using ink and nib.

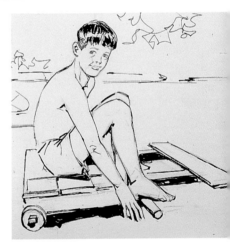

2. *Draw only those lines you consider necessary, ignore any details you feel are superfluous. Put in some of the shadows. Here several shadows are suggested, such as those cast by the cart on the ground.*

3. *Start painting the background and the ground without concerning yourself with the figure for the moment.*

4. *Now, paint the figure of the boy, developing the tones of his skin and bathing trunks. At the same time, set down the preliminary tones of the cart.*

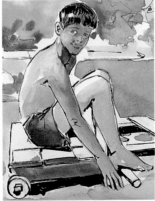

5. *Add the necessary finishing dark tones to finalize the shadows on the body of the boy and the wrinkles on the bathing trunks; also, balance the overall tones of the cart. In the illustration, you can see that part of the cast shadow under the cart has been developed with ink and the other with paint, obtaining two different intensities.*

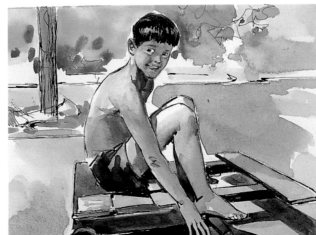

Shadows

Shadows are the dark images that bodies cast onto a surface, and they are an effect of light. Shadows are simply a lack or a lessening of the light that strikes a body. The direction and the color of a shadow depend on the body that casts it and the color and the direction of the light received.

CHARACTERISTICS

Subjects bathed in bright light will cast a dark or intense shadow. The brighter the light the darker are the shadows. Under a powerful light source or the midday sun, the shadows cast by an object are darker than those it would cast under either the soft light of a small lamp or the morning sun. Additionally, shadows follow the direction of light. If light strikes an object from the right the shadow will be cast to the left, and several light sources will, of course, produce several shadows in the appropriate direction. With multiple light sources, shadows are usually soft and sometimes hardly visible. It is thanks to the interplay of light and shadow in painting that a sensation of volume and three dimensionality can be created.

All objects produce two kinds of shadows: those of their own shaded areas where the light does not strike them and the shadow they cast on other objects. Every object that receives light presents a range of values. These vary from the most luminous, where the light strikes the object directly, to the darkest hues in the object's shaded areas. There is an entire range of intermediate tones between these two extremes.

TECHNIQUE

As with light, the artist uses color to represent shadows. There is no single color for painting shadows as their tone is dictated by the light and the color of the object that produces them. That is why using only black to paint shadows makes them appear unreal. In addition, black tends to cancel out objects rather than darken them.

Although almost all shadows have some blue in them, when the light is a warm color, the shadows usually have cool hues. And when the light is a cool tone, the shadows usually have a warm component.

A shadow almost always contains a slight tone of the color of the object that produces it, although it is not always necessarily a darker tone of the same color. A shadow may have gray tones or cool or warm ones, it may be bluish or violet and can even contain a tone complementary to the color of the object that casts it.

There are several methods for painting shadows and all are valid. Whether you choose one or another depends on your skill and preferences.

To paint shadows in watercolor, some artists resort to an underpainting, which is simply a sketch of the future work (see page 47). In this sketch the artist sets down the areas of shadow in the work and, as watercolor is a transparent medium, the darker areas are still visible after they are painted over.

Another way of painting small shadows before you start painting is to draw them in ink and then paint over them. In this way, the darker areas will appear well defined. If the paint is applied while the ink is still wet, the ink will diffuse and create a vague patch of color.

Generally, however, shadows are painted at the same time as the rest of the work. Even so,

it is best for the beginner to leave the shadows to the end as they are the darkest parts of a painting and if they are introduced too early in the process, the overall tonal balance of the work could be spoiled.

Shadows can be used to create strikingly different effects. Darkened areas can serve to heighten the luminosity of those parts of the subject on which the light falls. Conversely, a darkened area can itself serve as a focus into which the viewer is impelled to peer to discover details that are just barely discernable.

MORE . . .

A discussion of shadows necessarily involves light. You will find more information on this subject in the chapter entitled "Light" on page 96.

In this watercolor you can see all the tones ranging from the highlights, the lightest areas, to the darkest shadows.

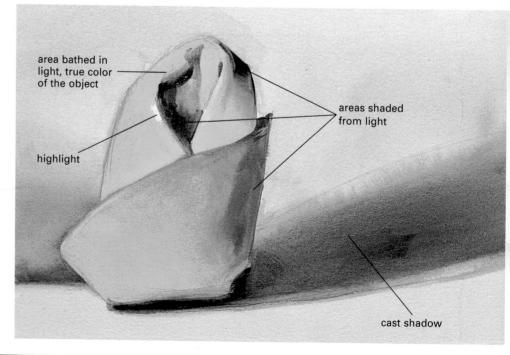

area bathed in light, true color of the object

areas shaded from light

highlight

cast shadow

SHADOWS — LIGHT WITHOUT SHADOW

The light of a fluorescent lamp or of a cloudy day spreads out in all directions and creates weak and poorly defined shadows that are hardly visible. Painting an object without shadows is difficult as it is the shadows that transmit the sensation of volume; moreover, an object that does not cast a shadow on the ground will appear to be floating in space.

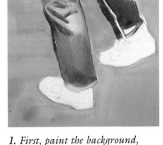
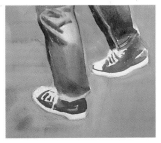

As you can see in the photograph this exercise is using as a model, the gray day in which the photo was taken hardly produced any shadows at all.

1. First, paint the background, reserving the areas for the legs. Then use a blue wash and dilute the paint accordingly to achieve the different tonal values in the legs.

2. Next, paint the shoes and the remaining details of the pants.

3. While the paint is still wet, touch up the wrinkles in the pants and some details in the shoes.

NOTE

Shadows on an object usually contain some of the color of the object, but in a darker tone. Shadows cast by the object also have a tinge of the color of the object that creates them.

4. Last, add the lines of the bricks and the small details, including a small shadow that is hardly visible behind the first shoe. Here, the artist has succeeded in grounding the shoes to the floor with the merest hint of a shadow, avoiding that floating sensation that is usual when the shadows are completely missing in this type of light.

SHADOWS — SHADOWS AT SUNSET

Light at the start and close of the day is a warm color and produces long shadows that have a cool tone. The light at sunrise and sunset is interesting as it usually bathes objects with warm tones and, unexpectedly, produces shadows in cool or neutral tones such as violet.

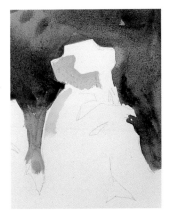

For this exercise you will reproduce a detail of the work by Sargent Villa di Marlia, The Balustrade.

1. Paint the background, reserving the figure in white; then, start painting the shadows in the lightest color, the yellow that will suggest the material the statue is made of and the color of the indirect light that bathes it.

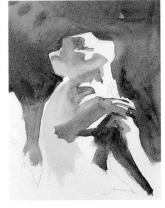

NOTE

Clouds act as a filter that can change the intensity of the shadows entirely as well as the overall atmosphere of the space, turning warm tendencies into cool.

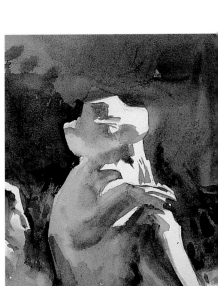

2. Spread out the yellow to soften the tone and add the shadows in blue, which, when it mixes with the yellow, will acquire a subtle violet tint.

3. Develop the darkest parts of the arm and leg. Be sure to reserve the white for the areas that receive the light directly.

4. Darken parts of the back slightly and soften the shadows of the leg and arm to balance the tones. To finish, add the vegetation with a few quick strokes.

SHADOWS SKETCHING THE SHADOWS BEFORE PAINTING

One way of painting shadows is to sketch them before you actually start to paint. This can be done with watercolor paint itself, with ink, or with the pencil you used to make the preliminary drawing. The transparency of watercolors will allow the sketch of the shadows to show through the subsequent applications of paint.

The subject, here, is a beach at sunset.

1. After drawing your sketch in pencil, use a bamboo pen and India ink to set down the darkest shadows.

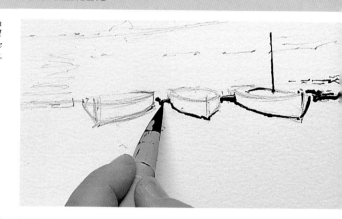

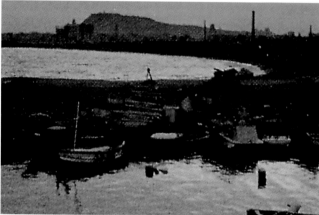

2. Lay a wash of burnt sienna for the background.

NOTE

If you use watercolor to sketch the shadows first, keep in mind that wetting the paper excessively with the additional washes could cause the sketched lines to diffuse as in the wet-on-wet technique.

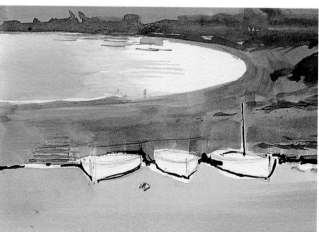

3. Suggest the warm color of the sky reflecting in the water and reserve the area for the boats. In the illustration, you can already see the contrast building in the shadows created with the ink.

4. Add the lower part of the boats and the reflections in the water.

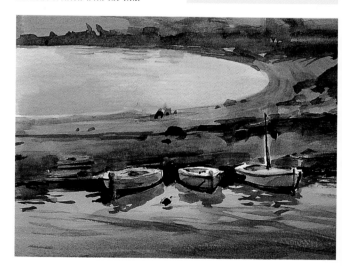

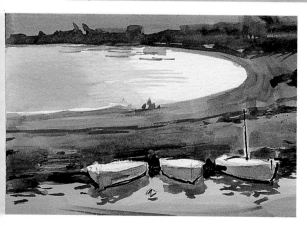

5. Finish your work adding some general touches of detail and painting the upper part of the boats.

SHADOWS | **DEVELOPING THE SHADOWS ALONG WITH THE FORM**

Each artist has his or her own method for painting shadows; nevertheless, the best way of doing this task is to develop the shadows at the same time as the painting itself. This allows you to evaluate the tones and correct mistakes as you construct the work.

For this exercise, you are going to use the twisted trunk of this olive tree as a subject.

1. First, apply some light washes to the background and to the darker parts of the trunk.

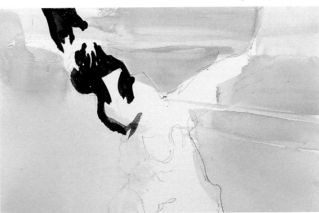

2. Diffuse and gradate the dark color of the first shadow. Lay a light wash for the entire trunk and suggest the shadows of the tree. Partially paint the shadows the tree casts on the ground. As here, reserve the areas on the branches that will have foliage over them.

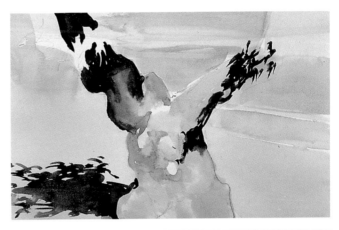

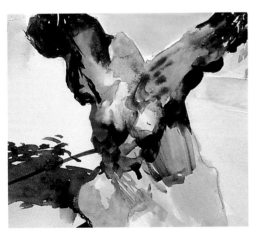

3. Continue building the tones to suggest the texture of the trunk and begin adding the foliage.

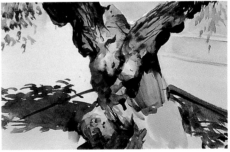

4. Continue painting the foliage of the branches, the other part of the gray cast shadow, and add a few small shadows to the lower part of the trunk.

NOTE

As you cannot lighten tones in watercolor painting by superimposing glazes, do not paint the shadows too dark until the rest of the painting is balanced. We recommend gradually darkening the shadows with washes as the other tones of the work are built up. This method makes timely corrections possible and allows intensifying the shadows with additional washes if the work calls for it.

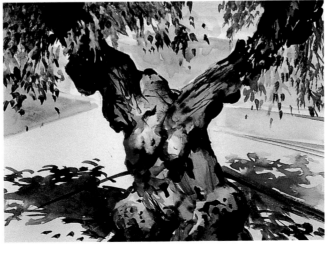

5. Last, complete the shadows in the lower part of the trunk and paint the cast shadow on the rear part using a diluted blue hue as it needs to be lighter.

Light

Light is what gives objects their volume and color. Everything you see depends on light. The color of an object is also affected by the light that illuminates it. Light establishes the atmosphere of a work and the sensations that this atmosphere, through its colors, will stimulate in a viewer.

The color of light can infuse a landscape with warm or cool tones. The direction and intensity of the light can make a subject appear mysterious, dramatic, or innocent.

TECHNIQUE

Without light, there is only the black of darkness; forms, colors, and the sensation of space do not exist.

Before starting to paint, an artist must study the light to evaluate tones correctly, to position the shadows properly, and to observe the effect light has on the colors.

To capture both the brilliance and dimness of light, the watercolorist uses the lighter colors for the most illuminated areas and the darker tones for the less illuminated ones.

As explained previously, the color white does not exist in watercolor paints, instead, the white of the paper is used. Nevertheless, remember that although an object may actually be white, it will not generally appear to have a purely white color, because all objects are affected by the color of the light striking them and that of other surrounding objects. The areas of maximum intensity, therefore, are usually small points where bright reflections, or highlights, occur. The artist employs the reserving technique to maintain the purity of the white paper that will represent these highlights, which will be the lightest areas of the entire painting.

It is impossible to discuss light without mentioning its color and the shadows it produces. For example, who can recreate the brightness of a sunny scene without warm colors and the contrast of dark and well-defined shadows. The subdued light of a cloudy day, on the other hand, would best be represented by cool, bluish gray colors and the complete absence or a mere hint of shadows.

THE DIRECTION OF LIGHT

Light, by its effect on colors and the direction from which it comes, can gain an important psychological component. The light of a powerful spotlight, when placed overhead, produces dark shadows that create contrasts and can give the work dramatic overtones. It is a type of lighting that has been used a great deal in paintings with a religious theme. By comparison, to create a sensation of freshness and purity, front lighting is used. In this case the shadows are not visible and there is no interplay of contrasts. Lighting a figure from below creates an eerie, mysterious effect. Backlighting an object or a figure can also produce striking effects. The parts of the subject that are dense and solid will appear dark—perhaps even in silhouette. Light will glow softly through thin or translucent areas; and it will stream around the opaque edges of the subject, sometimes creating a halo or aura that focuses the viewer's attention as effectively as a spotlight.

EXERCISES

In the following exercises you will see how the impression produced by the same object can change depending on the angle of the lighting. You will construct an image step by step and will experience how the treatment of a subject changes in accordance with the lighting used.

COLOR

Frontal lighting casts shadows behind the subject. The virtual absence of shadows when this type of lighting is used means that there is little tonal contrast, so volume is created by the color, not by the shadows. This kind of lighting is, therefore, highly suitable for emphasizing the color. The lack of contrast also produces a psychological sense of innocence. Front lighting allows you to see the forms just as they are, without any type of distortion. This is why it is particularly suited to portrait painting and has been used throughout the history of art to represent, for example, the purity of virgins.

FRONT LIGHTING

The subject is illuminated from the front.

1. Before starting to paint, partially erase the pencil lines of the preliminary drawing.

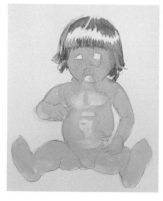

2. Color the outlined shape with a wash in a medium tone and reserve the highlight areas. Slightly deepen the tone in the darkest areas. Use a dark tone for the hair and try to suggest the texture with your brushstrokes; reserve the hair's highlights.

NOTE

As frontal lighting does not create dark shadows, avoid including them in the drawing. It is also advisable to erase any pencil lines before you start to paint because you cannot conceal them later with dark tones.

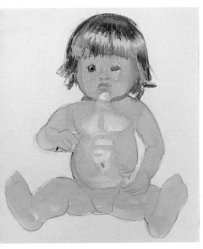

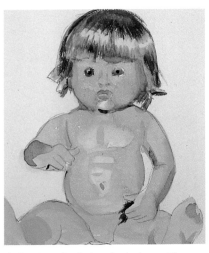

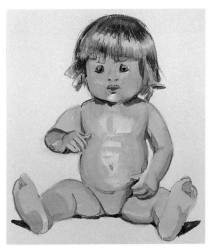

3. Finish the hair giving the highlights a yellow wash. Paint the eyes and mouth, and outline the forms with the small shadows on the neck and stomach.

4. Continue developing the shadows with washes that build up the underlying tone, each time making the direction of the light more evident.

5. Apply the last touches to the darkest tones in the small shadows that suggest the volume of the figure. With this procedure, the areas that were reserved at the beginning are still unchanged; the tones have been developed from light to dark.

VOLUME

SIDE LIGHTING

Light bathes the subject from one side, leaving the other side in shadow. Side lighting suggests volume through the shadows it creates. Although it is not commonly used in studio lighting, this type of light source is frequently found in daily life—for example, seated figures bathed in the light of a table lamp—so it is worth studying its effects. Side lighting is very suitable for rendering the volume of a subject through the interplay of light and shadow and for experimenting with chiaroscuro.

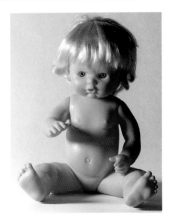

The subject has been illuminated from the side using a fairly powerful light that produces sharper contrasts with darker shadows.

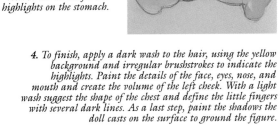

1. Apply a light-toned wash and reserve the whites for the highlights on the stomach.

4. To finish, apply a dark wash to the hair, using the yellow background and irregular brushstrokes to indicate the highlights. Paint the details of the face, eyes, nose, and mouth and create the volume of the left cheek. With a light wash suggest the shape of the chest and define the little fingers with several dark lines. As a last step, paint the shadows the doll casts on the surface to ground the figure.

2. With a few darker washes build up the tone to suggest the position, shape, and direction of the shadows on both the body and face.

3. Paint the shadows on the legs and add a yellow wash for the hair.

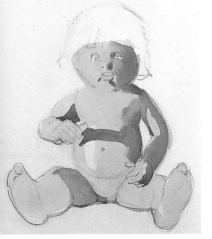

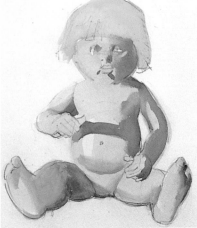

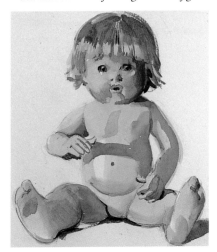

MYSTICISM OVERHEAD LIGHTING

Overhead lighting usually produces strong contrasts that distort the forms and features of a subject. This is why it is unsuitable for portrait painting or for representing forms. It can be used for painting distorted volumes or for creating certain kinds of atmosphere. Overhead lighting has been widely used in religious paintings to impart a sensation of spirituality and divine influence.

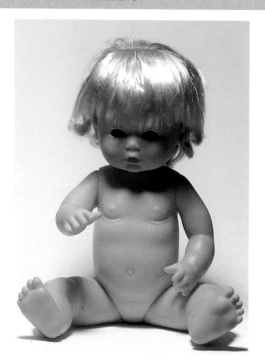

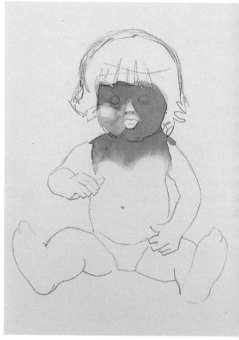

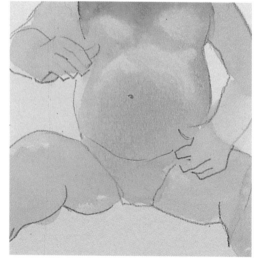

In this case, the subject has been illuminated from above; rather than giving a mystical aura to this nonreligious theme, the lighting here creates an effect similar to that of the midday sun.

1. Paint the shadows of the face and neck using a dark wash, and reserve the highlight on the cheek

NOTE

Overhead lighting and lighting from below are not suitable for portraits because the shadows they create distort the features of a subject. These types of lighting create opposing atmospheres and sensations.

2. Lay a light-tone wash in the area of the stomach and over the entire body.

3. Add the color of the hair and begin to flesh out the facial features. At the same time, develop the principal shaded areas of the body with washes in various tones.

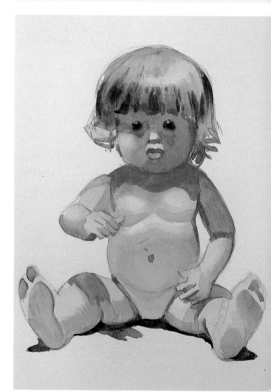

4. Give the final touches to the hair and mouth. Define the shadows on the left arm to lend it shape and volume. Finish the feet and the cast shadow.

MYSTERY Lighting from below

As with an overhead source, lighting from below produces long, sharp shadows that distort the features. Illuminating a subject from below can give it an eerie and mysterious quality. Therefore this type of lighting has been used to represent Hell and sinister, decadent atmospheres. On the other hand, this type of lighting is similar to that produced by a fire in a hearth or on the ground and is also ideal for working in chiaroscuro and for conveying a sensation of intimacy.

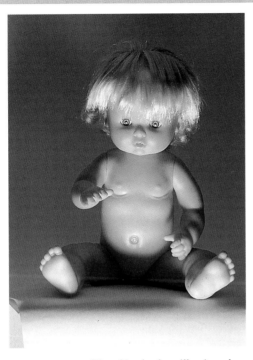

The subject has been illuminated from below using a light that creates sharp contrasts and makes the areas in shadow virtually blend into the background.

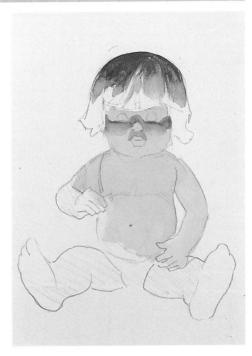

1. Paint the top part of the hair using a dark tone and reserving part of this area for the lighter tones. Add a light wash for the overall tone of the body and suggest the shadows on the face.

NOTE

The background has not been painted in this exercise so you can easily see the pattern of the shadows. Otherwise these shadows would blend into the background, distorting the forms and increasing the eerie effect produced by the image.

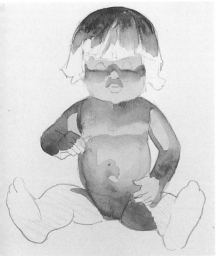

2. Develop the darker parts of the body, reserving the first wash for the areas of light.

3. Apply a yellow wash to the part of the hair that you reserved and develop the dark tones of the legs.

4. All that remains for you to do are the details of the hair, the eyes, and the small mouth. Finally, outline the arms, hands, fingers, and legs; also add a small cast shadow to avoid that floating sensation produced by a body that casts no shadows.

Atmosphere

In painting, *atmosphere* refers to the representation of air. The atmosphere greatly affects how an object is perceived; the air that comes between a viewer and an object makes the latter lose definition as the distance between the two increases. For the same reason, such an object also loses color and contrast. When observing objects situated nearby, or in the foreground, they appear perfectly sharp and possess all the tonal contrasts of light and shadow and all their color. As the observer moves away, the intervening atmosphere causes the objects to gradually lose their color and take on overall neutral tones, generally grays and blues. The outlines become more hazy and the forms barely have any contrast of tone or color.

KEYS TO PAINTING THE ATMOSPHERE

The atmosphere is something real that can be perceived in the color and the definition of the forms. To successfully paint the effect of the atmosphere on different objects, the following three key points must be considered.

1. The foreground of the work should contain the strongest contrasts as this will create a sensation of proximity and, at the same time, make the other planes appear more distant. To obtain these contrasts the artist needs to experiment with the values and the interplay of light and shadow. Color contrast can be achieved by using the complementary colors. In addition, the objects in the foreground must have clearly defined outlines; a wet-on-dry approach is ideal for this purpose.

NOTE

The atmosphere, laden with moisture and dust particles, always intervenes between spectators and the scene or objects they are observing; it is, then, a reality that cannot be ignored in painting.

2. Objects that recede into the backgound should turn a grayish tone and gradually become a more neutral bluish color. Contrasts should also be gradually softened as the objects move to the back planes of the painting.

3. In the background, the objects' outlines should become indistinct as this is the true effect of the atmosphere. The wet-on-wet technique can aid you in achieving this impression; if you are working on dry paper, however, dilute the edges with the brush.

GLAZES

REPRESENTING THE ATMOSPHERE BY SUPERIMPOSING TONES

Glazes are the main technique in watercolor painting; consequently, using them to create an atmospheric effect is quite common among watercolorists. By superimposing glazes, the tones in a painting deepen as they do in real life in the eyes of an observer.

To achieve the best results with glazes, it is essential that the first layer of paint be dry before you apply the next.

In painting this detail of the work by Winslow Homer, Two Men in a Canoe (1895), you are going to create the atmosphere by superimposing increasingly intense glazes.

1. Suggest the mountain in the background with a fairly diluted ochre glaze.

4. Last, paint the closest trees. Here, note how the artist, while superimposing layers, has also introduced the reflections in the water using the same tone, but a little more diluted.

2. Next, lay a glaze to hint at the group of trees on the right.

3. Paint the vegetation on dry, superimposing a color on the previous group of trees.

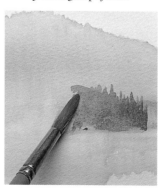

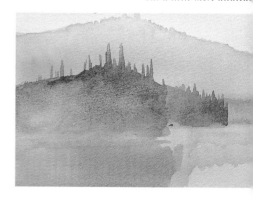

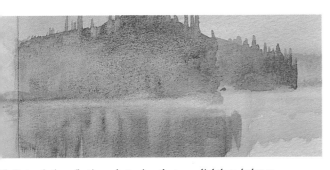

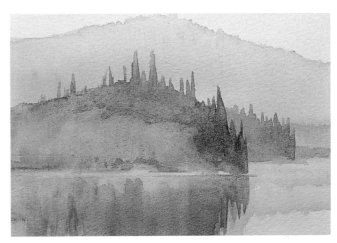

5. Retouch the reflections, deepening the tones slightly to balance the overall values.

6. To finish, complete the darker group of trees and their reflection in the water. You can see here how each layer is darker and more contrasting than the previous one. The lines also become more defined as they approach the observer.

CONTRASTS

PAINTING THE ATMOSPHERE WITH A SINGLE GLAZE

In this exercise, you are going to paint a city's atmosphere, which is usually denser than that of the countryside or the seaside, by covering the work with a glaze. This will allow you to differentiate the contrast between one plane and another and create an overall impression of atmosphere. At the end, you will need to retouch the foreground to add emphasis to the forms and the intensity of the colors.

The atmosphere in cities is usually more visible due to the pollution.

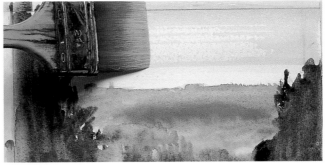

1. As usual, start with a soft blue wash for the sky and a cool blue tone for the most distant part. Over this you apply a neutral gray wash to create a second plane. In this way you have already created a sense of atmosphere.

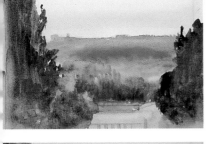

2. Add the foliage of the trees in the foreground.

3. Apply a light, cream colored glaze on dry.

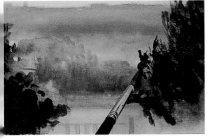

4. Cover the entire surface of the paper with this glaze, even the trees in the foreground, to create a definite sense of atmosphere.

5. Next, retouch the foliage to create contrasts and define the outlines.

6. Develop the foreground until it results in a clearly defined plane that heightens the sensation of distance between it and the other, more distant planes.

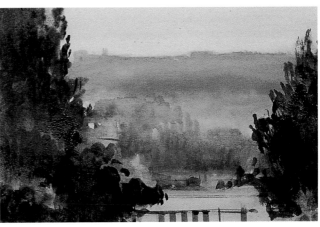

Skies

Watercolor is the ideal medium for reproducing the soft transparency of the sky, the fluffy and vaporous qualities of the clouds, the magical effect of the beams of light between storm clouds, or the moisture saturated atmosphere of a rainy morning.

Skies can be easy to paint, with only a simple wash if it is a clear sky, or rather complicated, if it is an overcast sky through which the sun's rays filter. Consequently, each type of sky requires a different approach.

SKIES AND LIGHT

In watercolor paintings the sky usually takes up a large part of the paper. This makes them into the main feature of landscapes and seascapes as they create the predominating atmosphere of the work and decide the tonality of the light.

Changes in weather directly affect the sky and therefore everything under it. These changes can be surprisingly quick and can alter the overall tones of the landscape and the colors in a few minutes.

The sky and the earth are closely related and you cannot paint a landscape or seascape in watercolor successfully if you are not aware of this.

When painting nature, the sky is the light source; therefore, it determines the colors that are to be used in the painting because the landscape or seascape takes on all the hues of the sky. Accordingly, a sky at sunset will inevitably imbue the natural setting and all objects under this light with its range of orange and violet hues, especially objects in the more distant planes. A few hours beforehand, under a brilliant sun, the same landscape was full of life and its colors shone in all their intensity. The same day, but under an overcast sky, the same landscape has cool tones and all the colors become grayish and lose their vividness.

Artists should never ignore the character and impact that the sky can lend to their work; the combination of the sun's rays with a fluffy mass of clouds can create truly dramatic scenes that are a work of art in themselves.

Given the endless variety of conditions the sky can present, creating one in watercolors can be easy or difficult. The complexity of the task is related to the light and cloud cover that exist at the time of painting it.

A quick sketch will help you capture the shape of the clouds, their position, and even the shadows they cast on the ground as they move.

TECHNIQUE

The variable character of the sky makes it essential to study it carefully before starting to paint. In the watercolor technique, as in all styles of painting, observation is basic to the successful execution of a work. Even a clear sky carries many different hues that cannot be appreciated at first sight. It is especially useful to make sketches of the subject, noting the position of the sun, the direction of the light, and the colors and tones. For fickle subjects like the sky and the sea, it is important to summarize what you are going to paint.

Watercolor skies can be painted using the dry or wet technique, depending on what you prefer. Even so, many watercolorists use the wet watercolor technique for skies because colors are easier to gradate, and the moisture creates soft edges and spongy textures that are ideal for suggesting clouds.

Painting a sky may seem difficult at first; as you begin to master this technique, however,

it may well become the easiest part of the work. Depending on the type of sky, you will have to continually gradate the colors, reserve whites, absorb paint with paper or with a brush, lift out color, and so on. In short, you must know all the secrets of watercolor painting as you will need to work quickly, without hesitation, and without pausing. This is how you can capture the freshness of the atmosphere, the sparkle of natural light, and the spontaneity of a cloud at a particular moment. Do not be discouraged if your first attempts are less than satisfactory. Practice will increase your confidence and your speed.

CLEAR SKIES

Clear skies are the easiest to paint because a simple wash is all it takes to suggest a clear morning sky.

In any case, painting a cloudless sky in watercolor involves gradating as the intensity of the color varies near the horizon line. The blue of the sky generally loses intensity as it reaches down to the earth and begins to take on grayish tones. As a general rule, a sky should not be painted with a flat wash in a single color because it would appear less realistic.

Although clear skies are not as difficult as cloudy ones to paint, rendering a cloudless sky in watercolor requires a certain mastery of the wash technique because on many occasions a sky of this kind contains numerous tones that gently merge into one another. The best example is the sky at dawn and at dusk when blues are mixed with grays, pinks, violets, and oranges. Gradated skies are usually painted using the wet watercolor technique, which allows the pigment to diffuse and the colors to blend together imperceptibly.

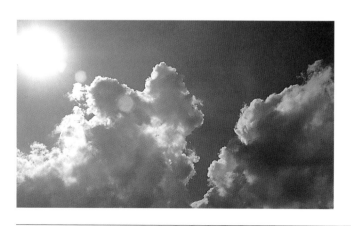

You are going to paint a cloudless sky at sunset with a light mist. This is a quick exercise that is not particularly difficult but can be used to good effect.

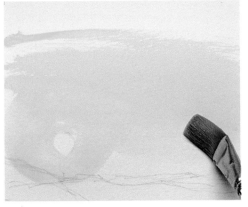

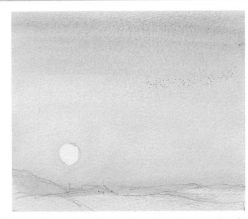

1. Paint the center using a medium yellow wash containing a touch of cerulean blue, reserving a round area for the disk of the sun.

2. Complete the wash, gradating the color as it approaches the horizon line. Here, in the upper part of the sky more cerulean blue has been added to create this greenish tone.

3. Paint the land; also intensify the yellow tone around the sun and soften the edges using a clean, damp brush.

4. Your result should resemble this clear sky in which the disk of the sun is the only part that is still white.

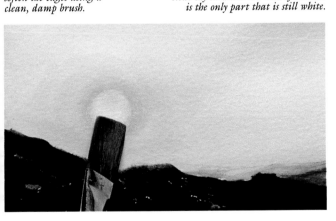

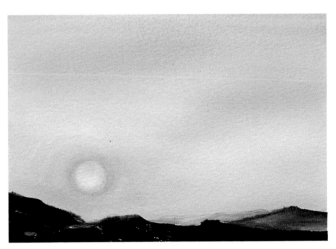

CLOUDY SKIES

Clouds and sunlight are the two factors that endow the sky with the strength to set the tone for the work. Clouds can appear to be small balls of cotton floating in space; they may form long sweeping ribbons that stretch across the entire sky; or they may become a gray, rain-laden, threatening mass. The many changes a clear sky undergoes with the various positions of the sun seem minimal when compared to the almost infinite variations of a cloudy sky; the clouds, driven by the wind, are continually changing their form and position.

Of course, as the clouds change, so do the shadows they cast. Remember that clouds, even though they are not solid, are also affected by sunlight. Some allow the sun's rays to penetrate them while others are so dense they can block the sunlight and take on a darker tone on the side not reached by the light. This is the area in shadow, the cloud's own shadow.

Clouds, like any other mass, have their own shadows and the shadows they cast on the earth and on other clouds. These shadow variations continuously alter the tones of the sky and the earth.

Before you start painting, therefore, it is important to make sketches of the position in the sky of the clouds, their shape, and the shadows they cast on each other and on the ground.

Apart from the color of the sky you must also note the clouds' color, which can vary according to the predominant tones of the atmosphere and also affect the color of the sun's rays. Clouds can have an infinite number of colors from pale pink at dawn to a pure white at other times of day, not forgetting the many different tones of blue they acquire at night, under the moonlight.

In addition to beautiful hues, clouds can also present a wide range of grays, usually neutral grays. Moreover, a stormy afternoon can produce groups of clouds that display a surprisingly wide spectrum of tones, ranging from the dark gray tones in the density of the clouds to much lighter tones where the sunlight strikes them.

Clouds do not always form high in the atmosphere and in a floating mass with a definite outline. They are often ill-defined and can sometimes be found at ground level as mist.

Using a palette of soft tones, watercolors are probably the ideal medium for suggesting the softness of a mist and the light of sunbeams radiating through a fog.

CLOUDY SKIES — CLOUDS AND SUNLIGHT

Although not simple to achieve, the effect of sunlight breaking through the clouds in splendorous beams can give a highly interesting and dramatic note to any work.

You are going to paint part of a watercolor by Stanley Roy Badmin, entitled Bolton Abbey, Wharfedale (1906). The meticulous style of the age required slow, detailed work. In this exercise, you will be creating the same detail quickly.

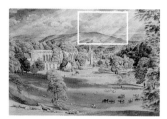

1. After suggesting the clouds on the left and applying a gentle wash on the right with a mixture of burnt sienna and cobalt blue, paint the mountain top. Before the paint dries, lift out the whites for the sun's rays using a clean brush.

2. Continue to work on the clouds, opening up more whites for the rays.

4. To finish, clean up the white of the sun's rays, which was painted over with the yellow wash, and add the green notes that suggest the trees on the ground.

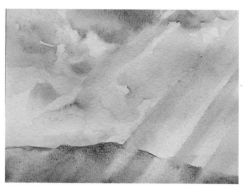

3. Apply a yellow wash to achieve this creamy effect.

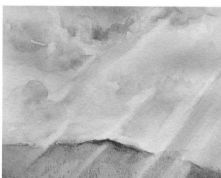

CLOUDY SKIES — LOW-HANGING CLOUDS

In this exercise, you are going to paint a sky with a low cover of large clouds that are extremely expressive. This subject presents voluptuous forms and a variety of color.

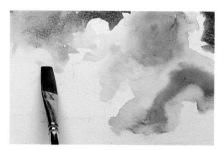

2. Fill the left corner with a mixture of cobalt blue and ultramarine blue. With a clean, dry brush absorb any paint that has spread beyond the outline.

3. Paint the patch of color in the center mixing cadmium orange with ochre and cobalt blue. In this illustration, the areas where the three colors have mixed perfectly have produced an almost black color; in other areas almost pure colors have been used to obtain these interesting contrasts.

1. Paint the first patch of color with a gray obtained by mixing burnt sienna and cobalt blue. While the first wash is still wet, add the brushstroke in the lower part with cerulean blue and touches of yellow ochre.

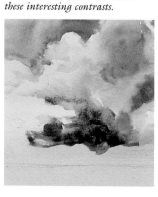

4. Extend the dark cloud toward the left and fill in the area that was still white. As you paint, be sure to reserve the white for the highlights. To finish, suggest the land and paint the water, adding the reflection. Here, the long reflection was created by lifting out the paint and then brushing on a very diluted yellow tint.

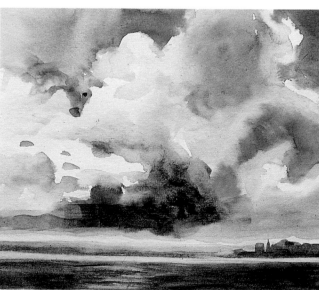

CLOUDY SKIES RAIN CLOUDS

Watercolor is the most suitable medium for representing the effect of rain in the air and a dark, stormy sky such as this one. The example illustrated on this page was painted using the wet-on-wet watercolor technique, which requires that an artist work fast to control the diffusion of the pigment and the direction of the brushstrokes. For this reason, study each step in this exercise before starting to copy this image.

1. Begin by applying a highly diluted cerulean blue wash over the entire area of the sky. The excess moisture in the paint will dampen the paper sufficiently for receiving the subsequent brushstrokes, which should follow immediately.

NOTE

A sky full of rain clouds is painted on dampened paper; it must be completed quickly and requires maintaining control of the dispersion of the pigment.

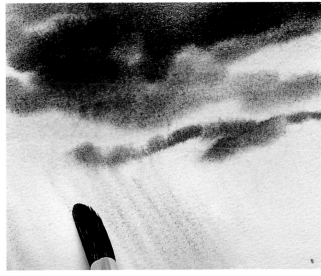

2. Set down the basic shape of the storm cloud using a mixture of Vandyke brown and ultramarine blue.

3. With a little cobalt blue added to the mixture, vary the tones in the contours of the cloud and add an elongated wisp below the cloud mass. Dilute this color further and draw a few diagonal brushstrokes; these will suggest the falling rain after the paint has spread out over the surface of the paper.

4. Next, clean and blot-dry the brush to absorb some of the paint that has spread out to the areas that must remain white where the cloud separates.

5. To finish, add a few touches using a mixture of cerulean blue and the tone used in Step 3, and then paint the ground. In your work, as in this illustration, you should see that the diagonal brushstrokes have softened with the expansion of the paint and have created a spontaneous and realistic impression of rain falling from the cloud.

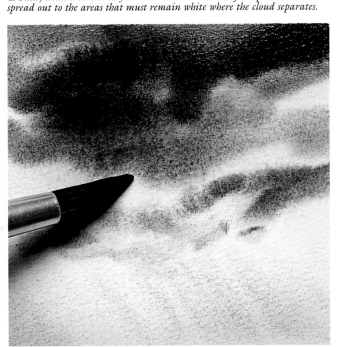

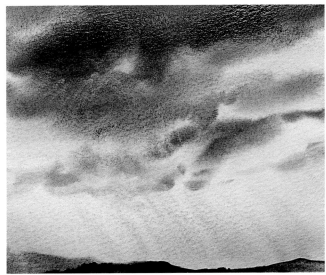

CLOUDY SKIES | Fᴀsᴛ-ᴍᴏᴠɪɴɢ ᴄʟᴏᴜᴅs

A cloudy sky does not necessarily mean the sun is not shining. Often, the sun appears over an intensely blue sky that contains clouds. Against such a bright background, the clouds look dazzlingly white. In this exercise you are going to portray a windy day with a brilliant blue sky punctuated with billowy clouds.

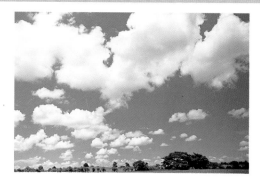

This photograph was taken on a sunny day, with a strong wind driving the clouds speedily across the sky.

NOTE

In watercolor painting, skies with white clouds should be thought of as a "negative image" because what you are really painting is the sky that outlines the clouds, which are left unpainted to maintain the pure white color of the paper.

1. Before starting to paint, use a pencil to sketch the position of the clouds on the paper. Create a gray by mixing burnt sienna and cobalt blue, then use it to paint the shaded area of the cloud to suggest its volume. To paint the most intense blue parts behind the cloud, make a mixture of ultramarine blue and indigo.

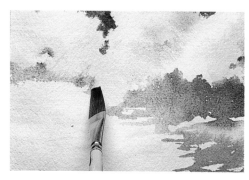

2. Proceed with the background, but lighten the blue tone by adding cerulean blue and cobalt blue. Carefully paint around the areas reserved for the clouds, applying the deepest colors around their outline.

3. Continue painting to complete the sky.

4. Finally, add the land and give the final touches to the sky.

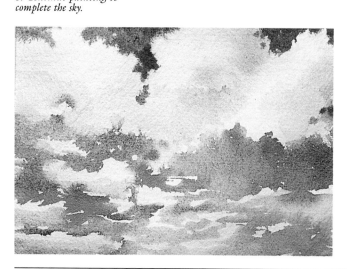

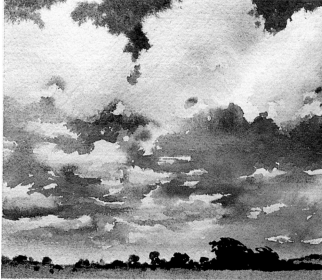

NIGHT SKIES

Night skies have never been as popular a watercolor theme as daytime skies because the darkness of night does not allow painting from nature and robs the landscape of its color. Even so, a night sky can have special charm—for example when a striking moon is present, or when the moonlight casts a magical atmosphere upon the landscape.

The colors of a night sky can vary a great deal more than those of a daytime sky; at night the clouds take on dark tones and the sky is virtually black. Night, however, does not limit the variability of forms that the sky displays throughout the day. To render the glow of a full moon in a painting, an artist will need the same soft blue tones that are commonly used to paint a daytime scene. Illuminated by moonlight, forms are discernible and cast shadows that make their volume easy to suggest in the work. A moonless night, by comparison, presents a sky in plain neutral gray, with hardly any gradation; forms appear as little more than silhouettes cut out of the background and yield few opportunities for creating a sense of volume.

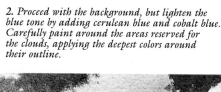

NIGHT SKIES — NIGHT OVER A MARSH

Here is an example of a sky with a full moon from which you can see the great amount of light it presents and the gentle atmosphere the moonlight creates.

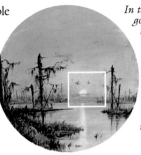

In this exercise, you are going to reproduce a detail of a James Hamilton work, Moonlight (1864), which shows a surprisingly light sky illuminated by the mist-diffused light of a full moon.

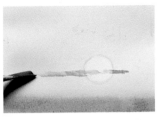

NOTE

A night scene has dark tones and strong contrasts that are more difficult to achieve than those of a daytime landscape.

1. Reserving a white area for the moon, cover the surface of the paper with a wash of cerulean blue and a little yellow. Before this first wash dries out entirely, deepen the tone of the horizon by adding more cerulean blue to the mixture to suggest a denser mist. Use the same tone to create the wavy line of the mist.

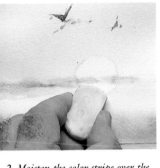

2. Moisten the color stripe over the moon to make it appear more nebulous. Then, with the same blue, but adding a touch of ultramarine blue, suggest the plants of the marshland. Paint the birds in burnt sienna, and erase the pencil line around the moon.

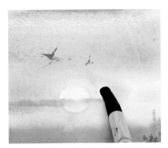

3. Apply a soft, highly diluted wash of medium yellow over the white of the moon. Then, paint the entire sky again with a glaze of cobalt blue.

4. To finish this work, retouch the perimeter of the moon and paint the bird on the right and complete the vegetation.

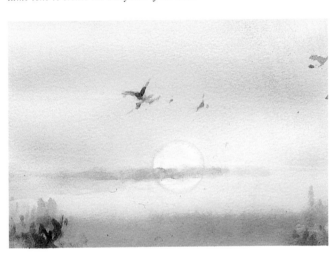

NIGHT SKIES — A FIERY SKY

The rays of the sun in the sky at dusk can display a surprising range of colors that is enhanced by the beautiful interplay of the light and dark areas.

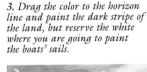

This work by Winslow Homer, entitled Gloucester Sunset *(1880), features an attractive sky, full of color, strength, and drama. It is the subject for our next exercise.*

1. First, paint the diagonal brushstrokes in medium yellow and a touch of vermilion.

4. Add the finishing touches to the sky, retouch the outline of the moon, and sweep the horizon with a few vermilion brushstrokes.

2. Paint the areas of light in pure cobalt blue and those of shadow with a mixture of this color and burnt sienna. This illustration shows, in certain parts of the sky, the cerulean blue that is in the mixture. Before the paint dries, use a clean brush to lift out the color for the white of the moon.

3. Drag the color to the horizon line and paint the dark stripe of the land, but reserve the white where you are going to paint the boats' sails.

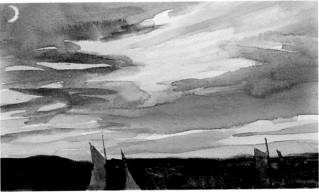

Water

Water presents an extremely complex appearance because its surface is constantly changing and there is no definite shape or color an artist can use as a point of reference in painting it.

A large body of water is in continuous movement; for this reason, its shape varies from one moment to the next. Water also reflects light, which endows it with many highlights. These fluctuations, force all artists who wish to paint water to resort to their memory or to quick sketches before starting to paint.

Water also acts like a mirror and reflects a distorted image of any solid objects on its surface. Depending on the light, water can appear transparent or opaque, or even both at the same time.

TECHNIQUE

You cannot expect to recreate water in a painting precisely and at the same time capture its spontaneity. Water's constant transformation forces the artist to summarize the impressions it evokes in its viewer. Moreover, it demands careful observation even before starting to make a sketch. Only close study of the moving body and its shimmery light reflections will give you sufficient knowledge to translate its fluidity into a static image.

Watercolor's transparency makes it one of the best media for capturing the crystalline quality and tenuous solidity of water, as well as the sparkle of its highlights.

To maintain the characteristic freshness of this subject in your painting, we recommend working with definitive tones and avoiding an excess of glazes or repeated brushwork. Even though renderings of this subject generally need a great deal of work (often requiring that they be finished in the studio), the impression they must convey should be exactly the opposite. Images of seas, lakes, rivers, and waterfalls should seem spontaneous and flowing.

STILL WATERS

The sea outside a harbor is usually calm at dawn and at dusk, although on certain days it remains calm all day long. A perfectly still sea seems as solid and reflective as a mirror.

Other bodies of water—a puddle in the street, a lake, the liquid inside a container, for example—can also behave like the sea. When water is calm it not only reflects light but also the images of the objects that are on or above its surface. These objects could be anything, a rocky cliff, a group of houses, clouds, a boat floating on the water, or even people strolling on a waterside path. When painting these reflections in the water, you need to remember that they should more or less match the object that produces them, so it is best to leave them until you have defined the objects themselves.

Before painting reflections it is also important to observe them closely. You will notice that reflections become less defined the farther the object that casts them is from the water that reflects them. That is, the greater the distance between the reflection and the object reflected, the more indistinct it will appear in the water. The reflected image must be simplified, because too accurate a reflection would cause the work to appear artificial. Additionally, keep in mind that large bodies of water are never entirely calm and cause wavering outlines in the reflections.

One last point you need to observe is that the color of the reflections is always a little darker than that of the objects reflected.

The water's appearance is dependent on the light and the color of the sky, and on the presence or lack of movement on the surface of the water.

STILL WATERS

CALM WATER WITHOUT REFLECTIONS

Still waters that have no reflections may appear easy to paint and often are. However, you should not forget that this type of water usually has an opaque, yet vibrant appearance, and these are the qualities you must capture.

You are going to reproduce a detail of the work Bermuda *(1901) by Winslow Homer, in which the water is a flat, opaque surface that produces no reflections.*

THE COLOR OF THE SEA

The color of the sea reflects the color of the sky. On a sunny day, therefore, the sea takes on an intense blue luster, whereas on overcast days it looks leaden.

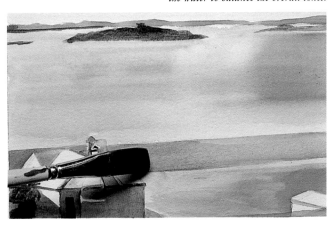

1. Using a mixture of cerulean blue and cobalt blue, apply a wash that covers the entire surface of the water. Then, using a deeper tone of the same color, start painting the lower half.

3. Deepen the blue of the thin stripe that crosses the water to balance the overall tones.

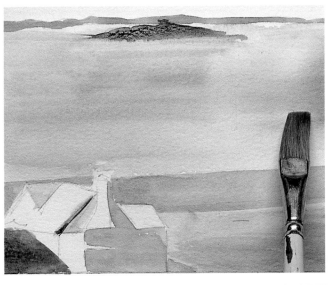

2. Suggest a change of current in the middle using the same mixture as before with a touch of medium yellow added. Increase the proportion of cerulean blue in the mixture and paint the upper part of the water. Before these last brushstrokes dry, absorb part of the paint with the brush to lighten the tone (do not forget to first clean the brush and blot it dry).

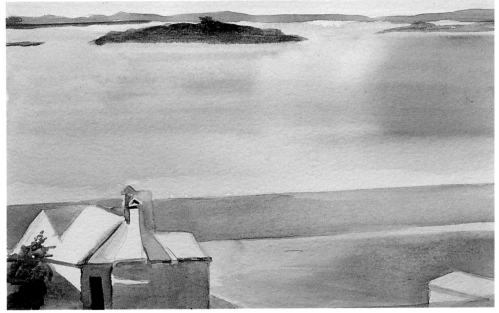

4. This illustration shows how with only two blue hues and a touch of yellow it is possible to suggest all the tonal variations of the mass of water.

STILL WATERS	REFLECTIONS IN THE WATER

Still waters act like a reflective surface in which you can clearly distinguish the images of objects. A puddle of still water reflects images almost as if it were a mirror, though there is often a slight movement in the water that breaks up the image into tiny fragments.

In this exercise, you are going to paint a detail of the work The Blue Boat *(1892), by Winslow Homer, which contains images reflected in the water.*

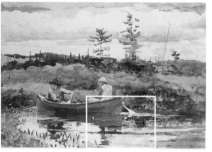

NOTE

Water that is not entirely calm usually breaks up the reflections as they recede from the object reflected. An example of this can be found in this exercise in which the hull of the boat is reflected in fairly good detail while the reflection of the angler appears distorted because he is farther away from the water.

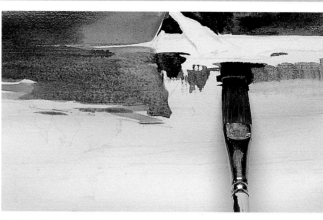

1. To begin painting the water, lay a soft wash of extremely diluted cerulean blue that will merely leave a hint of color on the white surface of the paper. Paint the reflection of the hull with a mixture of cobalt blue, olive green, and burnt sienna. Add the reflection of the grass using permanent green light for the light tones and olive green with a touch of cobalt blue for the dark tones.

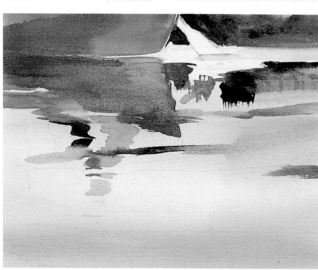

2. Reserve the highlights of the water and continue with the reflection of the figure; use a mixture of ochre and medium orange.

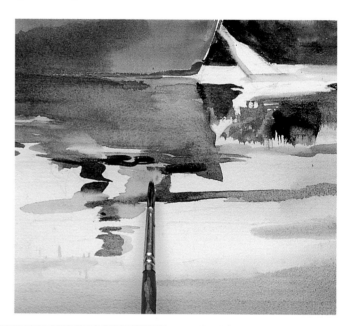

3. With a mixture of cobalt blue and burnt sienna, finish the grayer parts of the water and add some last touches to the grass and the figure.

THE COLOR OF REFLECTIONS

Although reflections are usually of the same color as the objects that cause them, they generally are a darker tone than the model. For this reason, whites are rarely pure but slightly neutral, unless the surface of the water is shiny. In this case the white of the paper is usually reserved to represent the maximum intensity of white light.

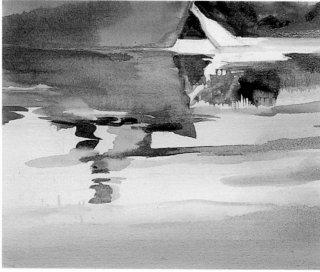

4. In this illustration of the finished exercise, note that the whites have been reserved to suggest not only the light reflecting on the water but also the oar. Additionally, you can see the reflections becoming more distorted the farther away they are from the object or person reflected.

STILL WATERS

REFLECTIONS AT NIGHT

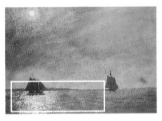

You are going to use this work by Winslow Homer, entitled Eastern Point Light *(1880), as your model.*

Because large masses of water take their color from the sky, at night water can seem dark and impenetrable unless the moon or any other light source pierces the blackness with a trail of shiny reflections.

1. You are only going to paint the detail of the water. Use a sheet of rough paper that will let the white of the paper show through. Apply a wash using a mixture of ultramarine blue, olive green, and burnt sienna. Reserve a white area for the reflection of the moonlight.

2. Paint the water using a wash with different intensities, but barely touching the paper in the area of the light. The roughness of the paper will create the mottled effect shown here. Then, add the sailing ship and the shadow it casts in the water using a dark glaze.

3. Touch up the water with some darker brushstrokes to suggest its volume. Using a mixture of ochre and cadmium orange, apply a few touches of color to the reflection of the light.

4. In this illustration you can see that the color of the water and the highlights at night have been created using tones that are quite different from those you would use to represent water illuminated by daylight.

STILL WATERS

CALM WATER AT SUNSET

At sunset, the tones and reflections in the water are in the middle of the range of colors evident between day and night.

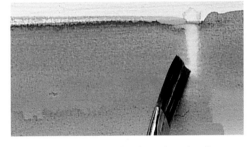

This work by Thomas Girtin, The White House at Chelsea *(1800), deals with the subject of water at sunset.*

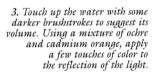

2. To paint the dark stripe of the horizon, use a mixture of ultramarine blue and alizarin crimson, reserving the white for the house. With the same mixture, paint the boat and its reflection in the water. Add more cobalt blue to the mixture used for the first wash and put in a few horizontal strokes on the left of the painting.

3. Immediately, drag the paint across the bottom part of the paper.

1. With a wash of varying intensity paint the water, using a mixture of cerulean blue, cobalt blue, and a touch of yellow. Before this preliminary wash dries, use a clean, blot-dried brush to lift out the paint to open up the white of the house's reflection.

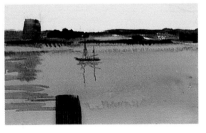

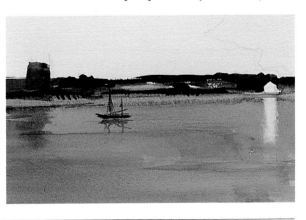

4. After this final glaze has dried you will see how in the finished work the brushstrokes suggest the variations in the characteristics of the water.

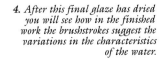

MOVING WATER

Water in motion has a fascinating spontaneity due to the rapid succession of impressions it causes. This instantaneous quality is what makes moving water so hard to capture. Artists painting from nature need to exercise their visual memory because the forms, color, and highlights change continuously. Even when painting images such as a rolling sea from a photograph, artists still need to simplify the movement or risk losing all spontaneity by attempting to copy the sea faithfully. Generally, the results of mere copying are an unrealistic and artificial image.

A moving mass of water under the sun usually presents important contrasts in color as the changing forms of the waves on the surface produce areas of intense brightness adjoined by dark areas of shadow. On a cloudy day, these contrasts are considerably less sharp.

Moving water also produces foam. For example, waves breaking against the shore, the churning water of the high seas on a windy day, the tumbling cascade of a waterfall. The density of the foam also varies—from a fine, barely perceptible mist to the dense mass of a surging torrent. Frequently, a range of these effects must be combined in one painting. This is a detail to bear in mind when planning white areas.

MOVING WATER

GENTLE WAVES ALONG THE SHORE

Even when calm, a large body of water always produces small waves or ripples where it meets the shore. The contrast of light and shadow in these small waves allow the artist to give them shape and volume to create interest. John Marin's treatment of water in the work used for this exercise is especially attractive thanks to the spontaneous and seemingly effortless brushwork.

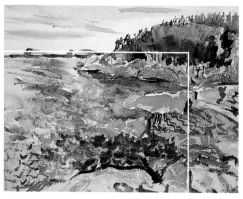

This work by John Marin, entitled Maine Coast *(1914), is particularly interesting in the way the artist has dealt with the color of the water and the movement of the small waves breaking on the shore.*

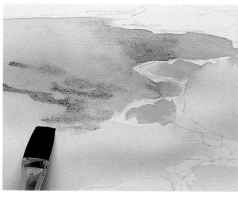

1. Tint the area of water with a light wash made from burnt sienna and cobalt blue with a touch of carmine. With a purplish tone obtained by mixing cobalt blue and alizarin crimson, apply a glaze of varying intensity to suggest the movement of the current toward the shore.

NOTE

Remember that the waves on the surface of moving water give rise to great tonal contrasts because some parts of the water reflect light and others remain in shadow.

2. Let your brushstrokes, as Marin's painting does, show the current that impels the water toward the shoreline where the surface of the water continuously changes form.

3. Suggest the waves near the rocks with irregular dots of the same color, only denser.

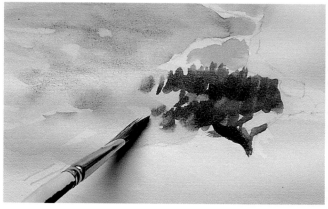

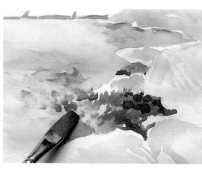

4. Correct the brushstrokes that suggest the movement of the water and continue developing the waves toward the left.

5. To finish, deepen the tone on the upper left part of the painting and finish the ripples near the shore with an almost-dry brush.

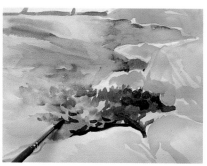

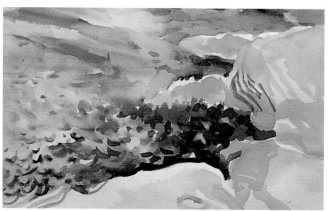

MOVING WATER WAVES IN THE HIGH SEA

Water out at sea may have small waves that produce contrasts of light and shadow.

Winslow Homer, in his work Tynemouth Returning Fishing Boats *(1883), shows the gentle waves out at sea with an interesting use of tonal and color contrasts that effectively represent the interplay of light and shadow on the changing surface. You are going to make a study of the detail of the water under the boat.*

1. After painting the hull of the boat to use it as a reference for the tones of the water, apply a pale yellow wash with just a touch of turquoise to the area of the water. Over this, lay a glaze consisting of a mixture of sienna, alizarin crimson, and turquoise to suggest the shadow under the boat.

2. Paint the water that is behind the boat at the horizon line in turquoise with a touch of yellow. Use pure orange to suggest some of the waves, dragging the paint across the paper with the brush. Use indigo blue to begin suggesting the large wave in the foreground. To indicate all the areas in shadow, use bottle green and begin at the area nearest the hull of the boat.

3. Continue developing the shadows of the waves, still in bottle green and working downward.

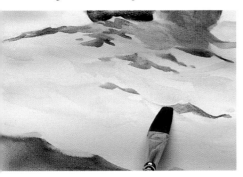

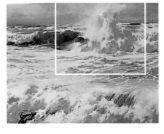

4. You can consider your study finished after applying a gentle wash of highly diluted indigo blue in the middle part of the water, taking advantage of the brushstroke to shape the waves and darken the tone of the wave in the foreground. Finally, intersperse a few wave shadows in this color with those already painted in bottle green.

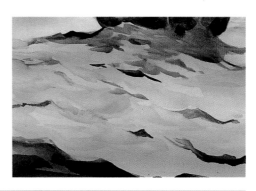

MOVING WATER A WAVE BREAKING

One of the most impressive images water can offer is that of powerful waves breaking against the shore and sending sprays of brilliant white foam up into the air. These images last only a fraction of a second so artists often have to resort to a photograph to capture the moment.

In this exercise, you are going to produce a study of part of the work Caribbean Surf *by Karl G. Evers.*

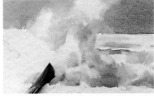

1. Color the sky with a gray wash mixed from cobalt blue, burnt sienna, and alizarin crimson. Reserve the white for the outline of the foam. To create the shadows

and the water in the background, use cerulean blue with a tinge of permanent green; to deepen the shadows in the lower parts, mix ultramarine blue with Vandyke brown. As you work, keep the brightest whites to represent the areas of maximum light. In this illustration, the artist has been a little heavy handed and is forced to lift out some of the paint to retain the white of the paper in these areas.

2. Paint the dark part on the left with Hooker's green and begin suggesting the undercurrent of the wave with a mixture of ochre and cadmium orange.

3. Drag the green and orange tones to the left.

4. To achieve the final result shown here, carefully open up some whites in the orange-ochre area of the painting and add a few touches with highly diluted Hooker's green; also, give the foam a few touches of cerulean blue.

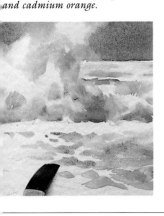

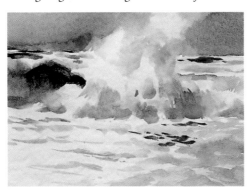

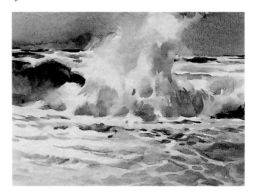

Vegetation

Unless you are rendering a polar ice field or a dry desert, when painting a landscape there is always vegetation. Vegetation can assume many sizes, shapes, and colors. When painting a landscape, the artist has to represent everything from a grassy meadow to a leafy tree, including all kinds of bushes and shrubbery. Vegetation is also to be found in city streets, a garden, or a vase of flowers on a table.

DIVERSITY

As previously explained, to paint anything, including vegetation, careful observation and study is essential. Every kind of tree, plant, and flower has its own shape that is different from the rest. The artist, however, rarely encounters a single specimen; it is more common to find several kinds of plants and trees mixed together forming different shapes, textures, and colors. The approach in this case is to consider such a group of objects as a whole and paint them as such. This entails simplifying the images, without getting lost in details, to emphasize the shapes and the most important colors.

The appearance of a landscape varies enormously according to the seasons and weather conditions. For example, in winter, a snowfall may blanket the landscape with white; in spring, sprouting and blooming plants flood the landscape with vivid greens, bright yellows, and other colors; the foliage of the trees, in fall, sets the woods ablaze with red and ochre hues.

In all forms of vegetation, however, green is the color that predominates, and it is not uncommon to find several different tones of green in a single plant. Consequently, it would be a mistake to try to paint any kind of plant using a single green.

TECHNIQUE

To paint vegetation—be it trees, bushes, grasses, or flowers—it is important to begin by defining its form and proportions. That is, in the case of a tree, set down the shape of the trunk relative to its branches or, in the case of a flower, the bloom relative to its stem.

In view of the complex shapes and a large variety of tones found in vegetation, it is important to simplify the images and capture the forms as they appear within the group, trying to avoid detailed work that would make the result seem broken and wooden.

Remember that the same type of tree will have different colors depending on whether it is in the foreground or the background, and that if trees in both locations were treated in the same manner, the illusion of perspective could easily be ruined. The same applies to a tree's foliage; if trees include detail, keep in mind that those nearest the observer are more distinct than those that are more distant.

It is common practice to suggest the foliage of a tree or the tonal variations in the petals of a flower by starting with washes in the lightest color and then adding darker glazes. To add points of brightness in the foliage of a tree or to represent a gap between the leaves, you can remove paint with the brush.

THE COLOR OF VEGETATION

Vegetation is predominantly green. Of course, here, *green* is intended in the widest sense of the word because in nature this color is found in all its varieties. Tones range from light, acid yellow greens to the dark and almost black greens seen on certain types of trees or in areas of shadow. Another tonal range that is always present is that of ochres, browns, and yellows; these are usually found on the trunks and branches or are visible on the foliage at certain times of the year. During the hot season in the fields, this range usually replaces the green hues. But apart from the green and ochre tones, vegetation can display any other color found in nature because this ample theme includes the flowers and fruits that appear in spring not only on trees but also on meadows and gardens.

The opportunities offered by fruits and flowers have long been exploited by artists who have chosen to study these subjects in isolation. Known as "still life" or "*nature morte,*" the careful arrangement of vegetation in the studio has evolved as a separate genre. (See page 122.)

The roughness of a tree trunk can easily be obtained by using the dry-brush technique, and a toothpick can be used for texturizing the twigs.

Natural sponges are one of the most widely used tools for suggesting vegetation, especially foliage, in watercolor painting as their shape usually leaves a mark that is very similar to the fragmented effect of contrasting leaves.

MORE . . .

On page 88 you will find more information on how to use sponges. Note the different marks natural sponges create that are ideal for representing vegetation.

TREES

Painting trees in watercolor can be easy when they are simply suggested with patches of color, or it can become a more involved task if a detailed rendering is necessary. The difficulty of painting trees lies in the intricate network of branches and leaves that form the foliage.

All trees have a structure consisting of the trunk, branches, and foliage. The leaves often conceal the position of the branches and make the general structure difficult to see. For this reason, it is useful to make sketches of trees throughout the different seasons of the year. Winter is a particularly good time to observe deciduous trees; they shed their foliage at that time and allow easy study of their trunks and branches. With close observation you will see that most trees do not grow straight; consequently, the trunk usually has a slight bend. You will also realize that the complex network of branches and twigs spreads out in all directions. This knowledge will let you avoid the common mistake of painting all the branches in the same direction, an error that weakens the rendering of the tree's structure.

Except for cypresses and a few others, most trees do not have a compact foliage; rather, the branches and leaves form gaps that allow some light to filter through and also make it possible to see some interior branches and the background.

The foliage of a tree creates a complicated interplay of light and shadow. The position and the angle of the light that falls on the leaves makes some areas look light and others dark, creating a wide variety of contrasting values. Again, the painter is forced to simplify the forms and the overall tones of the subject because painting the foliage in every detail would probably result in a fragmented series of broken colors that would not recreate the foliage as a whole.

TREES · CYPRESS

Cypress trees are relatively simple to paint as their dense and compact foliage conceals the structure of the branches. Because it is an evergreen, the entire tree has a uniform color with little variation.

Cypress trees have a well-defined vertical form that is easy to draw.

1. Begin by establishing the darkest shadows on the right in Hooker's green with a touch of sienna.

2. Next, paint the lighter foliage in the top half of the tree using the same mixture as before but lightening the tone with a little permanent green light. Develop the shadow at the bottom of the foliage by adding cobalt blue to the mixture.

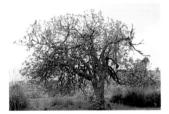

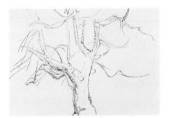

3. Apply darker glazes over the previous layers of paint with small and detailed brushstrokes to imitate the texture of the foliage and its undulating surface.

4. Complete the foliage and paint the trunk using a mixture of mauve and carmine.

TREES · FIG TREE

A fig tree, unlike the cypress, has scant foliage; its gnarled branches are the most visible feature and, thus, characterize this tree's appearance.

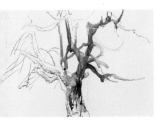

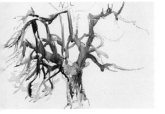

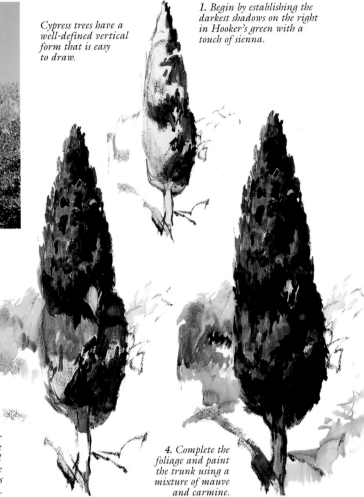

1. The irregular structure of the branches and its twigs spreading out in all directions require a preliminary drawing to faithfully reflect the model. Make your sketch with thick pencil lines that will serve to suggest some of the darker areas of the branches.

You are going to paint this fig tree. Although it has many leaves, its branches are the main focus of attention.

2. Use a mixture of cobalt blue and carmine to obtain the mauve tone of the tree trunk, varying the proportions of the two colors to create different hues. Add a touch of ochre to the middle of the trunk.

3. Continue working on the branches on the left, adding a little ultramarine blue to the mixture. Start suggesting the first leaves using medium yellow tinged with permanent green.

4. Develop the foliage further adding more green to the previous mixture. Complete the trunk by drawing out the brushstrokes to suggest the texture. To finish, rework the main branches and add small twigs in all directions to create the typically chaotic effect produced by this tree.

TREES

A PINE TREE

Pines have different shapes as they do not always grow straight and the trunk is often bent or twisted by the wind. In general, though, a pine stretches vertically upward and has branches that radiate uniformly around the trunk, creating a treetop that can be abstracted as a sphere.

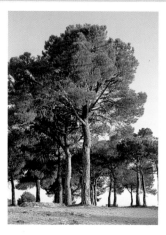

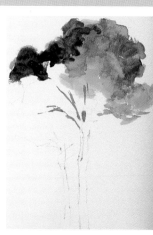

We are going to paint this beautiful pine tree that has had sufficient space to grow straight and tall.

1. Begin by painting the foliage of the right half using a mixture of permanent green light, olive green, and yellow ochre. Here, note how the artist has used the color to create the spongy appearance of the foliage, suggesting the areas of light and shadow with different colors. For the dark area on the left, add a little Hooker's green and ultramarine blue to the previous mixture. Paint the branches with cadmium orange.

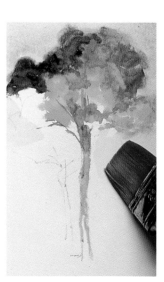

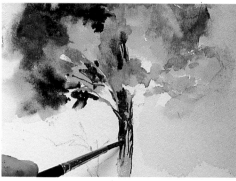

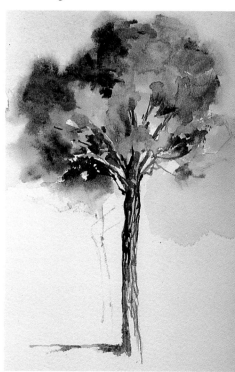

3. Finish the dark part on the left wet-on-wet, and with several small touches suggest the small shadows between the leaves. Paint the rough texture of the trunk with a mixture of burnt sienna and carmine over the previous wash.

2. Continue to work on the foliage and paint the tree trunk using a mixture of cobalt blue and burnt sienna. To highlight the palest greens of the foliage, cover the background with a light wash of the same mixture used for the trunk, but with more cobalt.

4. Finish the exercise by finalizing the form of the leaves on the left and adding small touches of green all over the treetop to represent the areas of light and shadow. Paint the trunk and add several branches among the leaves on the right. This step-by-step exercise allows you to experience the process of constructing the entire image at the same time without separating the foliage from the trunk. With this method, both elements blend together to form an integrated whole.

TREES

MAGNOLIA

The magnolia is a tree with a short trunk and branches that reach up in the form of an inverted cone. Because its leaves are fairly large, a rendering must include suggestions of their shape in certain places.

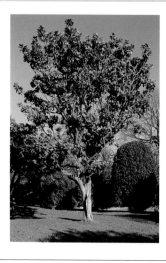

The magnolia in the sun presents a variety of colors and values you will need to suggest.

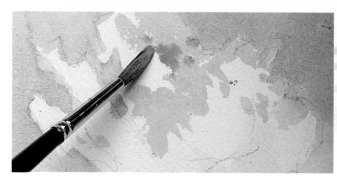

1. After covering the background with a light wash, begin to paint downward from the top. The lighter areas are painted in a mixture of permanent green and lemon yellow. Before continuing farther down, paint the adjacent colors in permanent green and cerulean blue to establish the tonal values.

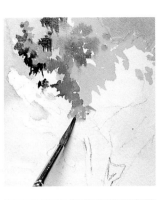

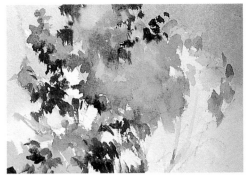

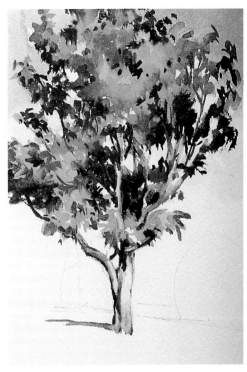

NOTE

Remember that each kind of tree has its own particular shape and color that distinguish it from the rest, so the mixture of colors and different hues is basic when it comes to painting them.

2. Continue to work on this area, adding cadmium orange to the previous mixture for the dry leaves and using small brushstrokes that suggest the form of the leaves either bunched together or separate.

3. Paint the remaining leaves in the same way varying the proportions of the color combination. For the darkest notes, use a mixture of Hooker's green and ultramarine blue. Develop the trunk with burnt sienna and ultramarine blue.

4. Complete the trunk using a mixture of Vandyke brown and cobalt blue. End with the darkest touches to the foliage.

TREES	**WEEPING WILLOW**

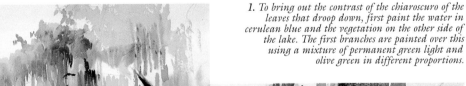

The appearance of a weeping willow is quite different from that of a magnolia. The magnolia stretches its branches skyward, whereas the willow droops its branches to the ground, producing a sense of sadness and melancholy.

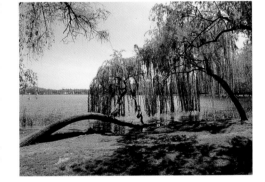

The foliage of the weeping willow looks more like ribbons than leaves.

1. To bring out the contrast of the chiaroscuro of the leaves that droop down, first paint the water in cerulean blue and the vegetation on the other side of the lake. The first branches are painted over this using a mixture of permanent green light and olive green in different proportions.

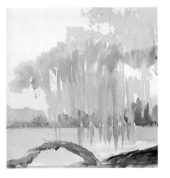

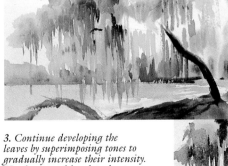

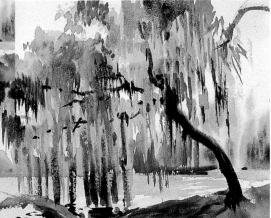

2. Paint the trunk with a mixture of Hooker's green and Vandyke brown. For the lighter foliage mix cadmium yellow and lemon yellow with permanent green light.

3. Continue developing the leaves by superimposing tones to gradually increase their intensity. Use downward brushstrokes to produce the drooping sensation.

4. To finish, add all the necessary details that will make your final work appreciably different from the previous step: paint the branches that are visible between the leaves and develop the shadows in the foliage with Hooker's green and a touch of brown, drawing the paint downward with the dry-brush technique. For the darkest shadows, add a touch of ultramarine blue to the mixture.

TREES

PALM TREE

Palm trees can be found all over the world, both in nature and as a decoration in gardens and streets.

The shape of a palm bears a certain similarity to that of the pine: it has a long trunk with an explosion of leaves at the top. The technique for painting the palm, however, is substantially different.

This palm tree has been pruned back, leaving only the fronds at the top; thus, it creates the interesting impression of a plumed hat.

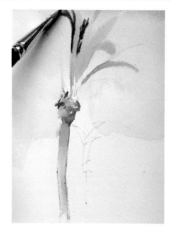

2. Continue to work on the palm fronds shaping them with short brushstrokes that suggest their form. Add the ridges on the trunk with a mixture of Vandyke brown and carmine.

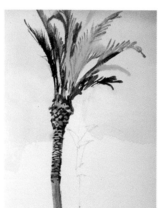

3. Keep adding leaves and cover the lower half of the trunk with a light cobalt blue glaze.

1. Paint the trunk using a mixture of cadmium orange and burnt sienna. Add a little more orange to paint the knot. For the light areas of the fronds use permanent green light mixed with cerulean blue; then, develop the shadows by superimposing a deeper glaze over them in the same mixture, but with a little cobalt blue added.

4. Use the tip of the brush to draw the trunk, and add the remaining palm fronds to finish this exercise. This may seem a relatively easy tree to paint. However, the position of the leaves and their fringed edges require close study before starting to paint.

TREES

A TREE IN FULL BLOOM

A tree in bloom, such as this almond tree, looks dramatically different during the rest of the year. In the picture, the tree is covered in white flowers; therefore, to paint it, you will have to reserve the white of the paper and use the background colors to create the form.

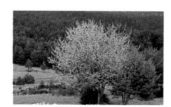

The white of this almond tree contrasts with the green of the surrounding vegetation.

1. Mix a little cobalt blue and alizarin crimson to paint certain branches and the areas in shadow.

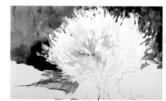

2. Use olive green and burnt sienna to paint the background which, as you can see, is essential to outline the form of the tree and create contrast.

3. Using a slightly more intense mauve than the previous one, add a few touches to the foliage; also, paint the trunk adding a touch of cobalt blue. The form of the tree should begin to take shape as you paint the grass on the ground and the surrounding vegetation.

4. In finishing, apply the last, more intense touches to the tree. But keep in mind that, above all, the tonal contrast of this work is achieved more by the paint applied to the background than that used on the tree itself. Here, the artist has developed the background as if it were the main subject. Note also the importance of the final patch of Hooker's green in the lower right corner.

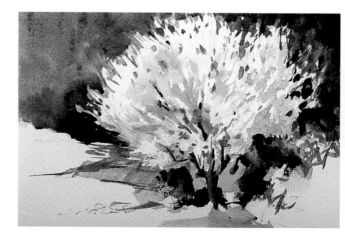

MEADOWS AND FIELDS

A meadow can be created with a simple wash. Plowed fields have symmetrical furrows that can make them no less attractive a subject for watercolor painting than a natural meadow. Fallow fields contain different forms of vegetation; in them grasses grow alongside tall weeds and wild flowers. Representing them becomes more difficult as there is a greater diversity of color, forms, and sizes that the artist needs to reproduce.

The changing seasons present additional challenges to the painter who wishes to convey the cool freshness of the fields during the spring, the heat and dust of summer, the changing colors of autumn, and the somber chill of winter.

MEADOWS AND FIELDS **A PLOWED FIELD**

Plowed fields present a regular pattern that may be separated into areas.

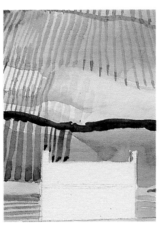

In the work by Kenneth Rowntree, Underbank Farm (1940), the artist captures the symmetrical beauty of the furrows in a plowed field.

3. While assessing the overal tonal value, continue to develop the values of the furrows and the land, darkening certain areas such as the one behind the farmhouse. Paint the furrows on the right of the middle plane only halfway across the field.

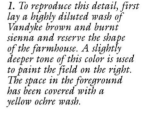

1. To reproduce this detail, first lay a highly diluted wash of Vandyke brown and burnt sienna and reserve the shape of the farmhouse. A slightly deeper tone of this color is used to paint the field on the right. The space in the foreground has been covered with a yellow ochre wash.

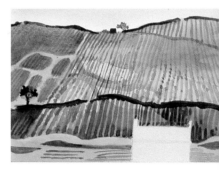

2. Paint the small fields using the same colors, but somewhat diluted. Also, begin suggesting the shadows between the furrows with Vandyke brown.

4. Now finish painting the furrows you left incomplete in the previous step; the pause will allow you to capture the slightly wavy form of the ground and the change in tone. Add a little cadmium orange to a few of the furrows, and paint the silhouette of the tree with Vandyke brown.

MEADOWS AND FIELDS **AN UNPLOWED FIELD**

Fields that have not been plowed allow all kinds of plants to grow freely in an array of different forms, sizes, and colors.

You are going to reproduce part of the work Great Wheal Prosper *by Ruskin Spear.*

1. Cover the field area with a wash of cadmium yellow with touches of orange at the top, burnt sienna in the middle, and permanent green light at the bottom.

2. Paint a few first brushstrokes in emerald green over this wash. Continue with horizontal, slightly curved brushstrokes in olive green, burnt sienna, and a mixture of burnt sienna and Hooker's green.

3. Add some dark tones made from burnt sienna and cobalt blue. After the paint has dried on the paper, with a fine brush draw a few small lines to suggest the grass.

4. To finish, paint the last blades of grass and add a few touches to the small grassy area in the foreground.

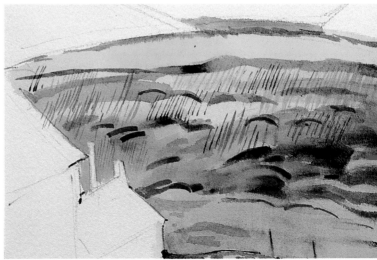

MEADOWS AND FIELDS | FIELD OF POPPIES

In spring, a field can be dotted with the colors of flowers peeking through the grass. Painting such a field requires more than a series of green washes.

This exercise consists of painting part of this poppy field employing a masking technique.

1. Before starting to paint, mask the areas where the poppies will appear using masking fluid.

2. After the fluid has dried, begin painting. For the light areas of the field, mix permanent green with lemon yellow. Paint the shadow area on the other side of the path with permanent green and cobalt blue, and use the same colors to suggest the grass in the foreground with short brushstrokes.

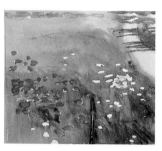

3. Add the shadows of the trees along the path using a mixture of carmine and cobalt blue. Paint the grass of the field in permanent green with a little cerulean blue. Once the paint is dry, remove the masking fluid and paint the poppies using vermilion for some and cadmium orange for others.

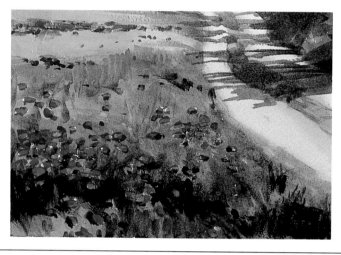

4. Give some finishing touches of carmine to the poppies and other darker notes of Hooker's green mixed with cobalt blue to make the flowers recede into the grass.

GRASS

In general, grass is seldom the main element in a watercolor painting, although it does appear in many themes. A meadow in the distance can be painted using a simple wash, but grasses and weeds in the foreground need more detail to give the work the sense of depth or texture that this part of a scene demands.

Careful observation will reveal subtleties that are not at first apparent. Grasses display an astonishing range of different greens, which of course, blend into a wide range of ochres as the season progresses.

GRASS | TALL GRASS

You will often see wide expanses of grass, either planted or wild.

You are going to paint a detail of this field that has a fairly uniform green color but may, nevertheless, seem difficult to paint.

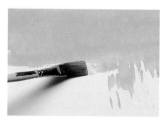

1. Using a mixture of permanent green and lemon yellow, lay the tone for the light areas. Apply the wash to the upper part of the paper and reserve the white in the lower-right part, but adding some vertical brushstrokes that suggest the grass.

2. Add cobalt blue to the previous mixture and paint the lower-left corner. Be sure to reserve the area of tall grass and flowers by painting around it with this mixture and a little carmine.

3. Over the base color, use a fine brush to suggest the grass using the previous tones.

4. As a final step, develop the shadows between the blades of grass with the previous mixture, but intensified with more cobalt blue. Let the reserved whites represent the flowering weeds.

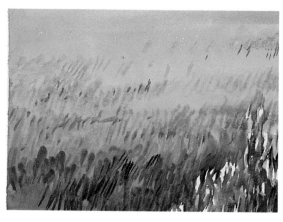

GRASS

CUT GRASS

The lawn of a garden or, in this case, a cemetery looks slightly different from the grass that grows wild in the fields. Among other things, lawns are mowed regularly and the uniformity in length gives them a homogeneous appearance.

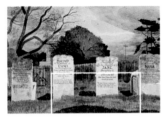

You are going to paint a detail of the work The Livermore Tombs, *by Kenneth Rowntree, that features a lawn.*

1. Apply a wash to the background in burnt sienna for the soil and permanent green with yellow for the light part of the grass. Paint the dark area in permanent green and Hooker's green.

2. After the previous colors have dried, suggest the grass using the tip of a flat brush loaded with Hooker's green.

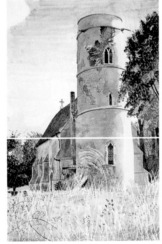

3. Continue to paint the grass and add the cast shadows of the tombstones. Assess the tonal key and deepen the foreground a little more.

4. To finish this exercise, you need little more than continue working on the grass with the flat-tipped brush.

GRASS

DRY GRASS

In the warm months or dry periods, grass can look very different from what you have seen in previous exercises. It changes color and takes on ochre and yellow tones.

In this exercise, you are going to reproduce part of the work SS Peter and Paul, *by Kenneth Rowntree, which includes tall, dry grass.*

1. Before starting to paint, use wax to mask the parts where the grass appears white.

2. For the walls of the church, apply a yellow ochre wash mixed with a little orange. Add a little cobalt to the previous mixture for the darker wall. Paint the grass area by mixing burnt sienna, cadmium orange, and a touch of lemon yellow directly on the paper. The lines you painted with the wax resist should now appear white.

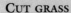

3. Paint the trees in the background to balance the values; also, suggest the grass with long, vertical brushstrokes in a mixture of lemon yellow and cadmium orange.

4. Continue to paint the grass using darker tones such as olive green. Additionally, darken the tone between the masked areas to heighten the contrast.

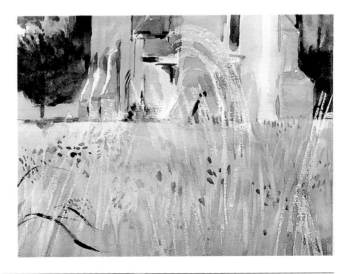

FLOWERS

With their delicate and beautiful shapes and colors, flowers have long appealed to artists of all techniques.

Flowers can be painted in their natural context or out of it.

Many artists become fond of flowers as a subject because, apart from being highly attractive, they are an alternative to painting vegetation with no need to leave the studio.

Fresh flowers are full of life and the watercolorist faces the challenge of capturing this on paper. Because the stems, leaves, and petals of a bunch of flowers in a vase form a pattern similar to what can be found in nature, painting flowers is a good exercise for gaining skill at simplifying forms, lines, and colors.

Painting flowers in the studio offers certain advantages that are not available in nature. Apart from comfort and convenience, working inside gives artists full control of the composition. They are free to choose the type of flowers, the amount, the position, the lighting, and the background.

Studio work, however, forces the artist to study the subject very closely. Bear in mind that a watercolor painting of a simple vase of flowers can be magnificent or terribly boring depending on how well the artist has arranged the final composition. To create excitement in a bunch of flowers, contrast is necessary. You can, for example, situate dark flowers against the light areas of a background and flowers with light-colored petals against the dark areas of leaves and stems.

As with any kind of vegetation, avoid overloading a rendering of flowers with detail. Remember that too much reworking causes the colors to lose their sparkle and transparency. You must simplify and capture the overall impression so that the painting is spontaneous and natural.

FLOWERS — A GLADIOLUS

The petals of a gladiolus have a highly interesting range of tones that contrasts sharply with the green hues of the stem.

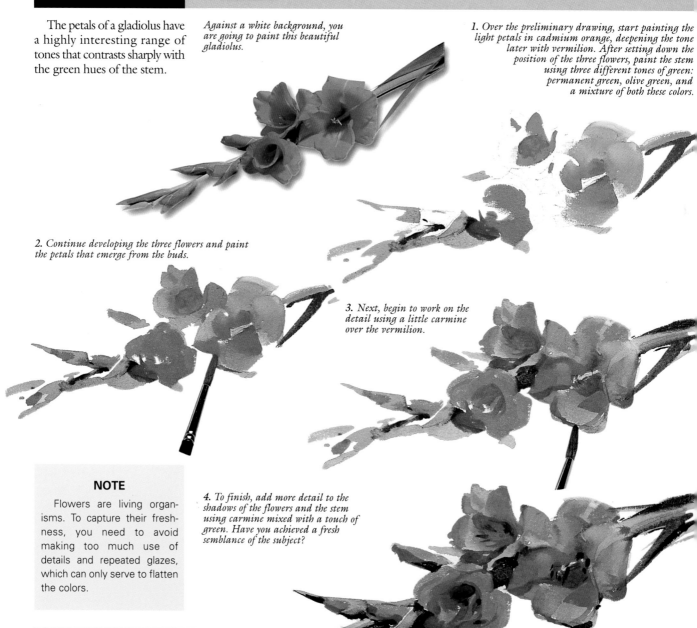

Against a white background, you are going to paint this beautiful gladiolus.

1. Over the preliminary drawing, start painting the light petals in cadmium orange, deepening the tone later with vermilion. After setting down the position of the three flowers, paint the stem using three different tones of green: permanent green, olive green, and a mixture of both these colors.

2. Continue developing the three flowers and paint the petals that emerge from the buds.

3. Next, begin to work on the detail using a little carmine over the vermilion.

4. To finish, add more detail to the shadows of the flowers and the stem using carmine mixed with a touch of green. Have you achieved a fresh semblance of the subject?

NOTE

Flowers are living organisms. To capture their freshness, you need to avoid making too much use of details and repeated glazes, which can only serve to flatten the colors.

FLOWERS · A BOUQUET

This exercise entails reproducing Emil Nolde's work, entitled Blue Bells, *which contains this small but vibrant bouquet of flowers.*

Flowers grouped in a bunch usually display a variety of colors and shapes; therefore, they are more difficult to paint. The artist needs to sort out the pattern of the stems and position the varying colors of the flowers over it.

1. Apply a wash to the background with a mixture of orange and cobalt blue, and reserve the white for the flowers. Paint the blue bells with a mixture of carmine and turquoise, then add a few touches of rose. Use a mixture of ultramarine blue and yellow for the first green brushstrokes.

2. Suggest the small flowers at the top on-wet in ultramarine blue, olive green, and yellow. Also paint the flowers on the right on-wet. To achieve the vague, blurred effect of the model, apply a diluted carmine glaze first and then a brushstroke of vermilion on top. Use indigo blue to outline the form.

3. With the previous tones, continue developing the flowers and the stems.

4. To finish, add several ochre notes to the background and outline the flowers in the middle using a mixture of carmine and mauve.

FLOWERS · SUNFLOWERS

Flowers in their natural context are particularly beautiful, but when painting them, you need to take into account everything that surrounds them.

Next, you are going to paint this field of sunflowers, in which some blooms partly conceal others and the leaves on the stems form a complicated pattern.

1. Use medium yellow to suggest the overall mass of flowers. Add a little turquoise in the more

distant part to create a greenish tone. The most intense tones are obtained by adding burnt sienna to the yellow. With small dots of paint, suggest the position of the flowers on the paper. The sunflowers in the foreground are the most complicated to paint because you must outline their shape with the background colors. For the center of the flowers, use a mixture of vermilion, mauve, and yellow.

4. Continue to paint in the same way, working outward from the center. Use simple dots of color to suggest the more distant flowers. Have you found this exercise to be more difficult than you first realized?

2. Begin developing the first flowers, use a mixture of permanent green and turquoise to outline the lower part of the petals. At the same time, make a few crisscross brushstrokes to suggest the leaves attached to the stems.

3. Continue working as before and, with the same green, begin outlining the flowers in the upper part of the painting. With a darker tone of the previous color define the flowers and stems by painting the shadows around them.

Flesh Tones

A term used to describe all the colors and different hues that the skin can have is flesh tones. Watercolor is an excellent medium for suggesting the forms of the human body, the silklike suppleness of skin, and natural attitude of a gesture. Flesh tones can be found in any kind of painting as it is not necessary for the figure to be the major element in the painting. Neither is it necessary to paint nudes to study these tones; a woman's legs as she walks along the street, a rower's torso or bathers in a swimming pool are all opportunities to introduce this feature in your work. Remember that figures are closely related to the context in which you find them and this relationship should be maintained in the final work.

WATERCOLOR AND THE FIGURE

When discussing flesh tones it is impossible not to discuss the human figure too. Perhaps watercolor is not the ideal technique for detailed studies of figures, but it is excellent for painting them quickly and capturing their spontaneity and naturalness.

As the medium demands speed, it forces the artist to simplify the form and define its colors and values confidently and decisively.

Undoubtedly, knowledge of human anatomy is a great advantage when painting figures, but a study of the skeleton and muscles is not essential for dealing with this subject in watercolor. If you are capable of closely observing the figure of a model and distinguishing its most characteristic features, you can start to paint human figures in watercolor as a prelude to progressing further with this subject.

In time, you may wish to learn the basics of human anatomy—indeed, you may be challenged to do so by the subjects you select. But do not hesitate to attempt to begin your figure studies without any special preparation.

THE COLOR OF FLESH

As everyone knows, human skin does not have a single, set color; it displays a wide range of hues and textures, from the white, almost transparent skin of an albino to the dark tones of a black person. Flesh tones vary not only among people of different origins, but among people of the same race, and even within one individual. Among other things, age and continuous exposure to sunlight, can give a person's skin several different tonalities. Parts, such as the face and hands, that are not protected by clothing can have a darker tone and show more wear than the rest of the body. Additionally, skin will also reflect the colors in the surrounding environment.

Some manufacturers sell paints in flesh tones, however, artists usually prefer to mix their own to arrive at the correct hues in each case as they do with other subjects. When painting flesh tones, therefore, the watercolorist must develop the many different tonalities evident on the human form in order to suggest its texture and shadows and to develop its contours and volume.

TECHNIQUE

The technique for painting flesh tones in watercolor is similar to that used for painting any other subject.

The artist must reserve the highlights; start with the light tones, and gradually superimpose glazes over the areas in shadow or those with the dark colors. As is generally the case, try not to use too many glazes as this will dull the paint and deprive the flesh tones of the liveliness you are attempting to capture on paper.

In assessing the tonal values of a subject's flesh tones, keep in mind that form is often defined by a subtle contrast of tones. To capture these slight tonal variations, closely observe the model with your eyes half-closed; narrowing your sight allows you to obscure unnecessary details and focus on the small tonal contrasts.

The human figure with its subtleties of tone is an ideal subject for painting in watercolor as this medium allows you to capture the freshness in the skin and the spontaneity in the gesture of a subject.

PAINTING SKIN IN SPECIAL TONES

Painting flesh tones does not always mean using colors that resemble those of the skin. The delicate texture of the skin and the contours of the body can be suggested using a substantially different palette.

In this exercise you are going to reproduce a detail of Georges Roualt's work Girl *(1906), in which the paleness of the flesh is suggested by the contrast and influence of the violet tones of the shadows.*

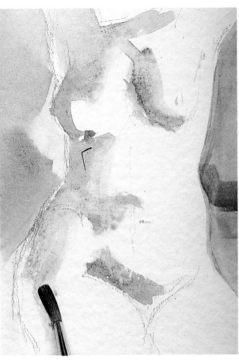

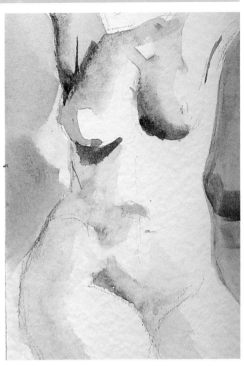

1. Paint the background and at the same time outline the figure with a mixture of cobalt blue and burnt sienna. Using this same mixture, but with minor changes in the proportions, quickly set down the first shadows. Suggest the curves of the breasts, first adding more burnt sienna to the mixture.

2. Next, add a little Vandyke brown to the same mixture to outline the shadows under the right arm and below both breasts. Clean the brush and drag the paint to blur the edges of these shadows to soften the color boundaries.

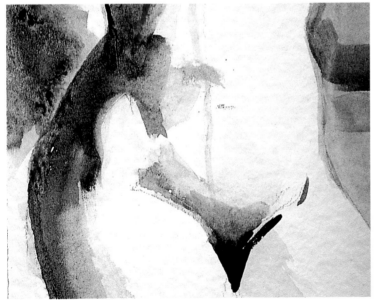

3. Continue extending the shadow on the left downward with slightly diluted Vandyke brown; with a denser brushstroke of this color, suggest the region of the pubis. At the same time, darken the background tone to balance the work. Using the first mixture, paint the soft vertical line that travels the abdomen.

4. To finish, paint the shadow of the left leg with parallel brushstrokes, softening the edges of the colors with a blot-dried brush. Add the nipples with a touch of vermilion. You will note that even the reserved areas appear to be bathed in a pale color. Note, in this illustration, how the colors are interrelated and to what extent one color affects an adjacent color.

DELICATE SKIN

The color of human skin can possess many hues and tonal variations. Next, you are going to paint a woman's hand with its white, delicate, almost transparent skin.

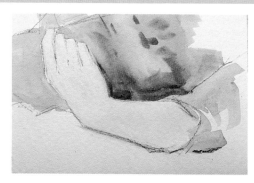

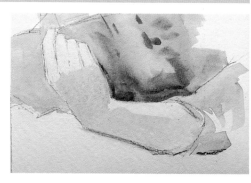

The model for the work The New Noble, *(1877) by Winslow Homer, like most of the women of a certain social position at that time, had white, well-cared for skin.*

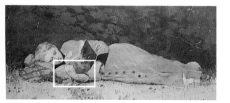

1. Paint the whole surface of the hand and forearm using an even vermilion wash diluted as much as possible. Because of the paleness of the girl's skin, you need to paint the background at the same time to help you understand the tonal interplay so you can arrive at the correct values.

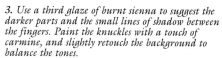

3. Use a third glaze of burnt sienna to suggest the darker parts and the small lines of shadow between the fingers. Paint the knuckles with a touch of carmine, and slightly retouch the background to balance the tones.

2. Give the wash time to dry, then apply a second glaze of highly diluted permanent green to the arm. This tone will create a sense of the transparency and delicacy that a skin that is seldom exposed to sunlight conveys.

4. You may think that the hand and arm are now complete. However, as the artist did here, intensify the tone of the sleeve. The additional contrast provided by the deeper tone is necessary to suggest the fragility of the skin, as you can appreciate by comparing this illustration with that of Step 3. This exercise emphasizes the importance of tonal balance and color interaction for achieving the desired effects.

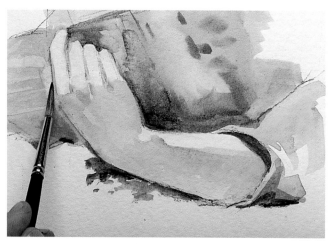

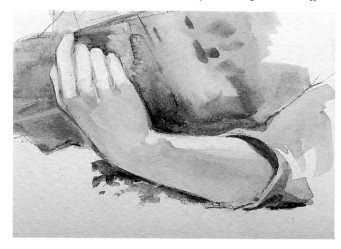

WEATHERED SKIN

Skin exposed to the sun over many years generally turns dark, becomes wrinkled, and acquires a leathery texture that appears harder than that of normal skin.

NOTE

The rendering of the skin in a portrait is much more complex than that in a figure. Artists must also capture a likeness and the expression of their subject as well as facial details such as wrinkles, hair, subtle changes of color, and a host of tiny shadows.

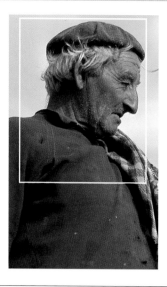

Now you are going to try your hand at capturing the weathered skin of this shepherd who spends a large part of his time outdoors. The painting illustrated here has been developed to this stage by superimposing glazes, as in the previous examples, to obtain the ideal tones for the light and dark areas. The general color of the face is a mixture of carmine with a little green. Olive green has been used for the hair. Prepare your own painting up to this point. Then, you can proceed with the detailed work to capture the most apparent feature of this type of skin, its roughness.

1. Paint the wrinkles on the forehead and the eyes using a mixture of carmine and burnt sienna.

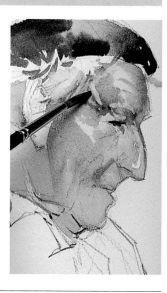

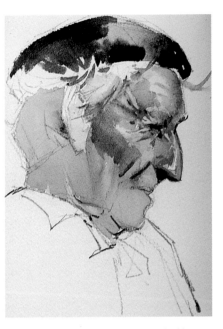

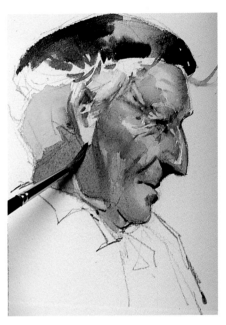

2. Use the same tone to intensify the cheekbone and the darker parts of the nose. Paint the wrinkles around the eye in Vandyke brown with a touch of carmine.

3. With the mixture you used on the cheekbone, go to the ear; then, add a little cobalt blue to the mixture and apply a glaze to the chin.

4. Continue retouching the areas in shadow and defining the wrinkles until you achieve the desired effect. This is a difficult exercise that requires you to work with the tip of your brush, so take your time and exercise great care to complete your painting.

FLESH TONES WET SKIN

Wet skin has a texture different from that of dry skin as the moisture produces small, shiny areas, intensifies the color, and forms tiny droplets on the skin surface.

Next, you are going to paint this wet, female breast; the droplets on the surface give it a granular texture that differs from the usual silkiness of feminine skin.

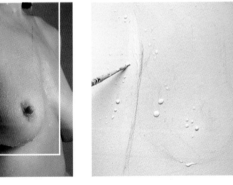

1. Cover the area with a highly diluted wash of medium yellow mixed with vermilion and a touch of carmine, to keep it from turning orange. When the glaze has dried, use masking fluid to reserve the spots that will suggest the drops of water and the shiny patches.

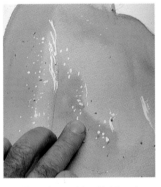

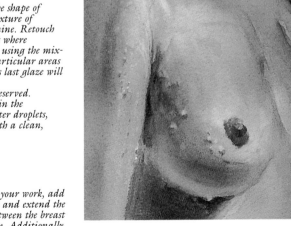

3. Begin defining the shape of the breast with a mixture of vermilion and carmine. Retouch the tones throughout where the work calls for it, using the mixture proper to the particular areas but less diluted. This last glaze will probably cover the highlights you had reserved. To restore the white in the more prominent water droplets, remove the paint with a clean, blot-dried brush.

2. Allow the masking fluid to dry and apply another glaze of the same tone, though less diluted. To create the shadow of the breast, add a little burnt sienna to the mixture; for the area under the neck, add a little carmine with a touch of vermilion. When these areas are dry, remove the masking fluid by rubbing gently with your finger. The masking fluid is removed at this point, and not when the work is finished, to avoid an excess of contrast between the masked areas and the rest of the painting and to prevent hard edges from forming.

4. To complete your work, add detail to the nipple and extend the shadow that lies between the breast and the arm. Additionally, darken the shadow underneath the breast. Deepen the tones to suggest the dark parts of the arm and upper part of the breast; in a deeper tone also outline the bone structure. To give prominence to the droplets of water, increase the contrast of the highlights by adding a small touch of color next to each one.

Wet skin under a strong light such as that of the sun contains multiple bright reflections of light; its usual velvety surface also takes on a smooth polished appearance.

NOTE

Dark, wet skin is more difficult to render in watercolor than light skin because this medium involves working from light to dark. Additionally, as the colors intensify with each progressive wash, it becomes harder to obtain tonal variations at the dark end of the range.

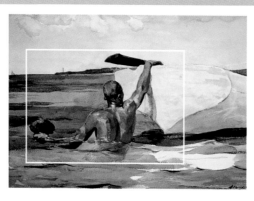

You are going to reproduce a detail of the work by Winslow Homer, The Sponge Diver *(1898–99), in which this dark-skinned man appears under the brilliant sunlight. The flesh tone is obtained by gradually superimposing increasingly deeper glazes.*

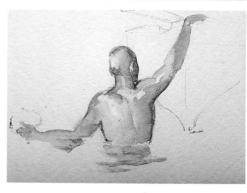

1. First, set down the areas of light and shadow with a mixture of burnt sienna and cadmium orange on the back and the left arm. The forearm resting on the boat, takes the same mixture with a little cobalt blue added. Use this tone also to suggest the reflections of the body on the surface of the water. Paint the head with a touch of Vandyke brown and reserve the highlights.

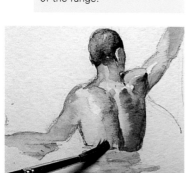

2. Now, darken the tone of the hair and begin building up the tone in the dark areas of the back using a mixture of Vandyke brown, burnt sienna, and a touch of carmine.

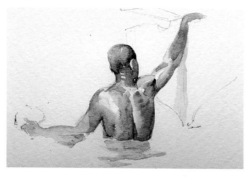

3. With the previous tone, continue working on the back and part of the arms. The cast shadow of the right arm on the boat is a mixture of cobalt blue and a little sienna.

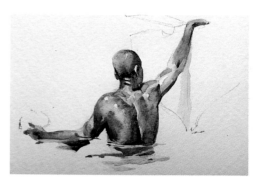

4. Last, darken the skin tone even more using a burnt sienna and vermilion glaze, and retain certain reserved whites as you lightly tint part of the highlights. Add a blend of Vandyke brown and cobalt blue in the darker areas and in the reflections in the water.

Human skin is rarely smooth. It often contains features that alter its overall color or texture. The body of a subject may show moles, freckles, scars, blemishes, and, especially in the case of men, an abundance of hair.

NOTE

The color of human skin is never uniform; from one part of the body to another there are always major variations in tone.

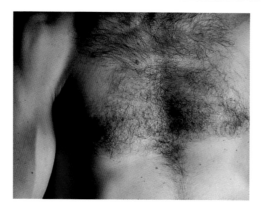

In this exercise, you are going to paint the hair-covered torso of a man.

1. Apply a light wash of carmine and cadmium yellow. Over this, outline the areas of light and shadow with burnt sienna.

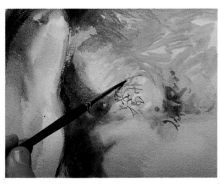

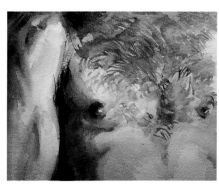

2. Now, add a touch of carmine to paint the dark area of the arm. Begin suggesting the mass of hair with a mixture of burnt sienna and a little olive green using the dry-brush technique.

3. Continue to balance the tones and darken the shadows by adding a touch of Vandyke brown to the previous mixture. With a fine brush loaded with Vandyke brown, paint the small hairs on the entire chest area and then blend them using a dry brush.

4. To finish, paint the right nipple with a mixture of sienna, cadmium orange, and a little carmine. Retouch the shadows on the arm, too. If you find that the hairy area in your painting still lacks detail, add it now. The fine brushwork makes this a painstaking exercise, but thoroughness will yield a more satisfactory result.

FLESH TONES A GROUP

In painting, a group of people must be treated as a whole; artists, thus, usually avoid detailing the features of the people and pay more attention to the balanced composition of the group. If you make the mistake of treating each figure individually, the result will seem artificial and fragmented. Mistakes of proportion or scale may even creep into the painting if this method is used. Remember that the figures in a group are interrelated and share the same space and often the same activity. When approaching the work, the artist must plan to convey the connection they share.

You are going to reproduce a detail of the work Ò Sole Mio! by Lorna Binns.

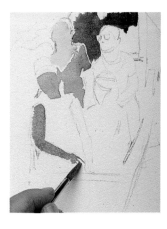

1. Paint the skin of the figure in the upper-left corner using highly diluted vermilion. The tone of the figure below takes the same mixture and a touch of orange.

2. With carmine, paint the right arm of this last figure, as well as the face of the woman seated to the right. Cover the face of the woman wearing glasses with diluted orange.

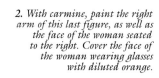

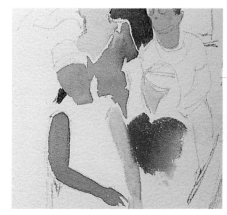

3. Paint the dark hair of two of the women in deep indigo, and apply a light carmine glaze to the right arm and face of the figure in the lower left to vary the orange tone used earlier. Paint the lips with a touch of carmine and start to detail the clothes. In this case, the flesh tones are light and need the surrounding colors to set them off.

4. Last, paint the left arm of the woman in blue and her glasses. Lightly, add the features to the face of the woman in red and give some finishing touches to her clothes. With a fine brush, paint the tattoo on the arm of the woman in white. In the finished work, here, you can see the tonal difference between one figure and another, and between the orange and carmine tones in the right and left sides of the woman in white.

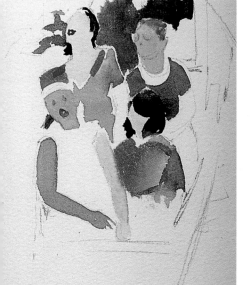

Animal Textures

I f human skin varies in color and texture, the world of animals presents far more differences in these features.

From small domestic animals to large ones in the wild, painting the skin of an animal in watercolor is an interesting challenge that provides material for the artist to develop different skills and innovative techniques. Animals insinuate themselves into many paintings dealing with other subjects: a still life where vegetables and fruits are featured alongside game such as rabbit and pheasant; a home scene that shows a fish swimming in its tank, or a cat curled up on a soft chair. Even if an animal is not the major element in a painting, artists will eventually find themselves obliged to paint the hair of a dog, the feathers of a sparrow, or the scaly skin of a sardine. Consequently, it is important to learn how to handle this subject. After all, the method is the same for painting textures as dissimilar as the rough, thick skin of an elephant; the fine, shiny skin of a frog; the long hair of the llama; or the feathers of a parakeet. Nevertheless, the results must obviously be different.

NOTE

Under the skin, hair, feathers or scales, the bony structure of the animal determines its form and volume and must be taken into consideration when painting.

SKIN

Animal skins have a great many different colors, textures, and qualities. It may be shiny, wet, fragile, and with striking colors as in the case of a frog; or matte, rough, and dark as in the case of an elephant. Each circumstance requires that the subject be treated differently.

SKIN	BAT'S WINGS

The membrane that joins the toes of a bat is soft, thin, shiny, and flexible; all these qualities must be represented in your rendering.

This exercise consists of painting in watercolor the wings of the bat illustrated here.

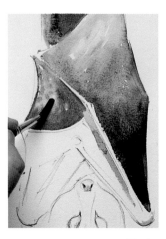

1. To obtain this dark tone, mix indigo, burnt sienna, and Vandyke brown; use this color to apply a wash over the surface intended for the wings. Note that the wash is not uniform, you must deepen it to suggest the shadow areas. Before the paint dries, lift out the highlights with a brush and blot dry.

2. Complete the wash, leaving the highlights unpainted. Deepen the color used for the background and begin to outline the shadows and the folds.

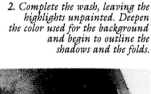

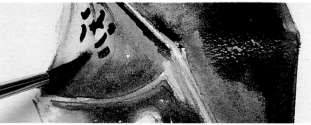

3. Soften the first brushtrokes with a damp brush and build up the darker areas with a deeper glaze. To contrast the highlights, add a few small touches in a dark tone.

4. Finish this exercise by completely developing the shadows and other details of contrast, being careful to maintain the highlights; use a few touches of ochre, as shown here, on the tips of the wings and throughout.

SKIN	ELEPHANT HIDE

An elephant's skin has an opaque color that combines several gray and brown hues; capturing its thick, rough, and wrinkled texture can be a challenge.

You are going to paint part of the elephant's back with its great many wrinkles.

1. Using a mixture of burnt sienna and vermilion, apply a wash that defines the shadow and highlight areas. Drag this color over the gray areas and add some cerulean blue. Give the leg a slight touch of cobalt blue. Before the wash dries, open up the whites on the back with the brush, rinse and blot dry.

2. In indigo and Vandyke brown, begin painting the lines to represent the wrinkles.

3. Continue to paint the wrinkles with the previous tone, lightening or darkening the paint as required.

4. As in the illustration, finish suggesting the rugosity of the elephant's hide with lines, varying their intensity, direction, and sharpness.

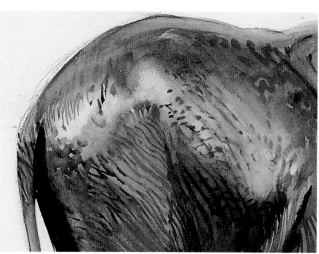

SKIN	A SHARK'S BELLY

A shark is a scaleless fish with thick, rough skin. The light color of the belly wraps around the animal and darkens at the back, where it presents a bluish, leaden hue.

You are going to reproduce a detail of the work Shark Fishing *(1895), by Winslow Homer.*

1. Paint the boat in burnt sienna to add contrast, and cover the surface of the shark's body in a highly diluted cerulean blue wash with a touch of sienna and yellow.

2. When the preliminary wash is dry, paint the water in cerulean blue with touches of cobalt blue; dilute the color to a soft tint where the water touches the shark's body.

3. Using highly diluted indigo, suggest the fin and the mouth; paint the lines of the gills in burnt sienna.

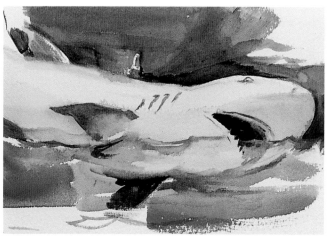

4. Last, cover the fin with a sienna glaze, and complete the details of the mouth, eye, and body under the water. In this illustration, note that the artist suggests the texture of the shark with the soft tones of the first wash because the rest of the exercise is directed toward developing the tones in the water to outline the shark's body, without retouching the skin.

HAIR

Hair is common to many different species. Each has its own characteristics that distinguish it from the rest: color, length, quality, and quantity. The hairs of a horse's tail are very long and separate at the end, whereas the body hair of a certain type of zebra is short and dense, making the animal look like a felt toy.

The hair of some animals glistens in the light, yet that of others is always dull. The coloration of the hair is also not the same in all; colors range from an overall even tone to colors that vary according to the part of the body they cover. Colors sometimes form surprising patterns such as the dark patches on the giraffe. Animal hair, then, has to be rendered in accordance to each case.

HAIR — A GIRAFFE

A giraffe has very short, dense hair, though its texture is hard to see at first glance. The pigmentation of the skin forms curious yet beautiful, almost geometrical patches of color that make it an interesting surface to paint in watercolor.

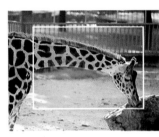

In painting the head and neck of this giraffe, you will be dealing not only with the animal's fur, but also with its mane.

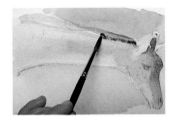

1. To bring out the contrast, apply a soft wash to the background. Paint the head and neck with a brown glaze in different tones, using a mixture of cobalt blue and burnt sienna with a little ochre for the shadows. Add the mane in cadmium orange toned down with yellow, and darken the base of it while the paint is still wet.

2. Paint the first few patches with a mixture of burnt sienna and Vandyke brown. Then, with the aid of a flat-tipped brush and the dry-brush technique, suggest the texture of the mane, using the tone of the first glaze though somewhat deeper.

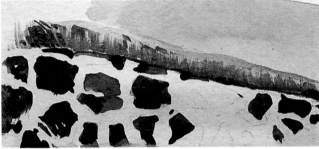

3. After completing the mane, continue to paint the color patches, building the pattern from the other side to avoid mistakes. Paint some patches lighter than others and vary the tonal intensity within each to suggest the texture of the short, soft hair.

4. With all the finishing touches in place, as here, does your work show the texture of the mane and the feltlike softness of the rest of the giraffe's body?

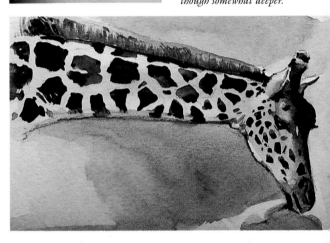

HAIR — A ZEBRA

This type of zebra has thick, soft hair that gives its texture the appearance of a sponge; at the same time, its stripes form an attractive pattern with a strong contrast that is exciting to render in a painting.

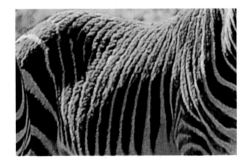

You are going to paint this zebra's back; because the sun that illuminates it is at a low angle, the light brings out the texture and bathes the surface in rich ochre hues.

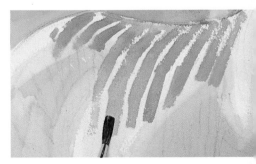

1. To start, paint the background green to set off the white areas. Cover the zebra's body with a soft, gray wash obtained by mixing burnt sienna, cobalt blue, and cerulean blue; be sure to set down the areas of shadow. Over this, paint the first stripes in ochre mixed with orange.

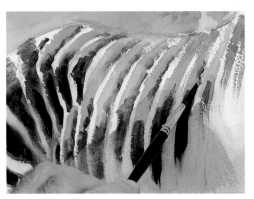

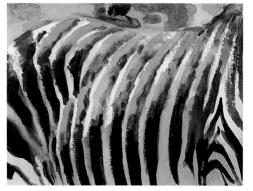

2. *For the areas in shadow, use Vandyke brown mixed with carmine. As the artist has done here, drag the color over the white stripes that fall in the shadows.*

3. *Continue to develop the shadows, softening the edges after each brushstroke.*

4. *Compare your work with this illustration. Add whatever detail is necessary to succeed in conveying the spongy appearance of the hair. Here, you can see that the artist has avoided hard edges and obvious brushstrokes and has suggested minor shadows on the stripes with small notes of color. Note also the tonal variation in the stripes on the right. This has been achieved by adding a little ultramarine blue to the mixture.*

HAIR	A BEAR

Bears' fur consists of dense, long hair. Although a bear does not usually present strong contrasts in color, it does display strong tonal contrast. This, therefore, is the feature artists employ to suggest the texture of the coat. Additionally, the contours of this large animal provide vast areas of light and shadow, apart from the contrast in the small shadows found between the tufts of hair.

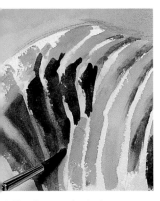

For this exercise, paint most of this bear's body; excluding the face will allow you to concentrate on the back and paws.

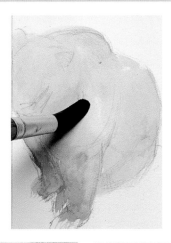

1. *Cover the entire surface of the bear's body with a wash containing cadmium orange and cobalt blue, but increase the proportion of orange for the paws.*

NOTE

In a watercolor painting, short hair is suggested by imitating the spongy effect it produces. Long hair, on the other hand, can be rendered through light brushstrokes that reveal its length, direction, and thickness.

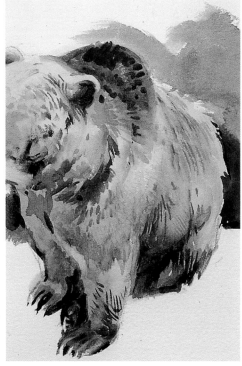

2. *Paint the background in indigo and sienna to add contrast; in outlining the form, use irregular brushmarks in imitation of the hair. Using burnt sienna and a touch of cobalt blue, paint the darker areas and, at the same time, reserve several highlights. Vandyke brown is used for the hairs around the ear and the face.*

3. *Continue to work on the texture of the hair in brown, and use short brushstrokes that follow the direction of the hair.*

4. *In this illustration of the final result, you can see that the hair has been given different intensities of the same color, in accordance with the light that falls on them. Note also that the edges of the dark tones have been softened; this was done with a wet brush.*

SCALES

Scales are another type of skin cover that can be found on numerous sea and land animals. The scaly skin of these creatures usually seems cold and fragmented but also displays a rich variety of colors.

On the body of one of these cold-blooded animals, it is possible to find scales of different sizes, thickness, and shapes that blend on the surface of the skin to present a beautiful mosaic of forms and colors; the scales may sometimes be shiny, especially in marine animals, or completely dull.

In the case of fish, their scales are usually transparent. Consequently, in a painting, they can only be suggested by means of their pattern and highlights.

Rendering the texture of scales in watercolor is a fairly difficult task; it is no less challenging than capturing the silkiness of human skin or hair.

Obtaining good results with this medium can make painting an exhilarating experience.

SCALES — AN ALLIGATOR

Alligator hide is very attractive because it is covered with numerous scales that vary in size and shape, according to their placement in the body, and form a beautiful pattern.

Of the several alligators that appear in John Singer Sargent's work, Muddy Alligators *(1917), you are going to reproduce only part of one.*

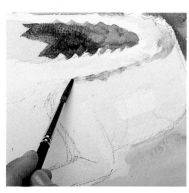

1. Use a mixture of burnt sienna and cobalt blue to paint the space around the body of the alligator, leaving the shape of the animal white. Add a little orange to certain areas to enliven the ochre, especially on the ground.

2. Begin by painting the toothed ridges that form the curve at the top of the back with a mauve mixed from cobalt blue and carmine. Then, paint the shadows that define the foot. With short brushtrokes, start painting the first scales.

3. Continue to work on the texture of the scales with the same mauve color used earlier.

4. To finish, add the final contrasting touches in a deeper mauve to the foot and certain points on the side.

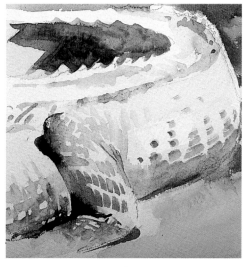

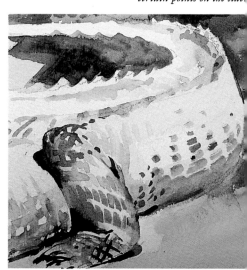

SCALES — AN IGUANA

The iguana is another animal with scales on its skin; the differences in size and structure, as well as the changes in color its scales display make this reptile interesting.

To capture the texture of this creature's skin, artists suggest the scales through the color and line patterns the scales present.

You are going to paint this detail of the head of an iguana, the scales of which offer an interesting variety of form, color, and size.

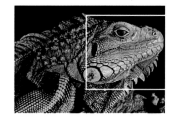

1. First, apply a base color over which the pattern of scales will be painted. This consists of a greenish wash made by mixing turquoise with a little medium yellow. For the chin, use ochre and yellow, and paint the jagged skin on the chin in cerulean blue.

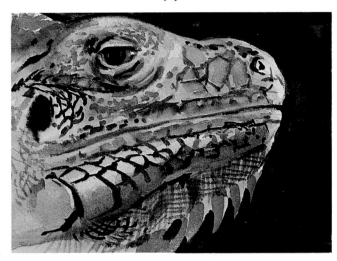

4. Observe this completed illustration. You can see that a grid pattern has been used to suggest the small, fine scales under the chin; the rest has been painted using olive green and indigo blue where necessary. Note the orange note on the snout of the animal that highlights the chromatic variety of the animal and contrasts the colors.

2. Use Vandyke brown and burnt sienna for the eyes; paint the ear in dense indigo blue, then use it highly diluted for the lines that pattern the chin area.

3. Paint the area over the eye with a mixture of olive green and cobalt blue, but leave some spots without color to suggest some of the scales; you can suggest other scales with small colored dots. This illustration shows the artist drawing the line pattern on the chin in indigo blue with a fine brush.

SCALES A RED MULLET

Among the scaly creatures that humans often encounter are fish. Finding a subject with scales for a painting, therefore, can be as easy as looking in the bins of a fish market or in the refrigerator at home. The red mullet in this exercise has transparent scales that will have to be suggested by the underlying color and the highlights they produce.

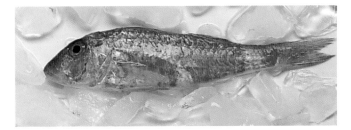

This mullet is a good example of a scaly skin that is full of highlights where the scales are so thin and transparent that they are barely visible at first glance.

1. Apply the base tone that will determine the predominant tones of the fish. Use vermilion for the back with a small touch of yellow to represent the highlighted area. Form the head with small, pink brushstrokes, and paint the belly in a mixture of turquoise and yellow.

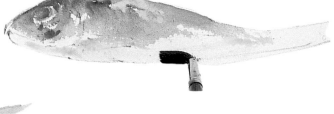

3. Add the cast shadow to create contrast and define the form, and continue to work on the structure of the head and the scales using short brushstrokes.

2. With pink dots, suggest the scaly texture of the back, at the same time adding small lines along the side.

4. In the finished work, here, you can see how the intensity of the tone varies. This is because several small, contrasting touches of alizarin crimson and cobalt blue were added.

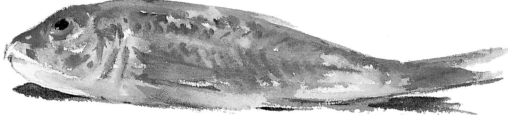

FEATHERS

Like hair, feathers vary enormously according to the species of the bird that produces them. It is not only a question of feather size or color but also of shape; feathers can be short, almost circular in certain birds and long in others. The plumage can vary even on the same individual. For example, a bird can have densely grouped feathers on its head and a row of long, separated feathers on its tail.

As regards color, most birds possess a wide variety of colors that may all be in the same range or, on the other hand, may create strong, even striking contrasts. Some feathers are similar to a certain type of long, dense hair, such as the plumage of the rooster illustrated in this page. In any case, the feathers on a bird can virtually conceal the body of the animal.

| FEATHERS | A ROOSTER |

Even though they are farm birds, roosters have beautiful plumage with a strongly contrasted variety of colors.

We are going to paint the part of the rooster's body that has the most varied feathers as regards color and size.

1. Paint the first patches of color to use as a base for constructing the texture of the plumage. Color the neck in ochre, with the darker part in a mixture of indigo blue and some Vandyke brown. Use vermilion for the wing, and paint the background with a mixture of turquoise and yellow to define the form of the bird. Add several lines, in a mixture of brown and alizarin crimson, to indicate the feathers.

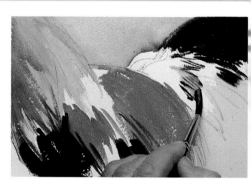

2. Paint the tail with indigo blue, and with the dampened brush soften the lines that are painted over the reserved white. Begin suggesting the first feathers on the neck with burnt sienna.

3. Continue outlining the texture of the plumage over all the patches of different colors.

4. Here, the finished illustration lets you see the long, flowing brushstrokes the artist used to paint the texture of the feathers. The color that has been used for outlining the plumage is a deeper version of the base color, which in some cases contained a touch of the surrounding colors.

| FEATHERS | A PARAKEET |

A parakeet is a pet that can be found in many homes. It has short, soft feathers on its breast and abdomen that contrast with the long feathers on its tail. The tiny white feathers on its head may seem difficult to represent but they can be rendered quite easily.

We are going to paint the blue parakeet, a small common pet with an interesting plumage.

NOTE
The long feathers of the tail should be treated differently from the small feathers most birds have on their breasts.

1. The preliminary colors are a mixture of cobalt blue and burnt sienna with a predominantly blue tone for the abdomen. Apply a few touches of color on the wing to suggest the feathers.

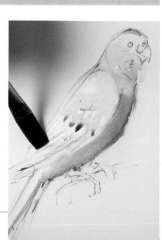

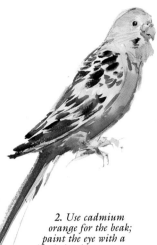

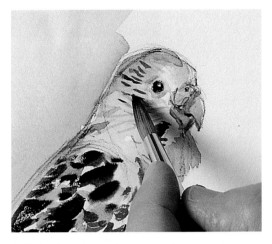

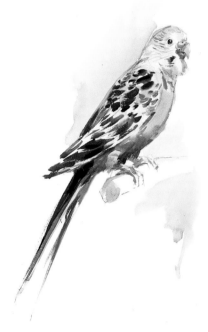

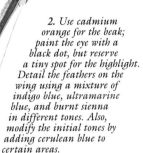

2. Use cadmium orange for the beak; paint the eye with a black dot, but reserve a tiny spot for the highlight. Detail the feathers on the wing using a mixture of indigo blue, ultramarine blue, and burnt sienna in different tones. Also, modify the initial tones by adding cerulean blue to certain areas.

3. Paint the background to increase the contrast. That leaves only the minor details to work out, such as the head feathers that are painted using a mixture of Vandyke brown and indigo blue.

4. In the finished illustration you can see that the tail feathers are suggested in an interplay of blue tones with fresh, long brushstrokes. Additionally, note that a touch of the color used for the small head feathers has been added to the wings to bring together all the tonalities of the body.

FEATHERS	**A** MACAW

The macaw is an exotic bird; its multicolored plumage has attracted the interest of painters and bird fanciers since the nineteenth century.

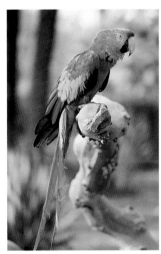

You are going to paint this macaw in its entirety as it has certain similarities with the parakeet. Nevertheless, it has a different plumage with more intense coloring.

2. Over the vermilion, give form to the plumage in pure alizarin crimson; add darker touches to suggest shadows with ultramarine blue and lemon yellow.

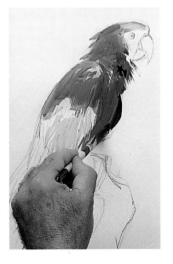

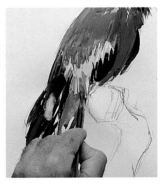

3. Use ultramarine blue for the tail, adding a touch of alizarin crimson to certain feathers.

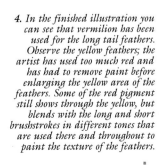

1. Apply the initial definitive colors with texturizing brushstrokes: first, lemon yellow as it is the lightest color; then, vermilion obtained by mixing the previous yellow with alizarin crimson.

NOTE

Birds may move, spread their wings, and ruffle their feathers. For this reason, it is a good idea to make a few sketches before painting them.

4. In the finished illustration you can see that vermilion has been used for the long tail feathers. Observe the yellow feathers; the artist has used too much red and has had to remove paint before enlarging the yellow area of the feathers. Some of the red pigment still shows through the yellow, but blends with the long and short brushstrokes in different tones that are used there and throughout to paint the texture of the feathers.

Glass

Because of its transparency, glass presents a challenge to the inexperienced painter. Glass is a substance that, if not transparent, is always at least translucent. That is, it allows light to pass through it, making it possible to discern the objects behind it. It also produces highlights and can reflect the objects near it. Glass may behave like a perfect mirror or distort the images it reflects.

CHARACTERISTICS

A glass of water, a flower vase, the window of a building, a person's eyeglasses, the stained glass windows of a church, or the face cover of a watch all are glass objects that are commonly encountered. It is, therefore, important to understand the way glass behaves to learn how to paint it. Many glass objects are both transparent and colored. Generally, however, glass is clear and colorless. These qualities are what make it difficult to paint. Some artists have said that when painting a glass object, what you really have to paint is not the glass but what stands behind it. This statement is correct as regards colorless glass, but when the the glass is colored or reflects what is in front of it, it must be painted with a different approach.

GLASS | COLORED GLASS

Stained glass maintains its transparency but alters the colors of the objects behind it. As it is colored, stained glass also projects its color onto the objects that surround it and onto its own shadow.

You are going to paint these colored-glass bottles, which clearly show the characteristics discussed in the text.

1. Cover the background with a soft gray tint, made by mixing turquoise and burnt sienna to make the highlights on the glass stand out. Paint the rear bottle in mauve; this tone can be obtained by mixing turquoise and alizarin crimson.

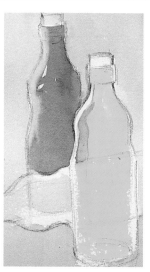

2. Paint the foreground bottle in lemon yellow, reserving the highlights. Note how the color of the part of the mauve bottle visible through the yellow one changes when a glaze is applied.

3. The middle bottle is painted in medium cadmium red, with a touch of carmine added to the bottom to darken it. Use the same tone, only more diluted, to paint the cast shadow.

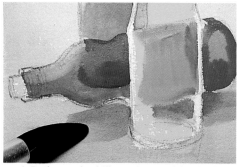

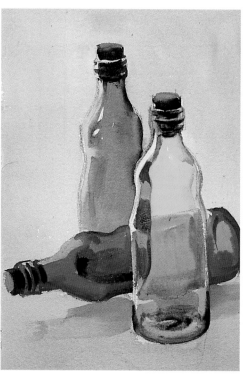

NOTE

Colored glass changes the color of any object that is seen through it. A shadow cast by a colored-glass object will also be tinged with its color as will any surrounding objects.

4. In the completed illustration, at right, the detail that has been added and the areas of shadow that have been darkened show the interplay in the tones of the three types of glass; the intensity of these areas serves as a contrast to the highlights.

GLASS — A VASE

Not all glass objects are smooth and totally transparent. Often, they are patterned and may distort the images seen through it.

This transparent glass vase allows its contents to show through; the ridges on its surface, however, distort the shapes.

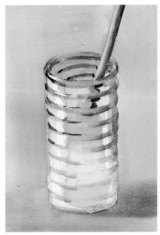

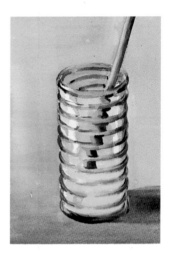

2. Paint the shadow on the stick with Vandyke brown and the shadows of the lines with a mixture of cerulean blue and permanent green.

1. Using a mixture of ultramarine blue and burnt sienna, paint the background, which is visible through the vase. With very diluted indigo, suggest the cast shadow; with lemon yellow and orange, the liquid; with ochre, the stirring stick. Over these preliminary patches of color, outline the shape and highlights that form the ridges of the glass with a mixture of turquoise and lemon yellow.

3. After working on the lines in the upper part, begin suggesting the broken shape of the stick inside the vase with a diluted brown.

4. As in this finished illustration, gradually complete the detail of the entire vase, working from top to bottom.

GLASS — MIRRORLIKE WINDOWS

Another characteristic of a certain type of glass is its capacity to reflect objects that stand before it. Rendering this mirrorlike glass in a picture entails painting the reflections in the glass, though often, such as in this case, the image reflected is a distortion.

For this exercise, you are going to paint part of the front of this building; it has windows that reflect the street, although the image is distorted.

1. Apply a gray wash, obtained by mixing burnt sienna and cobalt blue; over this wash suggest the first reflections in Payne's gray.

2. Paint the distorted image of the building in front using a mixture of Payne's gray and Vandyke brown.

NOTE

Painting glass that acts like a mirror involves painting what it reflects.

3. Add a last touch of neutralized orange.

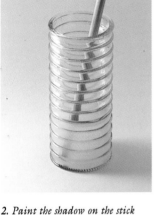

4. Note that you have not used a wide range of colors to produce these reflections, and what may have seemed complicated at first sight is one of the simplest of exercises.

Metals

Metal is a substance that is used in constructing many objects commonly used in daily life; a copper pan, a kitchen knife, gold jewelry, and a lamp all are examples of metal objects that an artist is likely to encounter when painting subjects from life. Metal can be found even in a landscape or outdoor scene, for example a steel fence, the doors of a building, cars in the street, the portholes of a ship, and so on. Metal presents a shiny appearance when polished, but in old objects it can be dull and covered with rust.

As always, careful observation of the subject before painting is paramount as you must paint what you see, not what you suppose is there. Some metals have no shine at all, perhaps due to poor illumination or because they are rusty or covered in dust; others, however, can act like mirrors. Often, a combination of effects will be necessary to capture a single subject. Silver objects, for example, frequently reveal both highly polished and heavily tarnished areas.

resenting those of gold, silver, or copper in a painting. Each of these metals has its own color and characteristics, yet the range of watercolors in the stores does not match any of them exactly. Artists cannot hope to imitate the exact color; the most they can do is suggest it. Moreover, they need to bear in mind that the color of the light falling on the metal surface and the surrounding objects will affect the tones of the metal.

CHARACTERISTICS

Principally, metal is hard and cold to the touch; these qualities, however, are not always the characteristics from which a metal surface derives its appearance. The surface of a rusty hull of a ship looks different from that of the polished blade of a sword, even though both are made of metal. In the same way, the surface of painted metal—as in a car—will present highlights and other features more characteristic of the paint than of the metal itself. Painting metals in watercolors, therefore, requires that each case be treated individually.

POLISHED METALS

Polished metal that has not been painted poses two problems when it comes to painting it in watercolor: the color and the reflections it presents.

The first problem arises before starting to paint. You may look at your palette and wonder what colors to choose for rep-

As to the second problem of reflections, these mainly involve small highlights where the polished metal surface reflects the light falling upon it or reflections of images of nearby objects. The highlights can be achieved by reserving small white areas; reflections, on the other hand, can be a little more complicated to render as they must correspond in form, color, and size with the object reflected. Also, metal generally distorts any images it reflects.

POLISHED METALS A SILVER RING

Silver is a cold metal, and this characteristic is apparent in its color, which has a cool tendency.

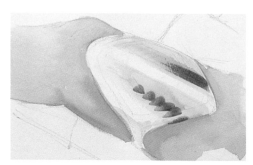

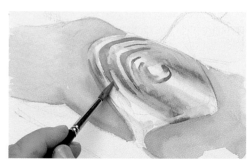

This silver ring is a representative example of a metal surface; its interesting design of concentric ovals shows many highlights.

1. Apply a mixture of burnt sienna and cobalt blue, reserving the white for the bright areas that reflect the light. Set down the areas of shadow over this first wash using a deeper tone of the same color.

2. Paint the shape of the oval strands in gray; for the skin showing between the ovals, use an intense color to increase the contrast.

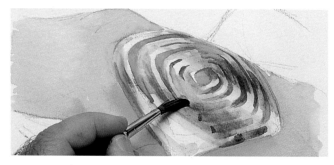

3. Continue working in this way on the design of the ring.

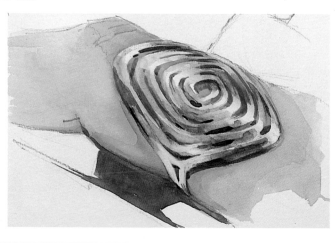

4. After fully developing the shape, finish this exercise by building up the tones as necessary to create the contrast that will make the highlights stand out.

RUSTY AND UNPOLISHED METALS

The appearance of an iron plate exposed to outdoor weather conditions is completely different from that of a shiny ring. When you paint rusty metal or metal that has not been polished, you need not worry about highlights; on the other hand, capturing the diverse tones and texture of such a porous and uneven surface can be a challenge.

Rusty metal, apart from its own color or the color of the paint it may be coated with, also presents the reddish color and texture produced by the oxidation process.

RUSTY AND UNPOLISHED METALS | **AGED BRASS**

This exercise involves painting an aged, unpolished metal surface that has acquired a dull but variously toned patina.

Here, you must try to suggest the color and texture of this old brass watering can.

1. Paint the top of the can in burnt sienna with a little vermilion. Using a mixture of yellow ochre and permanent green apply a wash to the side of the can; before the paint dries, lift out color for the highlighted areas by using a blot-dried brush.

2. Use Vandyke brown and emerald green to paint the handle; add a little lemon yellow to this mixture to suggest the ridges. Then, use brown mixed with burnt sienna for the shadows.

3. Darken the top part, and add the small patches of color with the same mixture used for the handle of the can.

4. Finish the exercise by adding the last touches to the darkest areas and painting the smaller details.

RUSTY AND UNPOLISHED METALS | **RUSTY METAL**

Metal that is left outdoors is bound to show rust in some areas; in time, this rust will alter the metal's color and texture.

You are going to paint the foreground edge of this metal container where you can clearly see the effects of the rust.

1. Apply a soft, gray wash over the entire sheet of paper. Develop the colors in wet to allow the pigment to spread; use a mixture of cerulean blue, burnt sienna, and a touch of vermilion. Paint the small dots and straight lines in burnt sienna and alizarin crimson.

2. Mix turquoise with burnt sienna to produce a gray for the front of the container. Then, paint the shadow on the right in burnt sienna with a little cobalt blue.

3. Paint the darkest parts of the edge using a mixture of indigo and Vandyke brown, and continue to work on the stains with rust red.

4. This final illustration shows that you need to make some small adjustments and paint a few of the larger rust stains with a highly diluted brown glaze.

Topic Finder

Original title of the book in Spanish: *Todo sobre la técnica de la Acuarela*
© Copyright Parramón Ediciones, S.A. 1997—World Rights
Published by Parramón Ediciones, S.A., Barcelona, Spain.
Author: Parramón's Editorial Team
Illustrators: Parramón's Editorial Team

© Copyright of the English edition 1997 by
Barron's Educational Series, Inc.

All inquiries should be addressed to:
Barron's Educational Series, Inc.
250 Wireless Boulevard
Hauppauge, New York 11788

International Standard Book No. 0-7641-5046-4

Library of Congress Catalog Card No. 97-21750

Library of Congress Cataloging-in-Publication Data

Todo sobre la técnica de la acuarela. English.
 All about techniques in watercolor / [author, Parramón's
Editorial Team ; illustrators, Parramón's Editorial Team].
 p. cm.
 ISBN 0-7641-5046-4
 1. Watercolor painting—Technique. I. Parramón Ediciones.
Editorial Team. II. Title.
ND2420.T6413 1997
751.42'2—dc21 97-21750
 CIP

Printed in Spain
987654